ahead of
the 21ˢᵗ
century

The Pisces Collection

D1486129

ahead of the 21st century

The Pisces Collection

Hatje Cantz

Contents/Inhalt

709.4092 /AHE

Acknowledgments

A dream comes true

May 2000:
Simon de Pury, Andrea Caratsch and I fantasise about an exhibition in the Fürstenberg Collections at Donaueschingen.

June 2002:
Opening of the exhibition "ahead of the 21st century – The Pisces Collection".

Looked at soberly, it is a quite ordinary story. In the background, however, lay two years full of emotion, difficulties and many committed and important people, who all made their contribution to the success of this unique project. My heartfelt thanks to them all.

So our dream has become reality and I hope that this synthesis of the arts in Donaueschingen will bring you as much enjoyment as it now gives me every day.

Donaueschingen, June 2002
Heinrich Erbprinz zu Fürstenberg

Dank

Ein Traum wird wahr

Mai 2000:
Simon de Pury, Andrea Caratsch und ich fantasieren über eine Ausstellung in den Fürstenberg Sammlungen zu Donaueschingen.

Juni 2002:
Eröffnung der Ausstellung »ahead oft he 21st century – The Pisces Collection«.

Nüchtern betrachtet eine ganz normale Geschichte. Im Hintergrund aber liegen zwei Jahre voller Emotionen, Schwierigkeiten und vielen engagierten und wichtigen Menschen, die alle ihren Beitrag zum Gelingen dieses einmaligen Projektes geleistet haben. Meinen herzlichen Dank an sie alle.

Unser Traum ist damit Realität geworden und ich hoffe, dass Ihnen dieses Gesamtkunstwerk in Donaueschingen ebensoviel Genuss bereitet wie es mir jetzt jeden Tag vergönnt ist.

Donaueschingen, Juni 2002
Heinrich Erbprinz zu Fürstenberg

Shortly after Daniella Luxembourg and I started our own company in 1997, a friend of mine asked me whether I would be prepared to put together a collection of contemporary art from the 1980's onwards. It obviously did not take me too long to accept this exciting challenge. It was decided not to have an encyclopaedic approach, but rather to concentrate on the work of a relatively small group of artists and have them represented in depth.

Pisces, the name of the collection is derived from the astrological sign of its owner. While the latter has chosen to remain anonymous, the desire was expressed from the outset that it should be made accessible to the public.

I am most grateful to Prince and Princess Heinrich zu Fürstenberg to host this collection in their family museum next to their castle in Donaueschingen. The vicinity of its "Schatzkammer" objects, skeletons, trophies and stuffed animals seemed to present an ideal counterpoint to the works of artists such as Rosemarie Trockel or Damien Hirst. I am indebted to Count Christoph Douglas for having come up with the suggestion and having acted as a gobetween.

The works were acquired from a variety of sources, mainly from galleries, dealers, artists and collectors, but also from the three main auction houses. One year into the project Andrea Caratsch joined de Pury & Luxembourg to open and run its gallery in Zurich. he was immensely helpful in the procuring of works and is to be credited for the installation of the exhibition. The Pisces collection opens a personal perspective on art created at the dawn of the 21st century.

Simon de Pury
June 2002

In 1997, kurz nachdem Daniella Luxembourg und ich unsere Firma gründeten, fragte mich ein befreundeter Sammler, ob ich dazu bereit sei, eine Sammlung zeitgenössischer Kunst ab 1980 zusammenzustellen. Natürlich nahm ich diese Herausforderung mit Begeisterung an. Wir beschlossen, ohne Vollständigkeitsanspruch zu sammeln und uns lieber auf eine relativ kleine Gruppe von Künstlern zu konzentrieren, um diese dafür ausführlicher präsentieren zu können.

Pisces – der Name der Sammlung – ist abgeleitet vom Sternzeichen ihres Besitzers. Während er selbst anonym bleiben möchte, so hat er doch von Anfang an den Wunsch geäußert, die Sammlung öffentlich zugänglich zu machen.

Ich bin Prinz und Prinzessin Heinrich zu Fürstenberg dafür zu großem Dank verpflichtet, dass sie diese Sammlung in ihrem Familienmuseum neben ihrem Schloss zu Donaueschingen aufnehmen. Die unmittelbare Nähe seiner »Schatzkammer« mit Skeletten, Trophäen und ausgestopften Tieren scheint ein ideales Gegengewicht zu den Arbeiten von Rosemarie Trockel oder Damien Hirst abzugeben. Ich danke Graf Christoph Douglas, diesen Vorschlag vorgebracht und als Vermittler fungiert zu haben.

Die Werke wurden aus zahlreichen Provenienzen erworben, größtenteils von Galerien, Kunsthändlern, Künstlern und Sammlern, aber auch von den drei wichtigsten Auktionshäusern. Ein Jahr später stiess Andrea Caratsch zu de Pury & Luxembourg, um unsere Galerie in Zürich zu eröffnen und zu leiten. Er war sehr hilfreich bei der Beschaffung der Kunstwerke und besorgte die Hängung der Ausstellung. Die Pisces Collection enthüllt einen persönlichen Blick auf die Kunst zu Beginn des 21. Jahrhunderts.

Simon de Pury
Juni 2002

Don't trust me – Trust me

First Survey: The Pisces Collection

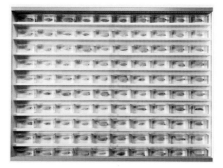

70 Damien Hirst
Alone Yet Together, 1993

Each fish is different. Each has its own showcase. All the showcases are the same. Order prevails. The way the bodies float in clear liquid can only conceal for a moment the fact that these fishes are certainly not in their element. They are offered to the viewer as objects prepared in a formaldehyde bath. Life suspended. English superstar Damien Hirst called this 1993 work "Alone Yet Together", and once again chose a so-called scientific form of presentation as a means of analysing this puzzle by transforming it into an artistic context, and in the process opening up new ways of looking at things. We see fishes, but we perceive them as metaphors for humans. A real object, presented frankly in such systematic orderliness, triggers thoughts of life and death, isolation and the faceless society, science and art. The symbolic values shift about in the *white cube* of the exhibition space.

Alone Yet Together

Damien Hirst's "Alone Yet Together" is the cover illustration for the catalogue accompanying this first public presentation of the Pisces Collection. The choice of this installation with the fishes as the front cover can be explained by the fact that *Pisces* is the zoological term for *fish* and also the name of the sign of the Zodiac. One could thus see the decision to use a motif, which is the pictorial equivalent of the name of the collection, and then again is not, as a first clue to the strategy of the collection. In the name of the collection, Pisces stands for the star sign of the anonymous collector. The fishes in Damien Hirst's work are a metaphor for humans. *Fishes* and *Pisces* – a picture and a word – and with them a variety of interpretational possibilities, depending on whether one looks at them from the standpoint of astronomy, astrology, biology or iconography. The description and the thing described are no more clearly related to each other than picture and meaning. In the context of presenting a collection of contemporary art, the chosen combination of name and motif makes it clear that particular attention was being given to the game of connecting words, ideas and images, and also to the resulting questions about possible truths in the notations of art. It is therefore scarcely surprising that the choice fell on works which – in terms of explicitness – gave preference to a multiplicity of perspectives. At the centre of interest are artistic strategies which attach great importance to the visual and meaningful presence of works of art, but at the same time allow them to make critical reflections about what it can mean to make art at the end of the 20th century.

Art from the '80s and '90s was collected and put on view, the work of 21 male and female artists from the United States, Europe and Japan. If the number of international stars represented in the list is what first impresses, it will also be evident, as soon as the viewer is confronted with the exhibited works, with what rigour the artists are working collectively at the highest level on a difficult subject. In the joint exhibition of paintings, objects, photographs and installations, a subtext is revealed that may perhaps have played a part in the selection of individual pieces. The Pisces Collection brings together a large variety of artistic formulations, all of which though, in one way or another, invite discussion of the image – whether it is a trivial advertising image or a work of art – and thus of the world of marks and notations, of writing and language, and together form a reflection on the media employed. The portrait of an age which they depict is not confined to that of one artistic generation but at the same time picks out the central themes that artists from different age groups present in their works. These are quite distinct, uncompromising artistic assertions, whose declared aim is to ask more questions than they answer, embracing the effective confrontation just as much as the provocative gesture or the well-calulated shock. The exhibition "ahead of the 21st century" now makes it possible to see part of the Pisces Collection, and in the panorama of very different artistic positions on show perceive common questions, approaches and strategies that perhaps from the perspective of future generations will be seen as hallmarks of art on the threshold of the 21st century.

Shocks and Irritations

Cindy Sherman, Paul McCarthy and Damien Hirst provoke the public, shocking them with attacks on moral or aesthetic values and promoting disgust as an artistic experience. Paul McCarthy, whose performances and objects continually and mercilessly parade vivid depictions of suppressed, forbidden and perverse material, is represented in the Pisces collection with photographs of "Propo Objects" and "Masks". Even without knowing that these are objects were originally part of a performance, the imagination of the viewer is bound to make connections with violence and terror when faced with a headless Ken from the Barbie family, who raises his right arm in a Hitler salute, and the Johnson's Baby Lotion container smeared in reddish-brown daubs. That the nightmarish visions of bloody events, which rise from our unconscious as a reaction to such key stimuli, are mostly far more threatening than the original performance – in which the artist used ketchup to make ironical gestures – leads us to draw conclusions about the viewer

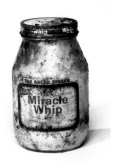

82 Paul McCarthy
Propo Objects (Miracle Whip), 1991

rather than make comments on the work itself. If McCarthy's masks seem like relicst which are photographically documented and stylised through enlargement, those of Cindy Sherman are both pictorial vocabulary and protagonists, which the artist uses as part of the set in which she herself appears. Here the appeal of the pictures stems directly from the ambivalence between the fear-inducing horror scenario and its exposure as a masquerade. For the works in her "Disgust Series", Cindy Sherman created nauseating images of putrid food remains coated with mould. While this reality in the camera's eye provides the pictorial material, the way it looks in a glossy photograph is equally determined by refined lighting, its careful composition and framing. In a large-format print the subject loses its unambiguity, and appears abstract – at least at first glance. The subject is not the mouldy food but the designed surface: the image.[1] Repugnance and fascination intermingle. Almost against our wishes, we see the beauty of the picture that we categorise as arousing disgust because of its subject matter.

Confrontation with the "Marble Floors" of Wim Delvoye also arouses a similar uncertainty. Here our eye takes delight for a long time in the art – which we see as craftsmanship handed down from a previous age – and the precision of the decoration with its warm red tones, until our brain, trained to classify what it has perceived, explains to us that these artistic mosaic floors we so admired were not made of stone but from assembled bits of salami, ham, mortadella and other kinds of sausage. Although this realisation tells us nothing about the picture (because it is a photograph anyway, and neither stone nor sausage), it shatters our received ideas about the appropriateness of materials in art, and at the same time poses a subversive question about what art is or may be. As with the compositions of Cindy Sherman, photography is the only way to give any permanence to installations made of transitory materials, and at the same time to use the abstract image portrayed to strengthen the visual irritation. A decisive feature of Wim Delvoye's approach is to break the common taboo that "You should not play with food" and to transform familiar and everyday material, which at the same time is imbued with moral characteristics, in the context of art. In a work such as "Marble Floors", there is a paradoxical mixture of uneasiness at this wastefulness and our practical everyday experience which forces us, against our wishes, to see the perfectly preserved floor turn after a short time into the counter-image of discoloured and crumpled slices of sausage.

Carpe Diem

The transitory nature of all earthly things is a subject that has been treated countless times in art. For contemporary art to pay it such attention, and for the works arising from this concern to be so outrageously extreme in their expression, and so disillusioned in what they say, can be easily attributed to the gradual replacement of Christian-led humanism by a scientific view of humanity. A human being, seen as a biological mechanism, whose optimisation is eagerly achieved by human beings, is however only a body without a soul. Our thinking would be no more than the result of neurological-chemical processes coursing through our brain. Working from an ever-changing point of view and in many different media, Damien Hirst has created works that take as their theme questions about the possibility of explaining mankind in biological terms, about his fear of death as well as his consequent trust and belief in medicine. The work "Loss of Memory is Worse than Death" can be seen as a kind of basis and summary of the numerous works in which he preserved the bodies or body parts of animals in formaldehyde. Here the magic potion, which can delay the physical disintegration of dead organic matter, but is a deadly poison for living creatures, becomes the protagonist. Writing about this substance, which he exhibits in a wholly minimalistic way in canisters in a sealed wire container, Hirst has said: "I use it because it is dangerous and it burns your skin. If you breathe it in it chokes you and it looks like water. I associate it with memory."[2] What is interesting about this quotation is not only the ambivalence, which the artist stresses, between danger and fascination but also the fact that it suggests an additional way of reading the title of the formaldehyde object. Would death be more bearable if we knew that our body was being preserved?

Spots and Dots and Happy Painting

An early example of Hirst's interest in the aesthetic and conceptual connections between art and medicine is the work "Untitled (Pill Painting)". This monochrome picture in broken white is reminiscent of works by Robert Ryman, but also, in the way the artist breaks up the smooth surface of the picture with shapes concealed under the paint layer, which are clearly recognisable as tablets, he allows their visibility/invisibility to provide a metaphor for the effectiveness/ineffectiveness of medicines. From his work with found objects, the artist turned to his "Pharmaceutical Paintings", which all feature coloured spots of equal size arranged on the canvas in grid formations. The starting point for these paintings may well have been the number of different chemical substances in psychiatric drugs, whereas the "Spot Paintings" are

77 Jeff Koons
New Hoover Deluxe Shampoo Polisher, 1980

concerned solely with painting: "They're about the urge or the need to be a painter above and beyond the object of a painting. (...) I started them as an endless series (...) a scientific approach to painting ..."[3] This is a form of painting which uses a systematic approach to suppress personal sensibility and by strictly following self-imposed rules to achieve surprisingly effective results which ask questions about painting as an artistic form of expression and at the same time redefine it. "No matter how I feel as an artist or a painter, the paintings end up looking happy."[4]

Although John M Armleder would be unlikely to define his "Dot Paintings" as the results of an analysis of the natural sciences, he would presumably agree with Hirst's way of looking at the "dumb paintings". As early as the end of the '70s, he began to paint pictures constructed according the simplest of rules – particularly aimed at quoting the vocabulary of constructivist or concrete art – in which, however, he used small changes or a different choice of colours to pose subversive questions about progress in painting. Aware that basically every painterly gesture which determines a painting is in some respect quotable, he decided on the one hand to make quotable pictures, like the "Dot Paintings", in which discovery and gesture play no part, and on the other to produce "Pour Paintings", in which the chemistry of the paint decisively influences the result. But for John M Armleder painting is only part of a continually moving artistic cosmos, which in the proven rewind & fast forward mode permits continually new and surprising views and insights. "I try most of the time to radically undermine what I tend to achieve easily. It works this way, but a system grows that has to be undermined as well."[5] The need to work against one's own ability is a result of the impossibility of having an experience repeatedly. A work of art that offers no individual quality of experience is a plagiarism, – the worst kind being when it is one's own art. For this reason, Armleder constantly introduced materials into his work that are hostile to art (mirrors, plexiglass, neon tubes) and extended his repertoire of found objects from reality. In recent years Armleder has worked intensively on large installations, "Towers", which enable very different work complexes to combine together and make the exhibition space a platform for new spatial and visual experiences.[6] The installation in the exhibition made of mirror-faced turning spheres ("Disco balls") indicates the strategic changes made to the space by light, the random light reflected from them turning everything in the room into a projection surface or screen.

Object Lessons – De Luxe

The works of Jeff Koons are also characterised by a willingness to cross boundaries and question our perceptual habits, and in the process provoke an alternative way of looking at everyday things and make us reconsider the meaning of good taste. His "New Hoover Deluxe Shampoo Polisher" from 1980 is one of the artist's early works, in which the veneration of the product is made visual in the form of vacuum cleaners arranged in an illuminated display case. "I went round and bought up all the vacuum cleaners I could before they stopped making a certain model. I wasn't showing them with indifference. I was being very specific. I was showing them for anthropomorphic quality, their sexual androgyny. They are breathing machines."[7] However much the visitor may see the work as ironic or even heretical – even 67 years after Duchamp's first ready-made – such views are not to be found in the author's statement. Quite the opposite: if one believes his words, and takes them seriously, it becomes clear that Koons's strategy is not only to display the vacuum cleaner as art but to look at it as such and put its formal and metaphorical qualities into words. This change of perspective opens up a new kind of perspective which is completely independent of the object's function. A vacuum cleaner can be a fountain.

Sylvie Fleury presents the *objectification* of a machine in her "283 Chevy". The chrome-plated cast of a car engine not only celebrates the beauty of technical functionality but at the same time takes it into the realms of the absurd. In her works using famous classic cars, the Geneva artist constantly visualises the personal identification of the car-lover with his or her vehicle. The engine thus becomes the heart of the car, whose stroke or beat dictates our movements. Isolated on its plinth, gleaming and beautiful, it becomes the pseudo fetish of a consumer-oriented society. The promises of worldly happiness made by advertising, which determine the spiritual health of consumers, are reflected in the "Current Issues" of the glossy magazine which Sylvie Fleury combines in a mural to present a women's image of the mass media, which is no more and wants to be, seen here as a collage of branded goods and beauty tips.

The photographic works of Richard Prince, in which cowboys from the Marlboro advertisements and girls from motor bike magazines unintentionally provide information about the philosophy of life of *Spiritual America*, also borrow the vocabulary of trivial culture and place it in the context of art, and in the process make references to the ruling spirit of the times and the manipulative power of the mass media. The meaning that the omnipresence and availability of the pictures has for the expe-

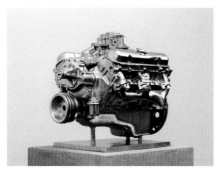

54 Sylvie Fleury
283 Chevy, 1999

riential category of art, in which authenticity and character are still traded as valuable concepts, is thus made clear. For Richard Prince, a principal representative of Appropriation Art, the flatness of the banal image serves as a starting point for his cynical commentaries on society, which finds itself reflected in these images. Prince's jokes and jokebook drawings, quoted on large canvases above or below traces of paintings and applied by silk-screen printing on monochrome surfaces, and constantly repeated, serve not only to thematise a redundant gesture but the insolent jokes expressed, which are often about racism and hostility to women, wear so thin that they have a reverse effect on the viewer.

Signs and Sounds

The combination of writing and painting on a very different level is characteristic of many works by Christopher Wool. Using simple stencilled lettering, Wool places words, sentences and fragments of sentences on a white picture ground. The texts contravene our usual way of reading because the ordering and spacing between letters and words is distorted. There are only capital letters, which the artist separates by larger or smaller gaps according to the inner logic of the picture, so that reading them is made more difficult. While the arrangement of the letters follows aesthetic principles, it always aims – even when words are only indicated by abbreviations, such as "TRBL" for TROUBLE – to make sense. Unlike Richard Prince's use of writing to make quotations, Wool uses letters as signs of meaning and as pictorial signs, and makes a point of giving them meaning according to both their content and formal appearance. This ambiguity can also be found in the installations of Jack Pierson, who puts together key words such as "fool" or short word combinations such as "The One and Only", formed from letters with very different origins, or places them as characters on lightboxes. While Pierson works more with colloquial formulations, many of the texts of Christopher Wool refer to the production and reception of art. The importance he attaches to relating the defined symbolism of the script to painting as a self-referential gesture is specifically demonstrated by certain inaccuracies he inserts, such as splashes or drops of paint. For his ornamental pictures he uses a rubber roll instead of a stencil or stamps the motif onto the surface. In the centre he places the repeat pattern of the decoration – as can also be found in the knitted pictures of Rosemarie Trockel – which differs in its lack of self-containment from Jackson Pollock's all-over conception in that it does without a compositional centre (as opposed to the word pictures, which are always presented as a self-contained unit). An ambivalence between iconoclasm and iconophobia also characterises Wool's apparently *free*

works, in which, instead of using a previously formulated motif to serve as a reference, he works with free brushstrokes or overpaints surfaces in an intensive shade of colour.

The works of George Condo represented in the Pisces Collection also use as their theme the possibility of a technique which has individual characteristics. These works belong to the "Jazz Paintings" group. They are equally a homage to the music of the '40s, '50s and '60s, and the paintings of Abstract Expressionism. In his "Notes on the Sounds of Painting"[8] Condo describes these paintings (from which the seriegraphs were later derived) as "improvisational compositions based on a predetermined set of coordinates"[9]. Each of the pictures features the name of a musician, most of them set in a monochrome field which spans the whole width of the picture. The rest of the canvas is reserved for abstract painting which presents a synaesthetic transposition of the music, whose pictorial vocabulary was defined beforehand by the artist. There are no free forms, but what appears as abstract painting is the application of established models. "The freedom is expanded upon when the limitations are faced head on. This way originality comes from the unique perception of existence presencing into the sphere of the present subject matter allowing the viewer to ascertain his own conclusions from a non-material objective association."[10] The fundamental questioning of what painting is/can be is explained not only through visualising the invisible, the music, but more insistently by quoting from the language of abstract painting. What looks formally like abstract painting proves to be a planned enactment and thus the opposite of what Pollock had in mind when he started to make the picture the direct witness of the creative act.

Transparencies

The intrigue of painting, works with painting against painting, works with quotations, found objects and styles also characterises the large-format paintings of David Salle. Here he examines the open-ended nostalgia with which the 20th century wanted to relate to the innocence of the Expressionistic gesture, confronted with an anti-Expressionist structure. For Salle the picture space is a field of play on which he directs his multiperspectival collisions of very different picture stories and stylistic quotations. In the diptych "Birthday Cake with One Eye" he paints male profile heads and a leg over a picture that movingly turns the sacred world of children's birthdays into a kitsch event. The disquiet stemming from the ghostly trouble-makers finds a parallel in the second picture in which the eye of the voyeur is placed, in the

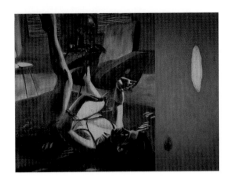

111 David Salle
Midday, 1984

manner of a collage, next to the portrayal of a naked, recumbent female figure, of whom we see only her bare bent legs with stockings and shoes and part of her buttocks. David Salle frequently uses erotic motifs like this as an eye-catcher and at the same time as syntax for the representation of subjects like childhood and violence, homelessness and displacement, simple-mindedness and deliberate posing. The appeal of Salle's pictures lies in the confusing, multi-layered titles, which often disclose a second layer of meaning. With his eclectic method and intelligent pictorial strategies he constantly manages to send the viewer off in a vain search for an unambiguous meaning of his work.

Shining Diamonds and Visual Targets

"Making art is an act of deception ... In a way I make my pictures as a way of testing my own lack of belief. That is exactly the opposite of what abstract painters do, because they are confirming their belief all the time."[11] So writes Ross Bleckner, making it clear that he too, as well as George Condo and David Salle, is practising painting about painting. Unlike them, however, Bleckner does not set about the deconstruction of his pictorial compositions by using quotations but resolves the presence of the pictures by means of a vibrating magical play with light. The impression of ephemeral intangibility, which Bleckner's pictures convey, is the result of an absolutely closed-in picture surface built up through a lengthy process using layer upon layer of oil paints, wax, metal pigments, graphite and encaustic. The motifs – mostly stripes, ornaments and blossom – seem to be enclosed in the picture as in a space beyond our visual grasp. The sense of them being out of focus is reinforced by the irritating, shimmering light whose source remains hidden in the darkness of the pictures. If Bleckner's pictures seem to concentrate entirely on their inner life, the circular pictures of Ugo Rondinone are filled with dynamism and jump directly out at us. Only with difficulty can we pull ourselves away from their hallucinatory force field. They demand attention and certainly disappoint the expectations of the viewer who goes up close to the canvas, since they too turn out to be deliberately out of focus. But perhaps the movements of the curious through the space and the dialogue between the viewer and the picture, which arises as they make their approach, are actually clues about how Ugo Rondinone places his paintings as signs in the space of his installations. It could be said that that the large-formatted striped pictures also set the viewer in motion and in the process make them experience the horizontal lines as an extension of painting through space and time.

Strategies

Not only the decisions to select certain works from an artist's œuvre but also the decisons not to select others tell us something about the strategy of a collection. Ugo Rondinone and Cindy Sherman are both artists for whom the staging of themselves in their work in roleplays has great significance. In the exhibition they are represented exclusively by work complexes in which this aspect plays no part. Once we are aware of this preference in the selection, it soon becomes clear that the same reservation about figurative representation and a psychologising "human picture" applies also to the other paintings, photographs and objects on view. When the human fugure appears in works, their portrayal is the expression of a style or cliché, as in the works of Richard Prince, David Salle and Sylvie Fleury, or is objectified, as in the "Frau" of Fischli/Weiss, as a possible manifestation of the world and is placed in a row with "Haus" and "Krähe". Finally, in the photographs of Andreas Gursky and Thomas Struth, humans play the part of extras and have no identity as individuals in a spatial situation. This conclusion confirms the thesis stated at the beginning, that a considerable part of the mission of the Pisces Collection to collect works in which reflections in art about art – or about the picture as a general conveyor of information – are given greater significance than a psychologising pictorial idea or artists featuring themselves in their works. Seen in this way, the decision to include "Red Light District" by Mariko Mori, the only work in the "ahead of the 21st century" exhibition in which the female producer and the protagonist are the same, can only be explained insofar as the artist takes over the leading role in the production, but not only conceals her identity behind the mask of the role portrayed (which represents a parallel with Cindy Sherman's work), but goes beyond this to the point of being a stylised medium. Established somewhere between a doll and a robot, standing apparently invisible in the pulsating nightlife of Tokyo, Mori perhaps defines her role as an artist, but certainly her role in the picture, as that of an outsider.

Elasticity in Artificial Gesture

The antiseptic high-tech art of Mariko Mori occupies one end of the spectrum of the artistic formulations in the exhibition, while the other end is represented by the work of Franz West, concerned to demonstrate the futility of the artistic gesture as an artistic gesture. One look at his cracked "Passstück", one of numerous objects in a series in which West explores the relationship between sculpture and the body, indicates that here art is to be seen as a procedural development and artworks as petrified gestures, witnesses of this process. As the

151 Franz West
Ohne Titel, 1984

"Passtücke" are actually thought of as being worn on the body, this process is not isolated, as long as a human being establishes a relationship between the object and his own body. Openness as a basic constant of the work's concept is, on another level, also clear in the installation "Schöner Wohnen", in which Franz West invites the viewer not only to stay by providing objects to sit on, but also at the same time asks him indirectly to give time and attention to the assortment of artworks hanging on the wall. The combinations of pictures and furniture – which John M Armleder in his "Furniture Sculptures" uses to direct questions about form, aesthetics and the history of style in the exhibition space – are aimed in Franz West's work at potential communication situations and seem at the same time to be spatial signs in a temporal dimension.

The idea of worldly acquisitions as an uncompleted process per se and the constant expansion of the world of things around new facets makes a connection between the often space-filling sculptures of Franz West and the mainly small objects, variations on the theme of models, of Peter Fischli and David Weiss, who have worked together since 1979. At the centre of most of the works – whether they are photographs, films, objects or installations involving the artistic duo – is the tension in the relationship between everyday experience and artistic representation, in which great significance is attached to the choice of medium as well as the material. Thus the objects shown here are all cast from synthetic rubber, in other words a material that is hostile to art. The raw material normally used in the production of extremely resilient and at the same time elastic utilitarian objects, such as car tyres, was here cast in shapes which transform the simplest of concepts such as "Haus", "Frau", "Auto" or "Vase" into three-dimensional objects. The artists' procedure consisted not only in making parallels between the openness of the concept and the elasticity of the material, but also in determining the appearance of quite specific – that is, clichéd – sculptural formulations from the most varied areas. While the piece called "Marokkanisches Sitzkissen" leaves little room for decision-making, and for that reason is distinguished from the other objects by being in original size, the concept of "Haus", represented by a flat-roofed bungalow, and the concept of "Frau", with its chaste seated figure, are closely related to bric-à-brac. In their visualisation of a possibility, which appears to be one among many, the subversive strategy of Fischli/Weiss is revealed, resulting from their recognition that searching for or believing in a single truth is anyway obsolete. Each of the works refers in its setting to the possible variants of itself. The lightly staged, delicate scales of different kitchen utensils, which document the "Equilibre Serie", illu-

strate this balancing act between sense and nonsense in the most impressive way. If the viewer should inevitably start smiling on seeing these works, it is not at all insignificant. Humour is always flexible.

The Normal as Special

A hallmark is a guarantee of standard quality, which basically means nothing more than that it leaves no room for interpretation. The decision of Rosemarie Trockel to select for one of her knitted pictures the woolmark sign as a regularly repeated pattern, refutes this in many respects. If one chooses, as the entry point to viewing a work, to make an ironical point about the *masculine* painting tradition of Abstract Expressionism, whose all-over approach is quoted here by the artist in the *feminine* medium of knitting, then the repeat pattern as motif replaces the artistic gesture and interprets this as empty repetition. With regard to the material used in the knitted picture, the woolmark sign is either redundant (if it is made of wool) or an expression of deception (if it is not wool). The critical association with the technique employed corresponds to the subversive analysis of the sign. Rosemarie Trockel indeed chose the technique of knitting as an indication of craftwork, or a traditional activity for women, but she let the pictures be designed and carried out by a computer program. "These knitted pictures with their knitted patterns produce a picture of a copying society, using industrial reproduction and replaceability for everything."12 The decision to produce the artwork by industrial means can be read on the one hand as a reference to Minimal Art, but on the other also contrasts the straight lines of mass production with the rules of the art market, which until a few years ago placed a higher value on the uniqueness of the original than on the object produced in quantity.

Heroes of Soberness

Andreas Gursky, Thomas Struth and Thomas Ruff are rated among the most internationally successful photographic artists of their generation. All three studied under Bernd and Hilla Becher and the strict, distanced pictorial language of their teachers is continued with variations in their own work. The large-format photographs of Andreas Gursky capture the viewer by the simultaneity of the close-up view and the long-distance view achieved in them. The camera picture makes it possible to do what our eye is not capable of, namely to see the total picture and the detail at the same time. That also means that Gursky's photographs deliver pictures from the real world of unbelievable sharpness of depth and richness of detail, but these do not accord with the reality that we

138 Thomas Struth
Via Guglielmo, Rome, 1988

experience from the world. Our irritation is further sharpened by the fact that Gursky usually opts for a bird's eye perspective and in the process positions the viewer far away from and above the event. The distance between viewer and picture resulting from this pictorial strategy awakens a feeling of insecurity. Our view of the world rests on our perception of reality, and this is chiefly supplied by the eye. While we see, we root ourselves in a particular place. Gursky's photographs show us pictures of the world in which we can neither find a secure standpoint nor place ourselves in a relationship with the people, who frequently appear just as colourful spots caught in their own movements and pressed together in clusters. This impression of encountering an artificial world is at the same time a starting point for understanding photography as a medium of transformation, and to reflect on its own set of laws and manipulative powers. At this point the concerns of Andreas Gursky and Thomas Struth come together, although the path that Struth takes to question the concept of the picture is quite different. In his photographs of streets, squares and urban landscapes, which can be viewed simultaneously as formally perspectival spaces and as the expression of a world created by humans, Struth orientates his camera perspective to the viewpoint of a person moving through the urban space. If the viewer gets a feeling of alienation when faced with many of the works, however, this is because Struth frequently works in black and white, which automatically introduces an element of abstraction and increases the soberness of the picture. Especially in his early works, there was the further point that he depicted empty streets from a central position which on the one hand can be read as a definite rebuke to the people living there but on the other hand the pictures appear completely to lose their hold on reality and are simply abstract pieces of spatial geometry. In such pictures, Struth's precise composition is particularly noticeable as he takes every detail into account to create concrete pieces of pictorial architecture in which the evaluation of masses, the angle of perspectival distortion and even the distribution of the chiaroscuro values correspond to his ideas.

The star pictures of Thomas Ruff are a firm rebuff to all romantic ideas about the starry canopy. Taking a negative produced by an anonymous hand, but one working at the highest level of astro photography, the artist has only to decide in what format to print the picture. The view of the starry sky which the large-format photograph suggests to us, proves however to be deceptive. The photochemical substance reacts, like our eye, only to light. However, despite the speed of light, with which it passes through the universe, starlight can only be perceived after a delay, so that we only think we see the places where the glowing sphe-

res of gas are to be found. Many have already set, others have long since wandered away or even never been where we thought we saw them. The insight which Thomas Ruff's star pictures brings to our eyes is the paradox that what we see in the photograph never existed in that form.

ahead of the 21st century

"ahead of the 21st century", both as title and as the exhibition of works from the Pisces Collection makes an assertion. The presentation of works from the '80s and '90s, the last decades of the 20th century, is an independent cross-section of things in the last 20 years that the international art community has recognised and defined as worthy of discussion. They are artworks which enunciate the radical relativism of the idea that truth is only one possible interpretation of an interpretation. The quest for truth, characteristic of a view of art, which the picture uses as the experiential space of the individual, is here replaced by the cool gesture of sampling. It is a strategy that draws a possible conclusion from the loss of innocence. Because of this, every gesture must be questioned, and in itself broken down, and every assertion must already contain its own negation. The fascinating paradox lies in the construction, which gives expression to this posture: an artistic strategy which, conscious of deceiving, uses pictorial means in such a way that the apparent picture could be experienced as a deception, but fails entirely to deceive. The question of the possibility of truth in pictures remains open, however. They do not try to give answers, but formulate new questions.

Do you know what it means to come home at night to face the collection, which gives you hope, future and a glimpse of eternity? It means you're in the wrong house. That's what it means.[13]

1 Cindy Sherman has stated that the "Disgust Series" arose among other things from her fury with the leading painters of the '80s and their grand gestures, and with the public for demanding ever more expressive paintings. She decided to take photographs "of highly unusable leftovers" as a reaction to these abstract paintings which were getting increasingly large, and to have her pictures printed in a large format. (Cindy Sherman in conversation with the author, Baden-Baden, January 1996).

2 Damien Hirst, quoted by Andrew Butterfield in: Christie's Contemporary, New York, 16.11.1999, p.129.

3 Damien Hirst in: "I Want to Spend the Rest of my Life Everywhere, with Everyone, One to One, Always; Forever, Now", London, 1997, p.246.

4 Damien Hirst in: see footnote 3, p.264. Hirst emphasises this statement by putting a sliding mechanism on the text of the opposite page, with which the colours of a "Pharmaceutical Painting" can be altered. When you pull the colour card down, a "Smiley" appears in the top-left square.

5 John M Armleder, quoted in John M Armleder, Wiener Secession, Vienna, 1993, p.58.

6 For the exhibition in the Staatliche Kunsthalle at Baden-Baden John M Armleder combined an extensive, traversable scaffolding construction ("Tower"), hung with neon tubes and flashing lights in different colours, on which science fiction films could be viewed on monitors and Japanese gagaku music could be heard, along with large Pour Paintings. (see John M Armleder, Rewind & Fast Forward, edited by Margrit Brehm, Baden-Baden, 1998).

7 Jeff Koons in an interview with Anthony Haden-Guest in: Jeff Koons, exhibition catalogue, Museum of Contemporary Art, Chicago, 1988, p.17.

8 George Condo, Portraits Lost in Space, Minneapolis 1999/2000, p.26-28.

9 George Condo, Notes on the Sound of Painting in: Portraits Lost in Space, see footnote 8, p.26.

10 George Condo, see footnote 9, p.26.

11 Ross Bleckner, quoted in Birth of the Cool, exhibition catalogue edited by Bice Curiger for the Kunsthaus Zürich and the Deichtorhallen Hamburg, Cologne 1997, p.110.

12 Peter Weibel, From Icon to Logo in: Rosemarie Trockel, exhibition catalogue Kunsthalle Basel/ICA London, 1981, p.40.

13 Starting point for the paraphrase was the text in the picture "The Canal Zone II", 1996 by Richard Prince.

Don't trust me – Trust me
Einführung zur Pisces Collection

Jeder Fisch ist anders. Jeder hat seinen eigenen Schaukasten. Alle Schaukästen sind gleich. Es herrscht Ordnung. Das Schweben der Körper in klarer Flüssigkeit kann nur einen Moment über die Tatsache hinwegtäuschen, dass diese Fische keineswegs in ihrem Element sind. Als Präparate im Formaldehydbad sind sie als Anschauungsobjekte dem Blick feilgeboten. Angehaltenes Leben. »Alone Yet Together« hat der englische Superstar Damien Hirst diese Arbeit aus dem Jahr 1993 betitelt, in der er einmal mehr eine vorgeblich wissenschaftliche Präsentationsform wählt, um diese durch die Transformierung in den Kunstkontext zu hinterfragen und damit neue Wahrnehmungsperspektiven zu eröffnen. Wir sehen Fische, aber wir begreifen sie als Metaphern für den Menschen. Ein reales Objekt, das sich als geheimnislose, systematische Ordnung darstellt, wird zum Auslöser um über Tod und Leben, Isolation und Massengesellschaft, Wissenschaft und Kunst nachzudenken. Im *white cube* des Ausstellungsraums verändern sich die Vorzeichen.

Alone Yet Together

»Alone Yet Together« von Damien Hirst ist auf dem Umschlag des Kataloges abgebildet, der die erste öffentliche Präsentation der Pisces Collection begleitet. Erklärt sich die Wahl der Installation mit den Fischen als Frontcover dadurch, dass *pisces* der zoologische Fachbegriff wie auch der Name für das Tierkreiszeichen *Fische* ist, so könnte man die Entscheidung für ein Motiv, das eine bildliche Entsprechung des Namens der Sammlung ist und – doch wieder nicht ist – als ersten Hinweis auf die Sammlungsstrategie lesen. Im Namen der Sammlung steht *pisces* für das Sternbild des anonymen Sammlers. Die Fische im Werk Damien Hirsts stehen metaphorisch für den Menschen. *Fische und pisces* – ein Bild und ein Wort – und daneben eine Vielzahl von Verständnismöglichkeiten, je nachdem ob man die Perspektive der Astronomie, der Astrologie, der Biologie oder der Ikonographie einnimmt. Bezeichnung und Bezeichnetes lassen sich einander ebensowenig eindeutig zuordnen wie Bild und Bedeutung. Im Hinblick auf die Präsentation einer Sammlung zeitgenössischer Kunst stellt schon die gewählte Kombination von Name und Motiv klar, dass dem Spiel mit den Bezügen zwischen Worten, Begriffen und Bildern, sowie der daraus resultierenden Frage nach einer möglichen Wahrheit im Zeichensystem Kunst besondere Aufmerksamkeit entgegengebracht wird. Es verwundert daher kaum, dass die Wahl auf Kunstwerke fiel, die – gegenüber der Eindeutigkeit – der Multiperspektivität den Vorzug geben. Im Zentrum des Interesses stehen künstlerische Strategien, die der visuellen, sinnlichen Präsenz des Kunstwerks zwar große Bedeutung beimessen,

diese aber zugleich als Methode und/oder Resultat einer kritischen Reflexion dessen erkennbar werden lassen, was *Kunst machen* am Ende des 20. Jahrhunderts bedeuten kann.

Gesammelt wurde und gezeigt wird Kunst aus den 80er und 90er Jahren von 21 Künstlerinnen und Künstlern aus den Vereinigten Staaten, Europa und Japan. Beeindruckt die Liste der internationalen Stars, die in der Sammlung vertreten sind, auf Anhieb, so wird die Konsequenz, mit der hier auf höchstem Niveau *sammlerisch* an einem schwierigen Thema gearbeitet wird, erst in der Konfrontation mit den ausgestellten Werken deutlich. Erst in der Zusammenschau der Gemälde, Objekte, Fotografien und Installationen lässt sich der Subtext erkennen, der vielleicht bei der Wahl der einzelnen Arbeit eine Rolle gespielt haben mag. Die Pisces Collection versammelt unterschiedlichste künstlerische Formulierungen, die aber alle auf die eine oder andere Weise Auseinandersetzungen mit dem Bild – sei es das triviale Werbeimage oder das Kunstwerk –, mit der Welt der Zeichen, also Schrift und Sprache, und zugleich eine Reflexion des eingesetzten Mediums darstellen. Das entworfene Zeitbild wird dabei nicht durch die Beschränkung auf eine Künstlergeneration eingeengt, sondern thematisiert zugleich den Perspektivenwechsel, den die Künstler verschiedener Altersgruppen in ihren Werken deutlich machen. Es sind ausschließlich entschiedene, kompromisslose künstlerische Setzungen, deren erklärtes Ziel es ist, mehr Fragen zu stellen als zu beantworten und von denen viele die griffige Konfrontation ebensowenig scheuen wie die provokative Geste oder den wohl kalkulierten Schock. Die Ausstellung »ahead of the 21st century« ermöglicht es nun erstmals, einen Teil der Pisces Collection zu sehen und dadurch in dem gebotenen Panorama unterschiedlichster künstlerischer Positionen gemeinsame Fragestellungen, Herangehensweisen oder Strategien zu entdecken, die vielleicht aus der Perspektive zukünftiger Generationen als Kennzeichen der Kunst an der Schwelle zum 21. Jahrhundert definiert werden.

Shock and Irritations

Cindy Sherman, Paul McCarthy und Damien Hirst provozieren das Publikum, indem sie es durch Angriffe auf moralische oder ethische Werte schockieren oder den Ekel als Kunsterfahrung thematisieren. Paul McCarthy, dessen Performances und Objekte immer wieder gnadenlos das Verdrängte, Verbotene oder Perverse anschaulich vorführen, ist in der Pisces Collection mit Fotografien der »Propo-Objects« und »Masks« vertreten. Auch ohne zu wissen, dass es sich bei dem Abgebildeten um Requisiten handelt, die ursprünglich Teil einer Performance

33 Wim Delvoye
Marble Floor no. 19, 1998

117 Cindy Sherman
Untitled #234, 1987-1991

waren, setzt die Fantasie des Betrachters sie in Handlungszusammenhänge, assoziiert angesichts des kopflosen Ken aus der Barbie-Familie, der den rechten Arm zum Hitlergruß erhebt oder der rötlich-braun verschmierten Flasche mit Johnson's Baby-Lotion Bilder der Gewalt und des Schreckens. Dass die Albtraumvisionen blutiger Geschehnisse, die als Reaktion auf solche Schlüsselreize aus unserem Unterbewusstsein aufsteigen, meist weitaus bedrohlicher ausfallen, als es die ursprüngliche Performance war – in der der Künstler in ironischer Geste mit Ketchup agierte – lässt eher Rückschlüsse auf den Betrachter als Aussagen über das Werk zu. Erscheint die Maske bei McCarthy als Relikt, das fotografisch dokumentiert und durch die Vergrößerung stilisiert wird, so sind bei Cindy Sherman die Masken zugleich Bildvokabular und Protagonisten, aus denen die Künstlerin vor der Kamera ihr Bild inszeniert. Hier ist es gerade die Ambivalenz zwischen Angst einflößendem Horrorszenario und seiner Entlarvung als Mummenschanz, die den Reiz der Bilder ausmachen. Für die Arbeiten der »Disgust-Series« hat Cindy Sherman ekelerregende Szenerien aus verdorbenen, von Schimmelpilzen überwucherten Essensresten gezüchtet. Diese Realität vor der Kamera bietet zwar das Bildmaterial, aber seine Erscheinung im Hochglanzfoto ist ebenso durch die raffinierte Beleuchtung, die gezielte Komposition und die Wahl des Bildausschnitts bestimmt. Im großformatigen Abzug verliert das Abgebildete seine Eindeutigkeit, wirkt – zumindest auf den ersten Blick – abstrakt. Das Thema sind nicht die verschimmelten Lebensmittel, sondern die gestaltete Fläche, das Bild[1]. Abscheu und Faszination mischen sich. Fast gegen unseren Willen entdecken wir die Schönheit des Bildes, das wir aufgrund des Dargestellten als ekelerregend einstufen.

Einen ähnliche Verunsicherung unserer Wahrnehmung hat auch die Konfrontation mit den »Marble Floors« von Wim Delvoye zur Folge. Hier erfreut sich unser Auge so lange an der *Kunst* – hier verstanden als handwerkliches Können –, der Präzision des Ornaments in warmen Rottönen, bis unser Gehirn, das auf die Kategorisierung des Wahrgenommenen trainiert ist, uns darüber aufklärt, dass die kunstvollen Mosaikböden, die wir gerade bewundern keineswegs aus Stein, sondern aus Salami, Schinken, Mortadella und anderen Wurstsorten zusammengesetzt sind. Obwohl diese Realisierung nichts über das Bild aussagt, (da es ohnehin ein Foto, also weder Stein noch Wurst ist) erschüttert sie unsere tradierte Vorstellung von der Angemessenheit der Mittel in der Kunst und wirkt zugleich als subversive Hinterfragung dessen, was Kunst ist oder darf. Wie bei den Arrangements von Cindy Sherman ist auch hier die Fotografie die einzige Möglichkeit, der installativen Arbeit aus vergänglichen Materialien Dauer zu verleihen und zugleich durch die Abstraktion, die das Abbild darstellt, die visuelle

Irritation zu verstärken. Entscheidend für die Werkstrategie Wim Delvoyes aber ist der Tabubruch, der hier die uns allen beigebrachte Grundregel »Mit Essen spielt man nicht«, betrifft und die Transformierung von aus dem Alltag vertrauten und zugleich moralisch hochbesetzten Material in den Kunstkontext. Gerade bei einer Arbeit wie den »Marble Floors« mischt sich in paradoxer Weise das Unbehagen über die Vergeudung mit unserer praktischen Alltagserfahrung, die selbst gegen unseren Willen dem auf dem Foto perfekt konservierten Bodenstück das Gegenbild der sich schon nach kurzer Zeit verfärbenden und sich wellenden Wurstscheiben entgegenstellt.

Carpe Diem

Die Vergänglichkeit alles Irdischen ist ein über die Jahrhunderte in der Kunst immer wieder behandeltes Thema. Dass die zeitgenössische Kunst ihm solche Beachtung schenkt und die dabei entstehenden Werke sowohl in der Krassheit des Ausdrucks wie auch in der Illusionslosigkeit der Aussage beispiellos sind, lässt sich unschwer auf die schrittweise Ablösung des christlich-geprägten, humanistischen durch ein wissenschaftliches Menschenbild erklären. Der Mensch, gesehen als biologischer Mechanismus, dessen Optimierung durch den Menschen eifrig vorangetrieben wird, ist aber nur Körper ohne Geist. Unser Denken wäre nichts anderes als das Ergebnis neurologisch-chemischer Prozesse, die in unserem Gehirn ablaufen. Unter immer neuen Aspekten und in unterschiedlichsten Medien hat Damien Hirst Werke geschaffen, die die Frage nach der biologischen Erklärbarkeit des Menschen, nach seiner Angst vor dem Tod sowie seinem daraus resultierenden Vertrauen in und seinen Glauben an die Medizin thematisieren. Als eine Art Grundlage und Zusammenfassung der zahlreichen Werke, in denen er Tierkörper oder Teile davon in Formaldehyd konservierte, kann die Arbeit »Loss of Memory is Worse than Death« gesehen werden, in der das Zaubermittel, das den körperlichen Zerfall toter organischer Substanz aufhalten kann, für den Lebenden aber ein tödliches Gift darstellt, selbst zum Protagonisten wird. Über die Substanz, die er – ganz minimalistisch – in Kanistern in einem verschlossenen Gittercontainer zusammen mit Schutzmaske, Handschuhen und Spritze ausstellt, schreibt Hirst »I use it, because it is dangerous and it burns your skin. If you breathe it in it chokes you and it looks like water. I associate it with memory.«[2] Interessant ist an diesem Zitat nicht nur die Ambivalenz zwischen Gefahr und Faszination, die der Künstler betont, sondern auch der Umstand, dass es eine zusätzliche zweite Lesart des Titels des Formaldehyd-Objekts nahelegt. Wäre der Tod erträglicher, wenn wir wüssten, dass unser Körper erhalten bliebe?

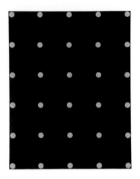

3 John M Armleder
Untitled, 1986

Spots and Dots and Happy Painting

Ein frühes Beispiel für Hirsts Beschäftigung mit der ästhetischen und konzeptuellen Verbindung von Kunst und Medizin ist »Untitled (Pill Painting)«. Erinnert die monchrome Leinwand in gebrochenem Weiß an Arbeiten Robert Rymans, so wird die glatte Oberfläche des Bildes durch unter der Farbschicht versteckte, aber doch als Formen erkennbare Tabletten aufgebrochen und durch die Sichtbarkeit/Unsichtbarkeit eine Metapher für Wirkung/Wirkungslosigkeit der Medikamente gefunden. Von der Arbeit mit Versatzstücken wendet sich der Künstler in den »Pharmaceutical Paintings« ab, die alle gleich große farbige Punkte in einer Rasterordnung auf der Leinwand zeigen. Bildet hier zwar angeblich die Anzahl unterschiedlicher chemischer Substanzen in Psychopharmaka den Ausgangspunkt, so wird in den »Spot-Paintings« doch allein Malerei verhandelt: »They're about the urge or the need to be a painter above and beyond the object of a painting. (...) I started them as an endless series (...) a scientific approach to painting ...«[3] Es ist eine Malerei, die die Arbeit am System dazu nutzt, die persönliche Befindlichkeit zu nivellieren und gerade durch die strikte Befolgung der selbst gesetzten Regeln, zu Ergebnissen zu gelangen, die in ihrer überraschenden Wirkung, Malerei als künstlerische Ausdrucksform zugleich in Frage stellen und neu definieren. »No matter how I feel as an artist or a painter, the paintings end up looking happy.«[4]

Läge es John M Armleder fern seine »Dot-Paintings« als Resultate der Auseinandersetzung mit Naturwissenschaften zu definieren, so würde er Hirsts Sichtweise der »dumb paintings« vermutlich zustimmen. Bereits Ende der 70er Jahre hat er begonnen, Bilder zu malen, die aus einfachsten – häufig das Vokabular der konstruktivistischen oder konkreten Kunst gezielt zitierenden – Ordnungen aufgebaut waren, aber durch kleine Verschiebungen oder eine andere Farbwahl geradezu subversiv die Frage nach einem Fortschritt in der Malerei stellten. Aus der Einsicht, dass im Grunde jede malerischen Geste, die ein Bild bestimmt, in gewisser Hinsicht zitathaft ist, entschied er sich zum einen für rapporthafte Bilder, wie die »Dot-Paintings«, in denen Erfindung oder Geste gar keine Rolle spielen, und zum anderen für »Pour-Paintings«, in denen die Farbchemie das Resultat entscheidend mitbestimmt. Aber die Malerei ist bei John M Armleder nur ein Teil eines stets in Bewegung bleibenden Kunstkosmos, der im bewährten rewind & fast forward-Verfahren immer wieder neue und überraschende An- und Einsichten zulässt. »I try most of the time to radically undermine what I tend to achieve easily. It works this way, but then a system grows that has to be undermined as well.«[5] Die Notwendigkeit gegen das eigene Können zu arbeiten, resultiert aus der Unmöglichkeit eine Erfahrung

mehrmals zu machen. Ein Kunstwerk, das aber keine Erfahrungsqualität bietet ist ein Plagiat, – im schlimmsten Fall der eigenen Kunst. Aus diesem Grund hat Armleder auch immer wieder kunstfremde Materialien (Spiegel, Plexiglas, Neonröhren) in seine Arbeit einbezogen und das Repertoire an Versatzstücken aus der Wirklichkeit erweitert. In den letzten Jahren hat sich Armleder verstärkt mit großen Installationen, »Towers« beschäftigt, die ihm die Möglichkeit bieten, unterschiedlichste Werkkomplexe miteinander zu verbinden und den Ausstellungsraum zugleich zur Plattform für neue räumliche und visuelle Erfahrungen zu machen.[6] Einen Hinweis auf die strategischen Veränderungen des Raums durch Licht, bietet die in der Ausstellung gezeigte Installation aus spiegelbesetzten, sich drehenden Kugeln (»Disco balls«), deren irrlichternde Reflektionen alles was sich im Raum befindet zur Projektionsfläche machent.

Object Lessons – De Luxe

Grenzüberschreitungen, die unsere Wahrnehmungsgewohnheiten in Frage stellen und dadurch ein anderes Sehen des Alltäglichen oder eine Infragestellung des guten Geschmacks provozieren, kennzeichnen auch die Arbeiten von Jeff Koons. »New Hoover Deluxe Shampoo Polisher« von 1980 ist ein Frühwerk des Künstlers, in dem die Sakralisierung des Produkts durch die Darbietung der Putzgeräte in einer beleuchteten Vitrine anschaulich vollzogen wird. »I went around and bought up all the vacuum cleaners I could before they stopped making a certain model. I wasn't showing them with indifference. I was being very specific. I was showing them for anthropomorphic quality, their sexual androgyny. They are breathing machines.«[7] So ironisch oder gar häretisch das Werk – immerhin 67 Jahre nach Duchamps erstem *ready-made* – auf den Besucher auch wirken mag, so wenig findet sich eine solche Sichtweise im Statement des Künstlers. Ganz im Gegenteil, folgt man seinen Worten und nimmt sie ernst, so wird deutlich, dass die Strategie von Koons darin liegt, dass er den Staubsauger nicht nur wie Kunst inszeniert, sondern auch genauso betrachtet, also seine formalen und metaphorischen Qualitäten verbalisiert. Allein durch diesen Perspektivenwechsel eröffnet sich eine neue Qualität der Wahrnehmung, die völlig unabhängig von der Funktion des Objekts ist. Ein *Staubsauger* kann eine *Fontäne* sein.

Die *Objektivierung* einer Maschine führt Sylvie Fleury in »283 Chevy« vor. Der verchromte Abguss eines Motors zelebriert nicht nur die Schönheit technischer Funktionalität, sondern führt sie zugleich ad absurdum. Gerade in ihren Arbeiten mit berühmten Autoklassikern,

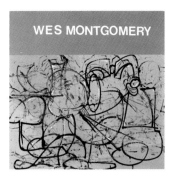

23 George Condo
Wes Montgomery, 1999

gelingt es der Genfer Künstlerin immer wieder die eigentümliche Identifikation des Autoliebhabers mit seinem Gefährt anschaulich vorzuführen. So wird aus dem Motor das Herz des Autos, in dessen Takt wir uns bewegen. Isoliert auf dem Sockel, glänzend und schön, wird er zum Pseudo-Fetisch, einer konsumorientierten Gesellschaft. Die diesseitigen Glücksversprechen der Werbung, die das Seelenheil des Konsumenten bestimmen, spiegeln sich in den »Current Issues« der Hochglanzmagazine, die Sylvie Fleury zum Wandbild kombiniert und damit das Frauenbild der Massenmedien vorführt, dass nicht mehr ist und sein will als eine Collage aus Markenartikeln und Schönheitstipps.

Auch die Fotoarbeiten von Richard Prince, in denen die Cowboys der Marlboro-Anzeigen und die Girls aus Motorradzeitschriften unbeabsichtigt Aufschlüsse über das Weltbild des *Spiritual America* geben, wird das Vokabular der Trivialkultur in den Kunstkontext übernommen und damit zugleich auf den herrschenden Zeitgeist und die manipulative Kraft der Massenmedien verwiesen. Die Bedeutung, die die Allgegenwart und Verfügbarkeit der Bilder gerade für die Erfahrungskategoie Kunst hat, in der Authentizität und Original immer noch als wertprägende Begriffe gehandelt werden, wird dabei deutlich. Für Richard Prince, einen Hauptvertreter der *Appropriation Art*, dient die Plattheit des banalen Bildes als Ausgangspunkt für seine zynischen Kommentare über die Gesellschaft, die sich selbst in diesen Bildern widergespiegelt findet. Auf großen Leinwänden mit zitathaft verwendeten Malereispuren oder auf monochrome Flächen mit Siebdruck aufgebracht und stetig wiederholt, dienen die nacherzählten Witze oder kopierten Witzblattzeichnungen Prince nicht nur zur Thematisierung einer redundanten Geste, sondern der aus ihnen sprechende, dummdreiste, vermeintliche Humor, der nicht selten auf Rassismus und Frauenfeindlichkeit basiert, wird so überstrapaziert, dass auch dem Letzten das Lachen vergeht.

Signs and Sounds

Die Kombination von Schrift und Malerei auf ganz anderer Ebene kennzeichnet viele Arbeiten von Christopher Wool. Mit einer einfachen Schablonenschrift bringt Wool Wörter, Sätze oder Satzfragmente auf den weißen Bildgrund auf. Die Texte verstoßen gegen die gewohnten Lese-Regeln, weil die Ordnung zwischen den Buchstaben oder Worten gestört ist. Es gibt nur Großbuchstaben, die der Künstler, der inneren Bildlogik folgend, durch größere oder kleinere Abstände voneinander trennt, wodurch die Lesbarkeit erschwert wird. Die Anordnung der Buchstaben nach ästhetischen Prinzipien zielt jedoch immer – selbst

dann, wenn Verkürzungen die Worte nur andeuten, wie »TRBL« für TROUBLE – auf einen Wortsinn ab. Im Gegensatz zur Verwendung der Schrift im Sinne eines Zitats bei Richard Prince, setzt Wool die Buchstaben als Sinn- und Bildzeichen ein und misst ihnen damit gleichermaßen inhaltliche und formale Bedeutung bei. Diese Doppeldeutigkeit findet sich auch in den installativen Arbeiten von Jack Pierson, der Signalworte, wie »Fool« oder kurze Wortkombinationen wie »The One and Only« aus Buchstaben unterschiedlichster Herkunft zusammensetzt oder sie als Schriftzeichen auf Leuchtkästen montiert. Arbeitet Pierson mehr mit umgangssprachlichen Formulierungen, so nehmen viele der Texte Christopher Wools auf die Produktion und Rezeption von Kunst Bezug. Wie wichtig es ihm dabei ist, die definierte Zeichenhaftigkeit der Schrift auf die Malerei als selbstreferentielle Geste zu beziehen, zeigen gezielt eingesetzte Ungenauigkeiten, Spritzer oder Farbtropfen. Für die ornamentalen Bilder wird statt einer Schablone eine Gummirolle verwendet, mit der er das Motiv auf die Leinwand walzt. Im Zentrum steht hier – wie übrigens auch bei den Strickbildern Rosemarie Trockels – die Rapporthaftigkeit des Ornaments, das sich entsprechend der all-over-Konzeption Jackson Pollocks gerade durch den Verzicht auf ein kompositorisches Zentrum und (im Gegensatz zu den Wortbildern, die sich immer als abgeschlossene Einheit präsentieren) durch ein Nicht-Abgeschlossensein auszeichnet. Eine Ambivalenz zwischen Ikonoklasmus und Ikonophobie prägt auch die scheinbar *freien* Arbeiten Wools, in denen gezielt gegen das zuvor formulierte, als Referenz dienende Motiv durch scheinbar zufällige Pinselspuren oder durch flächige Übermalungen in einem intensiven Farbton gearbeitet wird.

Die Frage nach der Möglichkeit individuell geprägter Darstellung thematisieren auch die in der Pisces Collection vertretenen Arbeiten von George Condo, die zur Gruppe der »Jazz Paintings« gehören. Sie sind gleichermaßen eine Hommage an die Musik der 40er, 50er und 60er Jahre und an die Malerei des Abstrakten Expressionismus. In seinen »Notes on the sound of painting«[8] beschreibt Condo diese Gemälde (aus denen später die Serigraphien abgeleitet wurden) als »improvisational compositions based on a predetermined set of coordinates«[9]. In jedes der Bilder ist der Name eines Musikers, meist in ein die ganze Bildbreite überspannendes, monochromes Feld geschrieben. Der Rest der Leinwand ist abstrakter Malerei vorbehalten, die eine synästhetische Umsetzung der Musik darstellt, deren Bildvokabular aber zuvor vom Künstler definiert wurde. Es sind also keine freien Formen, sondern was als abstrakte Malerei erscheint, ist die Anwendung festgelegter Muster. »The freedom is expanded upon when the limitations are faced head on. This way originality comes from the unique perception of

106 Ugo Rondinone
Fünfzehnteroktoberneunzehnhundert-
achtundneunzig, No. 114, 1999

existence presencing into the sphere of the present subject matter allowing the viewer to ascertain his own conclusions from a non-material objective association.«[10] Die grundlegende Infragestellung dessen, was Malerei ist oder/sein kann wird aber nicht nur durch die Visualisierung des Unsichtbaren, die Musik, sondern noch eindringlicher durch die zitathafte Verwendung der Sprache der abstrakten Malerei verdeutlicht. Was formal wie abstrakte Malerei aussieht, erweist sich als Planspiel und damit als das Gegenteil dessen, was Pollock im Sinn hatte, als er antrat, das Bild zum unmittelbaren Zeugen des Schöpfungsakts zu machen.

Transparencies

Die Intrige der Malerei, also die Arbeit mit Malerei gegen Malerei, die Arbeit mit Zitaten, Versatzstücken und Stilen kennzeichnet auch die großformatigen Gemälde von David Salle. Gezielt wird hier die nicht endenwollende Nostalgie, mit der das 20. Jahrhundert an die Unschuld der expressionistische Geste anknüpfen wollte, mit einer anti-expressionistischen Struktur konfrontiert. Für Salle ist der Bildraum das Spielfeld, auf dem er seine multiperspektivischen Zusammenstöße unterschiedlichster Bilderzählungen und Stilzitate inszeniert. So sind etwa auf dem Diptychon »Birthday Cake with One Eye« über ein Bild, das die heile Welt des Kindergeburtstags anrührend verkitscht, männliche Köpfe und ein Bein gemalt. Die Beunruhigung, die von den geisterhaften Störenfrieden ausgeht, findet eine Parallele auf der zweiten Tafel auf der das Auge des Voyeurs collagehaft neben die Darstellung einer nackten, liegenden, weiblichen Figur gesetzt ist, von der nur die angewinkelten Beine mit Strümpfen und Schuhen und ein Teil des Gesäßes zu sehen sind. David Salle benutzt erotische Motive wie dieses häufig als eyecatcher und zugleich als Syntax für die Darstellung von Themen wie Kindheit und Gewalt, Häuslichkeit und Ortlosigkeit, Einfalt und gezieltes Posieren. In der verwirrenden Vielschichtigkeit, der die Titel nicht selten eine weitere Sinnebene hinzufügen, liegt der Reiz der Bilder von Salle, dem es durch seine eklektizistische Methode und seine intelligenten Bildstrategien immer wieder gelingt, den Betrachter auf die vergebliche Suche nach einem eindeutigen Sinn des Dargestellten zu schikken.

Shining Diamonds and Visual Targets

»Kunst machen ist ein Akt der Täuschung (...) auf eine Art mache ich meine Bilder, um meinen eigenen Mangel an Glauben zu testen. Das ist genau das Gegenteil von dem, was ein abstrakter Maler macht, der seinen Glauben immerzu bestätigt.«[11] schreibt Ross Bleckner und macht damit deutlich, dass auch er wie George Condo und David Salle Malerei über Malerei betreibt. Im Unterschied zu ihnen, setzt Bleckner aber nicht auf die gezielte Dekonstruktion der Bildkomposition durch Zitate, sondern löst die Präsenz des Bildes zugunsten einer vibrierenden Lichtmagie auf. Der Eindruck ephemerer Ungreifbarkeit, den die Gemälde Bleckners vermitteln, ist das Resultat einer absolut geschlossenen Bildoberfläche, die in einem langwierigen Arbeitsprozess mit Ölfarben, Wachs, Metallpigmenten, Graphit und Enkaustik Schicht für Schicht aufgebaut wird. Die Motive – meist Streifen, Ornamente oder Blüten – scheinen im Bild wie in einem Raum jenseits unserer visuellen Ordnung eingeschlossen zu sein. Die Wahrnehmung unscharf zu sehen wird dabei durch das irritierende, flirrende Licht verstärkt, dessen Ursprung im Dunkel der Bilder verborgen bleibt. Scheinen die Gemälde Bleckners sich ganz auf ihr Innenleben zu konzentrieren, springen uns die den Raum dynamisierenden Kreisbilder von Ugo Rondinone geradezu an. Es ist kaum möglich sich ihrem halluzinatorischen Kraftfeld zu entziehen. Sie fordern Aufmerksamkeit und enttäuschen doch die Erwartungshaltung des nah an die Leinwand herantretenden Betrachters, indem auch sie sich als gezielt unscharfe Malerei erweisen. Aber vielleicht bieten die provozierte Bewegung des Neugierigen durch den Raum oder der Dialog zwischen Betrachter und Bild, der im Prozess der Annäherung entsteht, schon Anhaltspunkte dafür, wie Ugo Rondinone seine Malereien als Bildzeichen in seinen Installationen einsetzt. Dafür spräche, dass auch die Streifenbilder den Betrachter in Bewegung versetzen und damit die horizontalen Linien als Ausdehnung von Malerei durch Raum und Zeit am großformatigen Objekt erfahrbar machen.

Strategies

Nicht nur die Entscheidungen für, sondern auch die gegen bestimmte Werke aus einem Œuvre erzählen etwas über eine Sammlungsstrategie. So sind Ugo Rondinone und Cindy Sherman, beides Künstler, in deren Werk die Selbstinszenierung als Rollenspiel große Bedeutung hat, in der Ausstellung ausschließlich mit Werkkomplexen vertreten, in denen dieser Aspekt nicht zum Tragen kommt. Einmal auf diese Präferenz der Auswahl aufmerksam geworden, wird schnell deutlich, dass die gleiche Zurückhaltung gegenüber der figürlichen Darstellung und einem psychologisierenden Menschenbild auch für die anderen gezeigten Gemälde, Fotografien und Objekte gilt. Wenn die menschliche Figur in den Werken erscheint, dann ist ihr Abbild Ausdruck eines Stils oder Klischees, wie bei Richard Prince, David Salle und Sylvie Fleury oder wird wie bei »Frau« von Fischli/Weiss als eine mögliche Erscheinungsweise von Welt objektiviert und in eine Reihe mit »Haus« und »Krähe«

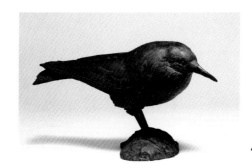

40 Fischli/Weiss
Krähe, 1986

gestellt. In den Fotografien von Andreas Gursky und Thomas Struth schließlich nimmt der Mensch eine Statistenrolle ein, die ihn als Teil einer räumlichen Situation, nicht aber als Individuum ausweist. Diese Festellung bestätigt die anfangs aufgestellte These, dass es ein wesentlicher Aspekt des Profils der Pisces Collection ist, Werke zu sammeln, in denen der Reflexion der Kunst über Kunst – oder über das Bild als Informationsträger im allgemeinen – größere Bedeutung beigemessesen wird als einer psycholgisierenden Bildidee oder der Selbstdarstellung des Künstlers. Unter diesem Aspekt betrachtet, wäre die Entscheidung für »Red Light District« von Mariko Mori, die einzige Arbeit in der Ausstellung »ahead of the 21st century«, in der die Produzentin und Protagonistin identisch sind, nur dadurch erklärbar, dass die Künstlerin zwar die Hauptrolle in der Inszenierung übernimmt, aber dabei nicht nur ihre Identität hinter der Maske des dargestellten Charakters verschwindet (was eine Parallele zu den Werken Cindy Shermans darstellt), sondern sie sich darüber hinaus selbst zum Medium stilisiert. Zwischen Puppe und Cyborg angesiedelt, scheinbar unsichtbar mitten im pulsierenden Nachtleben Tokios stehend, definiert Mori – vielleicht ihre Rolle als Künstlerin – sicher aber ihre Rolle im Bild als die einer Außenstehenden.

Elasticity in Artificial Gestures

Die antiseptische High-Tech-Kunst Mariko Moris markiert das eine Ende des Spektrums der künstlerischen Formulierungen in der Ausstellung, dessen anderes Ende die Demonstration der Überflüssigkeit der künstlerischen Geste als künstlerische Geste im Werk von Franz West besetzt. Schon ein Blick auf das schrundige »Passstück«, eines von zahlreichen Objekten einer Serie, in der West das Verhältnis zwischen Skulptur und Körper untersucht, gibt Hinweise darauf, dass Kunst hier als prozessuale Entwicklung und die Kunstwerke als erstarrte Gesten, als Zeugen dieses Prozesses, verstanden werden. Da die »Passstücke« darüber hinaus tatsächlich dazu gedacht sind, am Körper getragen zu werden, ist dieser Prozess solange nicht abgeschlossen, wie ein Mensch einen Bezug zwischen dem Objekt und seinem eigenen Körper herstellt. Die Offenheit als Grundkonstante des Werkbegriffs wird auf anderer Ebene auch in der Installation »Schöner Wohnen« deutlich, in der Franz West den Betrachter nicht nur durch die Bereitstellung objekthafter Sitzgelegenheiten zum Verweilen einlädt, sondern ihn damit auch gleichzeitig indirekt auffordert, den an der Wand hängenden Kunstwerken unterschiedlichster Provenienz Zeit und Aufmerksamkeit zu schenken. Die Kombinationen von Bild und Möbel – die John M Armleder in seinen »Furniture Sculptures« dazu gebraucht, formale,

ästhetische und stilgeschichtliche Fragestellungen im Raum zu inszenieren – zielen im Werk von Franz West auf potenzielle Kommunikationssituationen ab und erscheinen damit zugleich als räumliches Zeichen einer zeitlichen Dimension.

Die Idee der Weltaneignung als per se unvollendetem Prozess und die ständige Erweiterung der Welt der Dinge um neue Facetten, stellen eine Verbindung her zwischen den nicht selten raumgreifenden Skulpturen von Franz West und den häufig kleinen, die Idee des Modells variierenden Objekten von Peter Fischli und David Weiss, die seit 1979 gemeinsam arbeiten. Im Zentrum der Werke – seien es Fotografien, Filme, Objekte oder Installationen des Künstlerduos – steht meist das Spannungsverhältnis zwischen Alltagserfahrung und Repräsentation in der Kunst, wobei sowohl der Wahl des Mediums wie auch des Materials große Bedeutung beigemessen wird. So sind die hier gezeigten Objekte alle aus synthetischem Kautschuk angefertigt, also einem kunstfremden Material. Der normalerweise zur Herstellung von extrem belastbaren und zugleich elastischen Gebrauchsgegenständen, etwa Autoreifen, verwendete Rohstoff wurde hier in Formen gegossen, die einfachste Begriffe wie »Haus«, »Frau«, »Auto« oder »Vase« oder komplexere wie »Marokkanisches Sitzkissen« in dreidimensionale Objekte umsetzen. Das Verfahren der Künstler besteht nun nicht nur darin, die Offenheit der Begriffe mit der Elastizität des Materials zu koppeln, sondern auch darin, dass ganz spezifische – nämlich klischeehafte – skulpturale Formulierungen aus unterschiedlichen Bereichen das Aussehen bestimmen. Während das »Marokkanische Sitzkissen« dabei wenig Entscheidungsmöglichkeiten zu lässt und sich darüber hinaus durch seine Originalgröße von den anderen Objekten unterscheidet, ist der Begriff »Haus« durch einen Flachdachbungalow oder der Begriff »Frau« durch eine keusche Sitzende kaum ausgeschöpft. Gerade in der Sichtbarmachung einer Möglichkeit, die als eine von vielen erscheint, aber zeigt sich die subversive Strategie von Fischli/Weiss, die aus der Erkenntnis resultiert, dass eine Suche nach oder ein Glaube an eine einzige Wahrheit ohnehin obsolet ist. Jede der Arbeiten verweist damit schon als Setzung zugleich auf die mögliche Abweichung von derselben. Die mit leichter Hand inszenierten labilen Gleichgewichte aus unterschiedlichsten Küchenutensilien, die die »Equilibre Serie« dokumentiert, veranschaulichen diesen Balanceakt zwischen Sinn und Unsinn aufs Eindrücklichste. Dass der Betrachter beim Anblick dieser Werke unweigerlich zu schmunzeln beginnt, ist dabei keineswegs unwesentlich: Humor ist die permanente Mobilität der Zeichen.

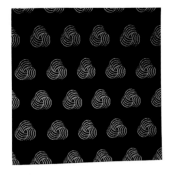

141 Rosemarie Trockel
Untitled (Brown Wool Seal), 1986

Normales als Besonderes

Ein Gütezeichen bürgt für gleichbleibende Qualität, was im Grunde genommen nichts anderes bedeutet, als dass es keinerlei Interpretationsspielraum lässt. Die Entscheidung von Rosemarie Trockel für eines ihrer Strickbilder das Wollsiegelzeichen als sich im gleichmäßigen Rapport wiederholendes Ornament auszuwählen, widerlegt dies in mehrfacher Hinsicht. Wählt man als Einstieg zur Betrachtung des Werks die Ironisierung der *männlichen* Malereitradition des Abstrakten Expressionismus, dessen all-over die Künstlerin hier im *weiblichen* Medium des Gestrickten zitiert, so ersetzt das sich permanent wiederholende Zeichen als Motiv die künstlerische Geste und interpretiert diese damit als leere Repetition. In Bezug auf das im Strickbild verwendete Material ist das Wollsiegelzeichen entweder redundant (wenn es Wolle ist) oder es ist Ausdruck einer Täuschung (wenn es keine Wolle ist). Der subversiven Hinterfragung des Zeichens entspricht auch der kritische Umgang mit der verwendeten Technik. Zwar wählt Rosemarie Trockel die Stricktechnik als Hinweis auf Handarbeiten, also eine traditionell der Frau zugeordnete Tätigkeit, entwirft die Bilder aber mit einem Computerprogramm und führt sie mit computergesteuerten Maschinen aus. »Diese gestrickten Bilder mit ihren Strickmustern liefern das Bild einer Gesellschaft der Kopien, der industriellen Reproduktion und der Ersetzbarkeit von allem.«[12] Die Entscheidung für die industrielle Produktion des Kunstwerks ist dabei einerseits als Referenz an die Minimal Art zu lesen, kontrastiert aber andererseits die Richtlinien der Massenproduktion mit den Regeln des Kunstmarkts, der bis vor wenigen Jahren dem Unikat als Original einen höheren Wert zugestand als der Auflage.

Helden der Nüchternheit

Andreas Gursky, Thomas Struth und Thomas Ruff zählen derzeit zu den international erfolgreichsten Fotokünstlern ihrer Generation. Alle drei haben bei Bernd und Hilla Becher studiert und die strenge, distanzierte Bildsprache ihrer Lehrer im eigenen Werk weitergeführt und variiert. Die großformatigen Fotografien von Andreas Gursky fesseln den Betrachter durch die in ihnen vollzogene Gleichzeitigkeit von Nah- und Fernsicht. Das was unser Auge nicht zu leisten vermag, nämlich zugleich die Totale und das Detail wahrzunehmen, ermöglicht das Kamerabild. Das bedeutet aber auch, dass die Fotografien Gurskys mit ihrer unglaublichen Tiefenschärfe und dem daraus resultierenden Detailreichtum uns zwar Bilder von der realen Welt liefern, aber diese nicht mit den real von uns in der Welt erfahrbaren übereinstimmen. Verschärft wird die Irritation zusätzlich dadurch, dass Gursky meist die Vogelperspektive wählt und damit den Betrachter zugleich weit weg von und über dem Geschehen positioniert. Die aus diesen Bildstrategien resultierende

Distanz zwischen Betrachter und Bild weckt ein Gefühl der Verunsicherung. Unser Weltbild beruht auf unserer Wirklichkeitswahrnehmung und diese wird in erster Linie durch das Auge geleistet. Indem wir sehen, verorten wir uns zugleich. Die Fotos von Gursky zeigen uns Bilder der Welt, in denen wir weder einen sicheren Standort finden noch uns in Relation zu den Menschen setzen können, die häufig nur als bunte, in ihrer Eigenbewegung gefangene, sich zu Clustern zusammenschließenden Pixeln erscheinen. Der Eindruck einer künstlichen Welt zu begegnen, ist aber zugleich der Ausgangspunkt um die Fotografie als Medium der Transfomation zu begreifen und deren Eigengesetzlichkeit und manipulative Kraft zu reflektieren. An diesem Punkt treffen sich die Interessen von Andreas Gursky und Thomas Struth, obwohl der Weg, der Struth zu dieser Hinterfragung des Bildbegriffs führt ein ganz anderer ist. In seinen Aufnahmen von Straßen, Plätzen und Stadtlandschaften, die zugleich als formal perspektivische Räume und als Ausdruck einer vom Menschen geschaffenen Welt betrachtet werden, orientiert Struth seine Kameraperspektive am Blickwinkel des sich durch den Stadtraum bewegenden Menschen. Dass den Betrachter dennoch angesichts vieler der Arbeiten ein Gefühl der Fremdheit beschleicht, liegt zum einen daran, dass Struth häufig mit Schwarzweißfotografie arbeitet, wodurch automatisch eine Abstraktion volllzogen und die Nüchternheit der Aufnahme gesteigert wird. Besonders in seinen frühen Werken tritt als weiterer Aspekt hinzu, dass er von zentraler Stelle aus menschenleere Straßenzüge zeigt, die dadurch einerseits als steingewordener Verweis auf die sie bewohnenden Menschen gelesen werden, aber andererseits ihren Realitätsgehalt auch völlig verlieren und als abstrakte Raumgeometrien erscheinen können. Besonders an solchen Bildern fällt die präzise Komposition Struths auf, der jedes Detail berücksichtigt, um konkrete Bildarchitekturen zu schaffen, in denen die Gewichtung der Massen, die Winkel der perspektivischen Verzerrung und selbst die Verteilung der Helldunkelwerte, seinen Vorstellungen entsprechen.

In nüchternem Schwarzweiß gehalten, präzise mit der genauen Angabe der Zeit und des Ortes betitelt, strafen die Sternbilder von Thomas Ruff jede romantische Vorstellung des Himmelszeltes Lügen. Für das von anonymer Hand, aber auf höchstem Niveau der Astrofotografie produzierte Negativ fällt der Künstler nur die Entscheidung, in welchem Format das Bild abgezogen werden soll. Die Sicht in den Sternhimmel, die der großformatige Fotoabzug uns suggeriert, erweist sich aber als trügerisch. Die photochemische Substanz reagiert, wie unser Auge, allein auf das Licht. Das Sternenlicht kann aber trotz der Lichtgeschwindigkeit, mit der es durchs All zur Erde fällt, nur so verzögert wahrgenommen werden, dass wir nur glauben zu sehen, wo sich die glühenden Gaskugeln befin-

den. Manche sind schon verloschen, andere längst weitergewandert oder gar nie dort gewesen, wohin unsere Wahrnehmung sie projiziert. Die Einsicht, die uns die Sternbilder von Thomas Ruff vor Augen führen ist paradox: Was wir auf den Fotos sehen, hat so nie existiert.

ahead of the 21st century

»Ahead of the 21st Century« als Titel wie als Ausstellung der Werke aus der Pisces Collection stellt eine Behauptung auf. Die Präsentation von Werken aus den 80er und 90er Jahren des 20. Jahrhunderts ist ein souveräner Querschnitt dessen, was die internationale Kunst-Community in den letzten 20 Jahre als diskursrelevant erkannt und definiert hat. Es sind Kunstwerke, aus denen der radikale Relativismus eines Denkens spricht, das Wahrheit nur noch als eine mögliche Interpretation einer Interpretation begreift. Die Wahrheitssuche, prägend für eine Kunstauffassung, die das Bild als individuellen Erfahrungsraum nutzt, wird hier durch die coole Geste des Samplings ersetzt. Es ist eine Strategie, die eine mögliche Konsequenz aus dem Verlust der Unschuld zieht. Schon deshalb muss jede Geste in Frage gestellt, also in sich gebrochen werden, muss jede Setzung bereits ihre Negation beinhalten. Das faszinierende Paradoxon bleibt die Konstruktion, die dieser Haltung Ausdruck verleiht: Eine künstlerische Strategie, die im Bewusstsein zu täuschen, die Bildmittel so einsetzt, dass das Erscheinungsbild als Täuschung erfahrbar wird, täuscht eben gerade nicht. Die Frage nach der Möglichkeit von Wahrheit in Bildern bleibt dennoch offen. Sie versuchen nicht Antworten zu geben, sondern formulieren neue Fragen.

Do you know what it means to come home at night face the collection, which gives you hope, future and a glimpse of eternity? It means you're in the wrong house. That's what it means.[13]

MARGRIT BREHM

1 Cindy Sherman erzählt, dass die »Disgust-Series« unter anderem auch durch ihre Wut auf die mit großer Geste auftretenden Malerfürsten der 80er Jahre und auf das immer noch nach großer expressiver Malerei verlangende Publikum entstanden. Sie entschied sich, Fotos »mit schon lange unbrauchbaren Resten« als Reaktion auf die immer größer und immer beliebiger werdende abstrakte Malerei zu machen und diese im großen Format abziehen zu lassen. (Cindy Sherman im Gespräch mit der Autorin, Baden-Baden im Januar 1996).

2 Damien Hirst, zit. n. Andrew Butterfield, in: Christie's Contemporary, New York, 16.11.1999, S.129.

3 Damien Hirst, in: I Want to Spend the Rest of my Life Everywhere, with Everyone, One to One, Always; Forever, Now, London, 1997, S.246.

4 Damien Hirst, in: s. FN 3, S. 264. Hirst pointiert dieses Statement, indem er auf der dem Text gegenüberliegenden Seite, einen Schiebemechanismus angebracht hat, mit dem sich die Farben eines »Pharmaceutical Paintings« verändern lassen. Zieht man die Farbkarte nach unten, so ist im linken obersten Feld ein »Smiley« zu sehen.

5 John M Armleder, zit.n. John M Armleder, Wiener Secession, Wien, 1993, S. 58.

6 So kombinierte John M Armleder etwa für die Ausstellung in der Staatlichen Kunsthalle Baden-Baden eine raumgreifende, begehbare Gerüstkonstruktion (»Tower«), an der verschiedenfarbige Neonröhren und Blinklichter angebracht waren und auf der Science-Fiction-Filme auf Monitoren zu sehen und japanische Gagaku-Musik zu hören war, mit großen »Pour Paintings«. (s. John M Armleder, Rewind & Fast Forward, hrsg.v. Margrit Brehm, Baden-Baden, 1998).

7 Jeff Koons in einem Interview mit Anthony Haden-Guest, in: Jeff Koons, Auss.kat. Museum of Contemporary Art, Chicago, 1988, S. 17.

8 George Condo, Portraits Lost in Space, Minneapolis 1999/2000, S. 26-28.

9 George Condo, Notes on the sound of painting, in: Portraits Lost in Space, s.FN 8, S. 26.

10 George Condo, s. FN 9, S. 26.

11 Ross Bleckner, zit. n. Birth of the Cool, Ausst.kat. hrsg. v. Bice Curiger für das Kunsthaus Zürich und die Deichtorhallen Hamburg, Köln 1997, S.110.

12 Peter Weibel, Vom Ikon zum Logo, in: Rosemarie Trockel, Ausst.kat. Kunsthalle Basel/ICA London, 1981, S. 40.

13 Als Ausgangspunkt für die Paraphrase diente der Text im Bild »The Canal Zone II«, 1996 von Richard Prince.

Plates

John M Armleder

1 Untitled, 1992

3 Untitled, 1986

5 Untitled, 2001

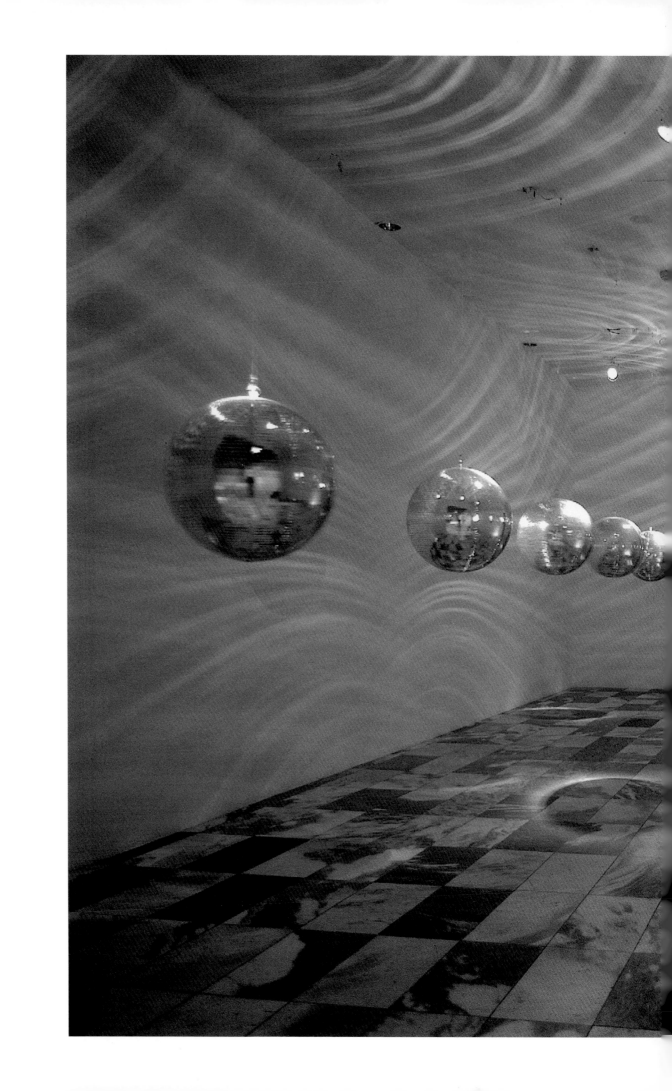

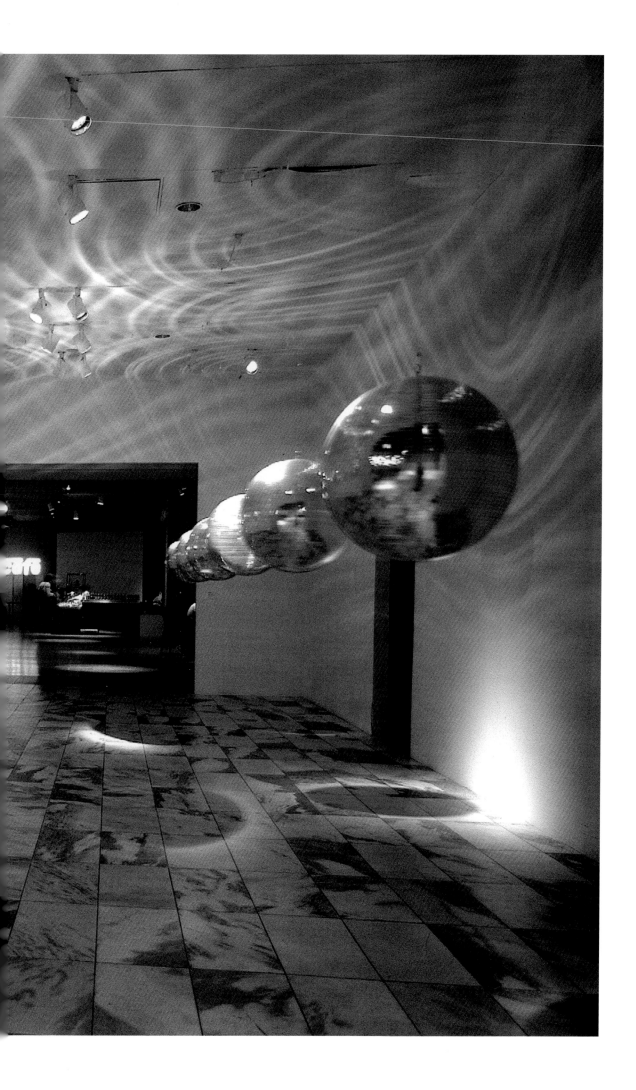

Ross Bleckner

7 Fallen Sky, 1981

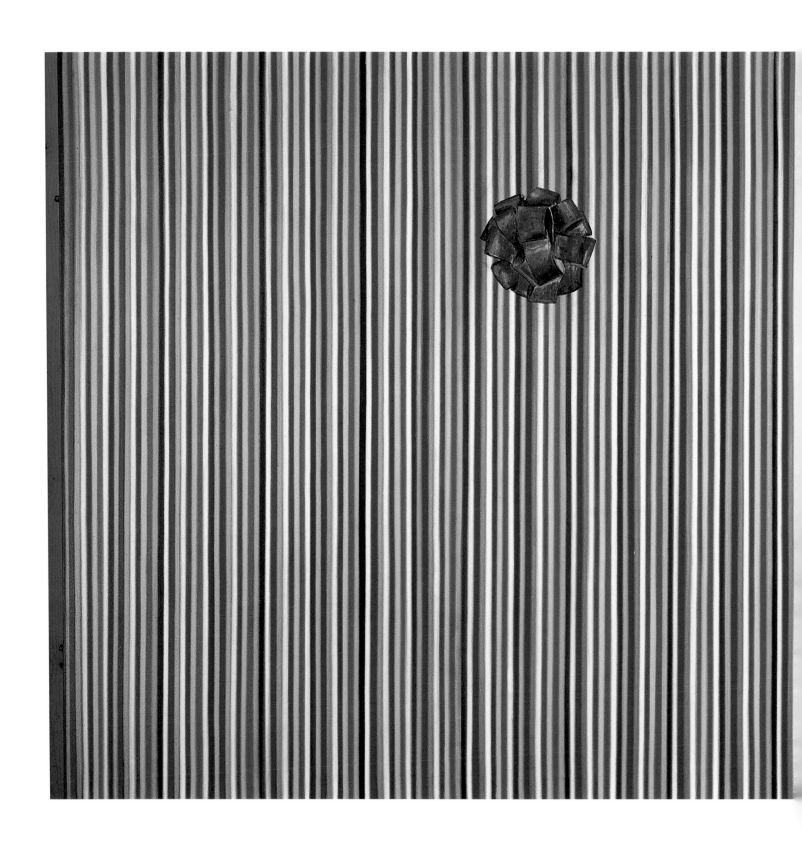

8 Infatuation, 1986/87

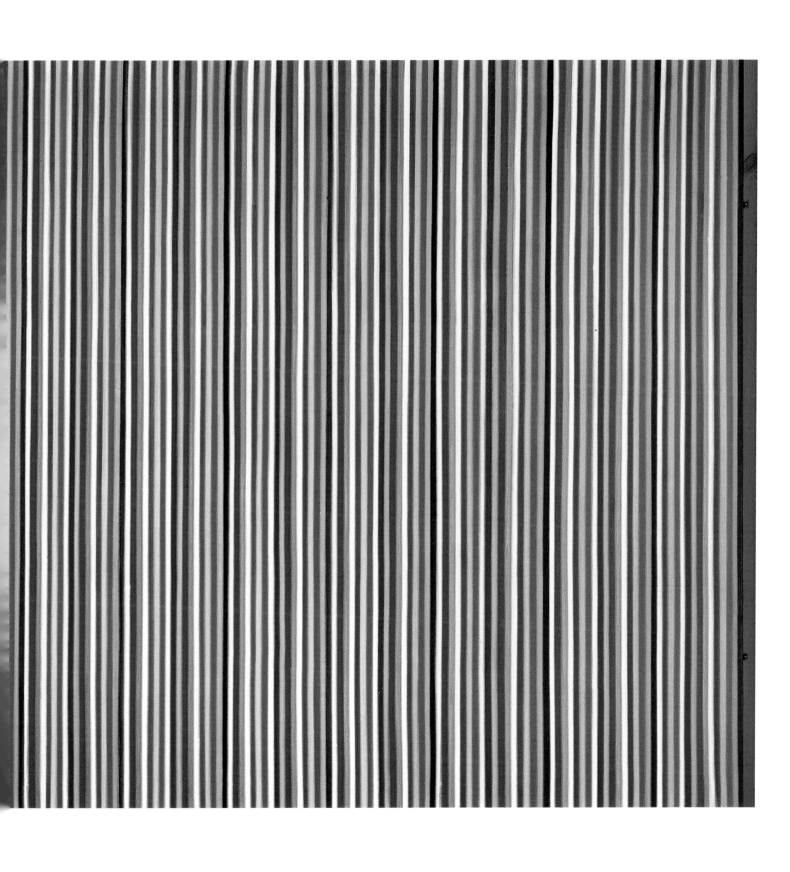

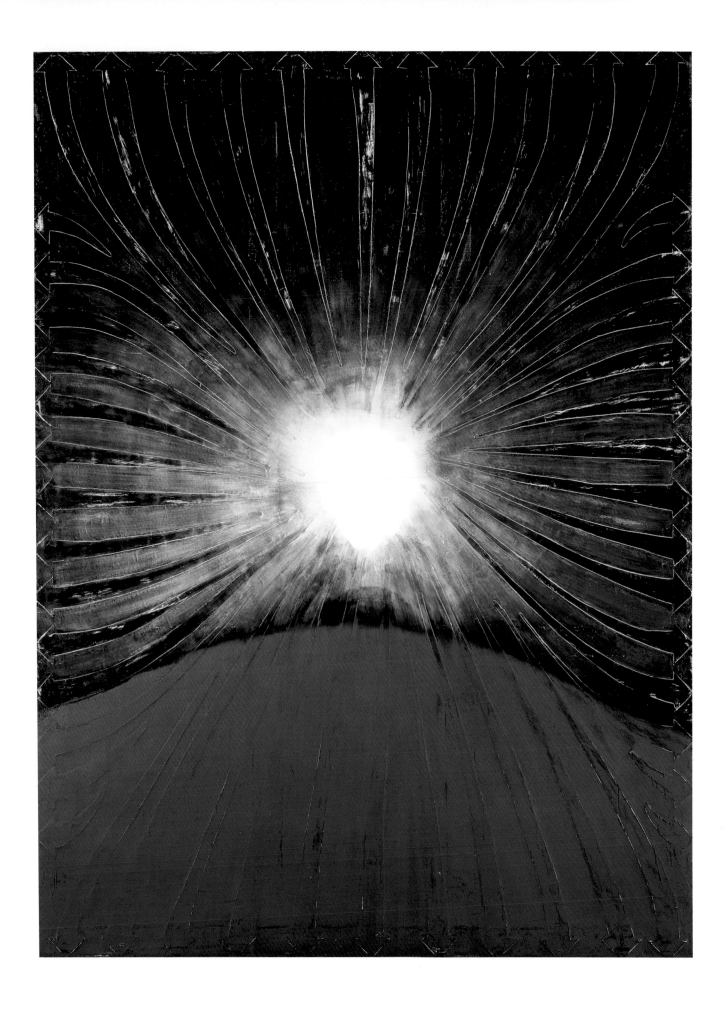

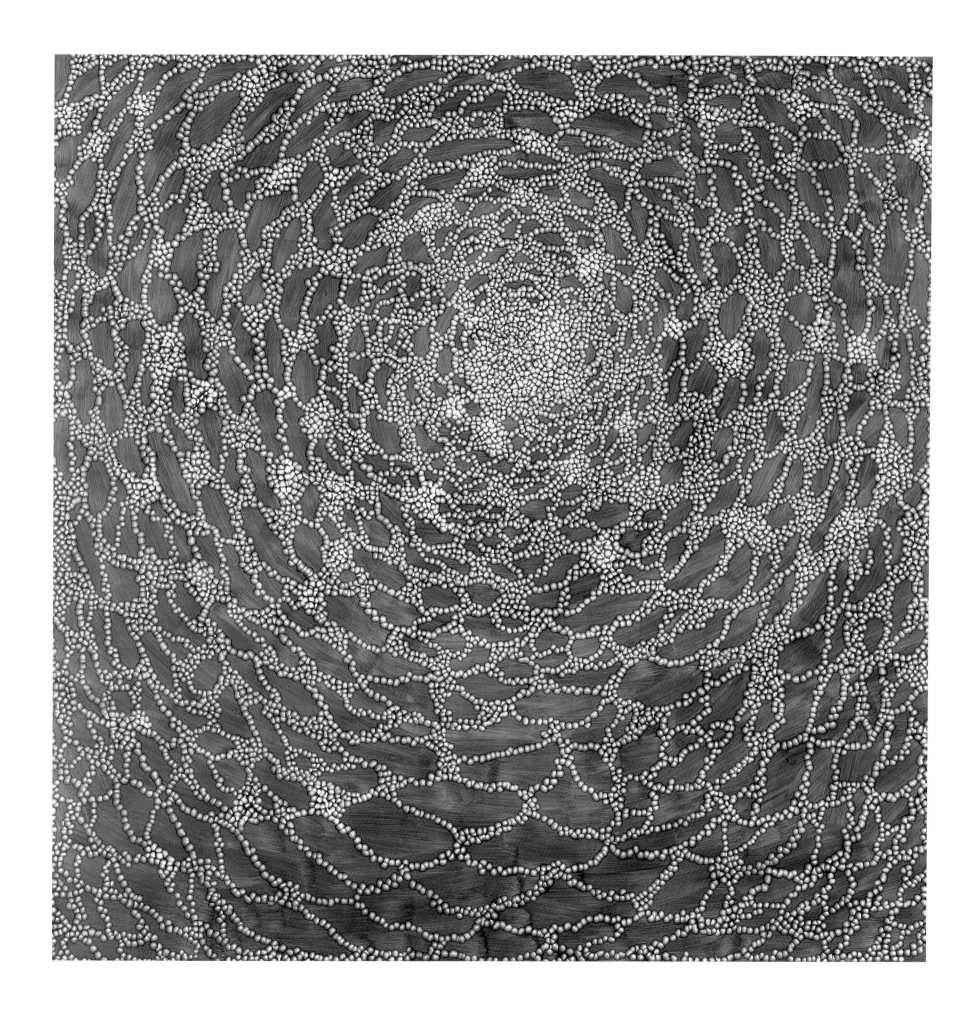

10 Blue Net, 1999

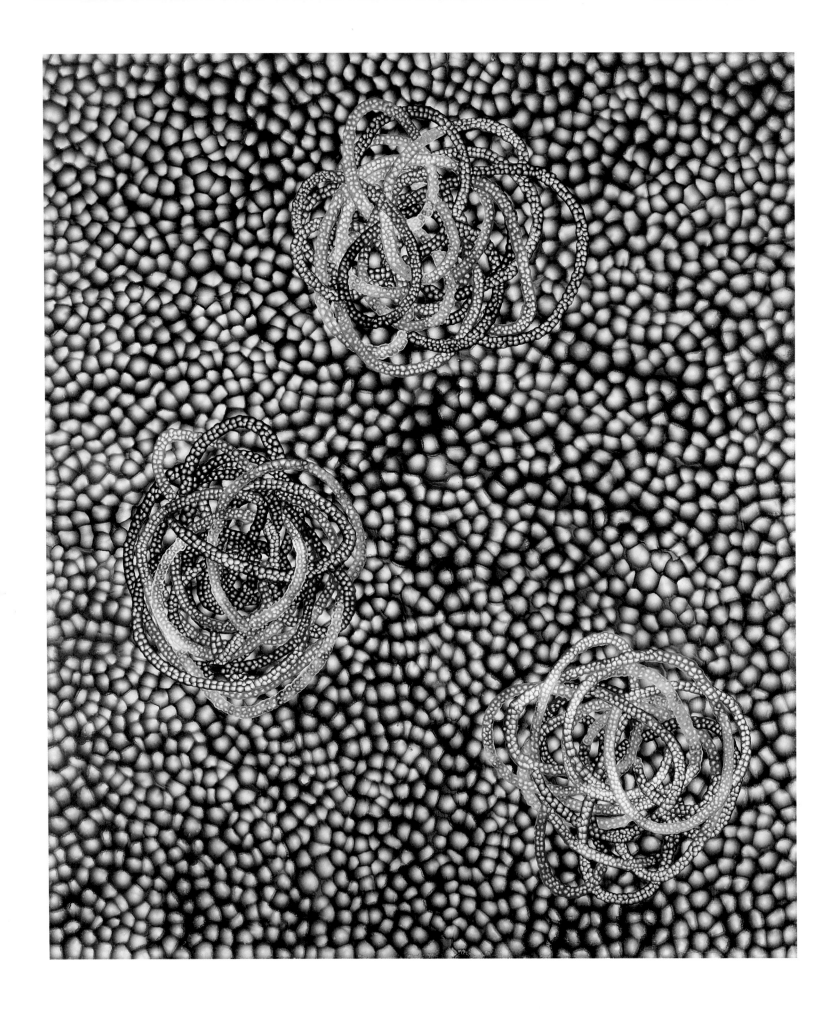

George Condo

13 Jimi Hendrix, 1999

THE JIMI HENDRIX

CHARLIE PARKER

15 Charlie Parker, 1999

16 Jazz at Newport, 1999

JIM HALL

17 Jim Hall, 1999

19 John Coltrane, 1999

ORNETTE COLEMAN

20 Ornette Coleman, 1999

21 The Beatles, 1999

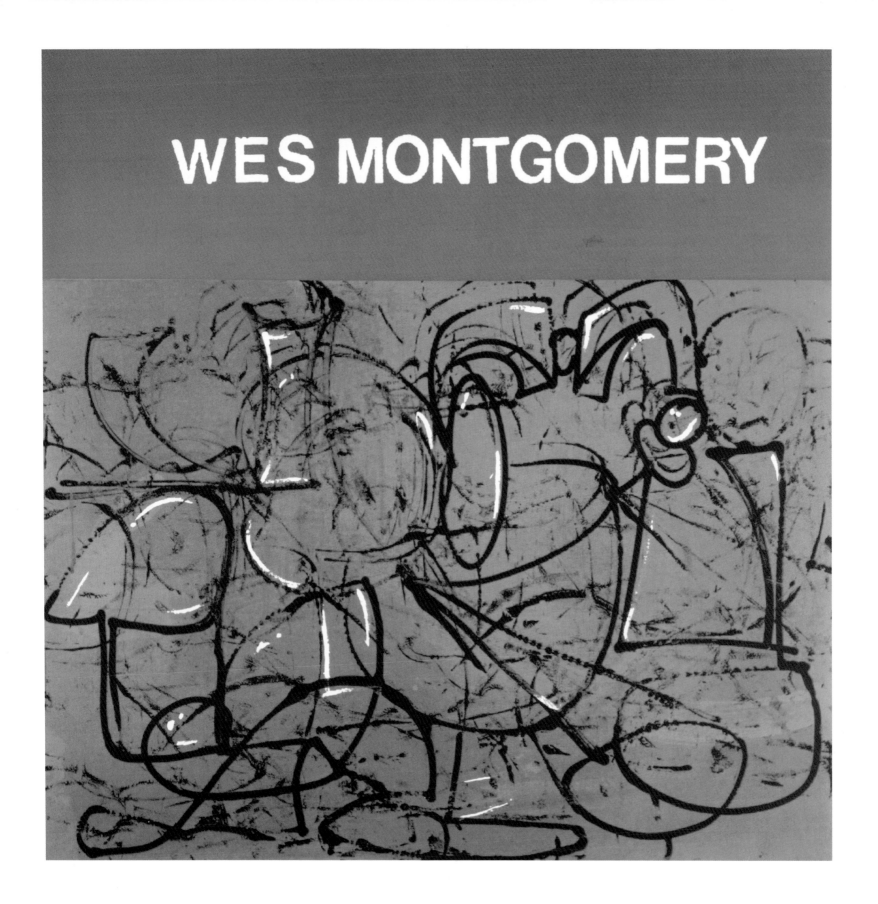

WES MONTGOMERY

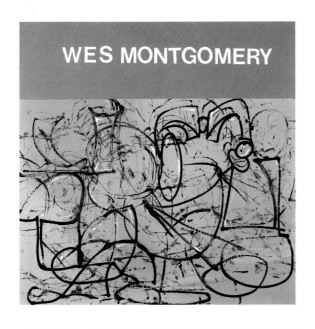

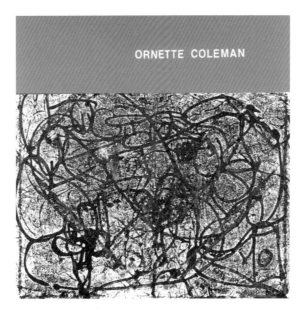

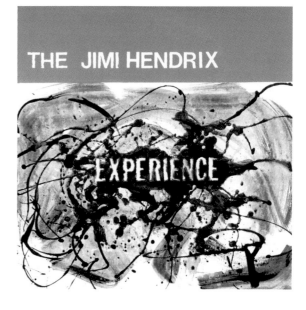

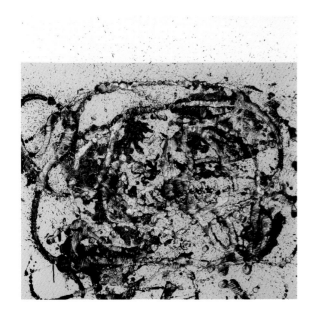

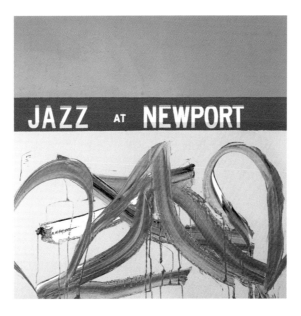

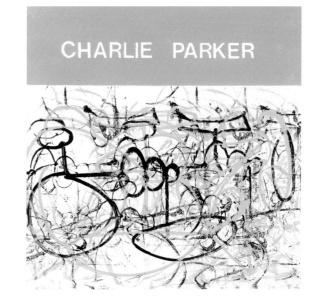

23 Wes Montgomery, 1999

24 John Coltrane, 1999

25 The Beatles, 1999

26 Miles Davis, 1999

27 Ornette Coleman, 1999

28 Jazz at Newport, 1999

29 Jim Hall, 1999

30 The Jimi Hendrix Experience, 1999

31 Charlie Parker, 1999

Wim Delvoye

33 Marble floor no.19, 1998

34 Marble floor no.23, 1998

Fischli/Weiss

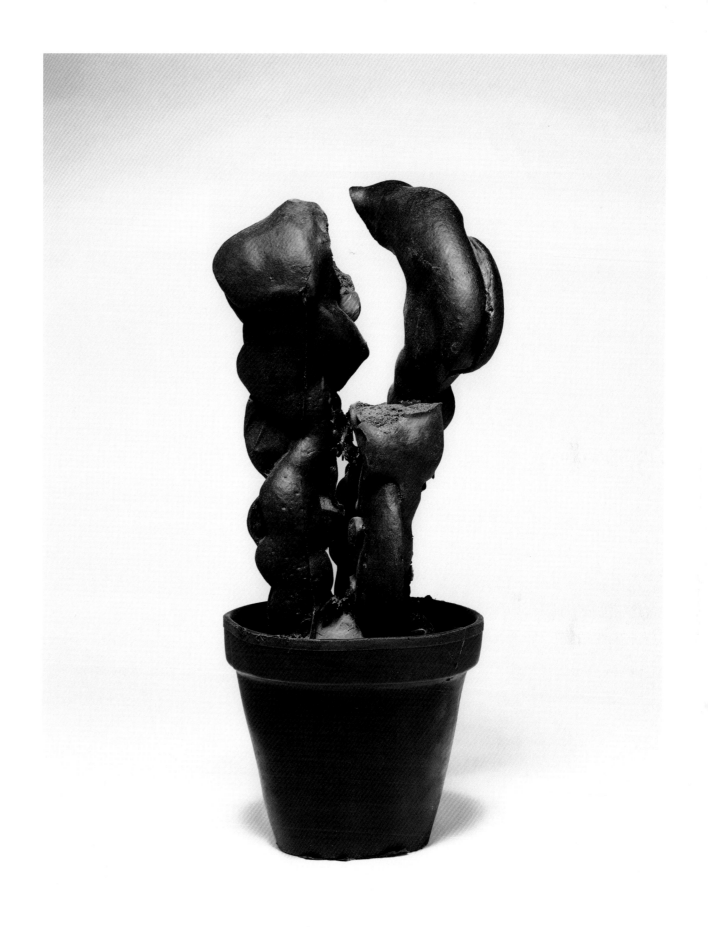

35 Pflanze, 1987

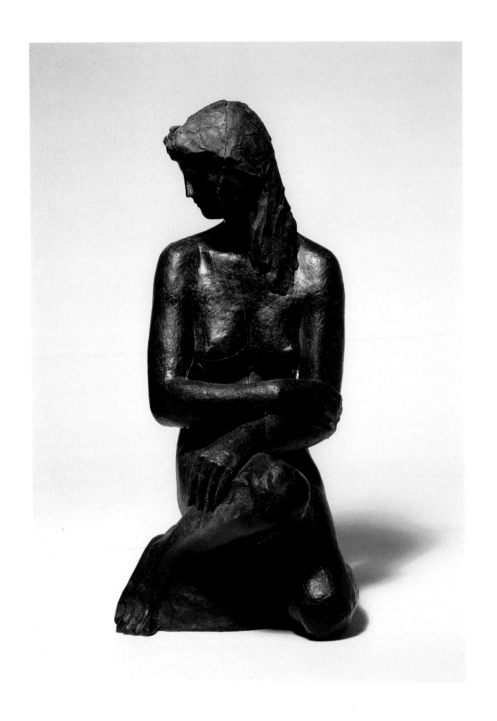

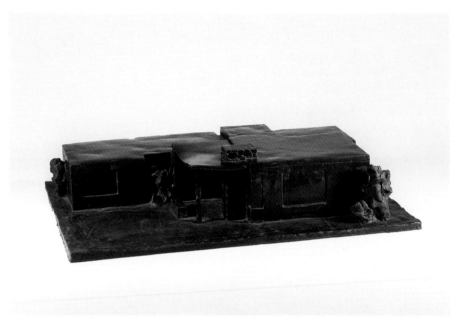

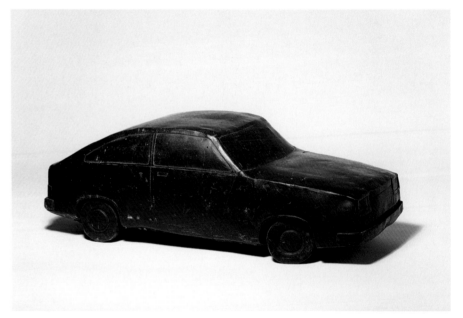

37 Haus, 1986
38 Auto, 1986

36 Frau, 1986

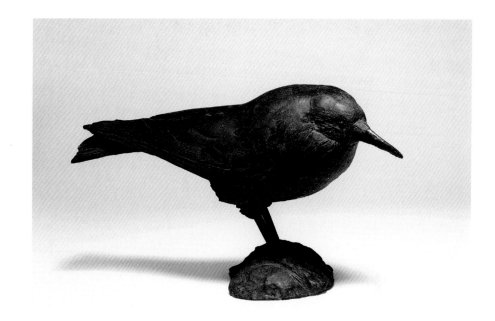

40 Krähe, 1986
41 Marokkanisches Sitzkissen, 1986/87

39 Vase, 1986

42 o.T. (Dark Impulse) (Equilibre Serie), 1984/85

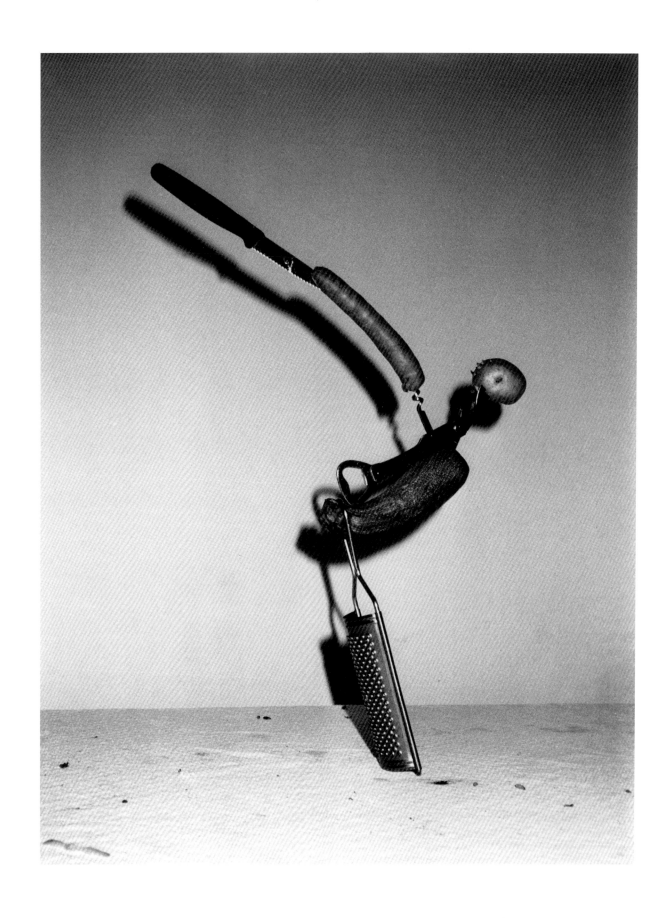

43 Der Zorn Gottes, 1985

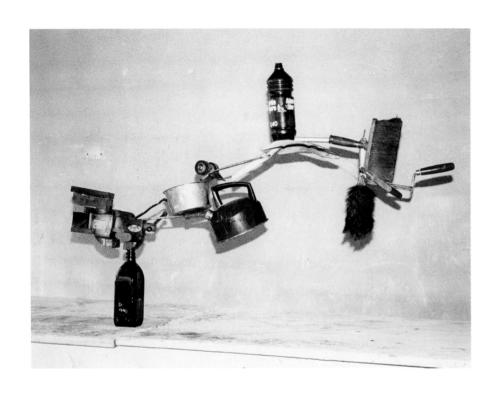

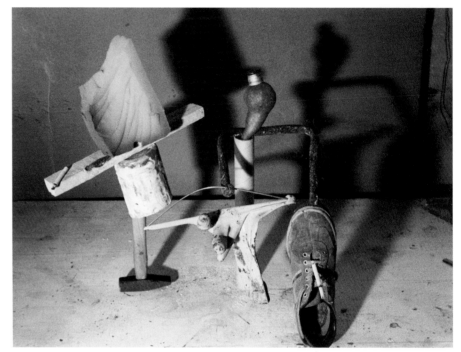

o.T. (Equilibre Serie), 1986

Frau Birne bringt ihrem Mann vor der Oper

das frischgebügelte Hemd, 1984/85

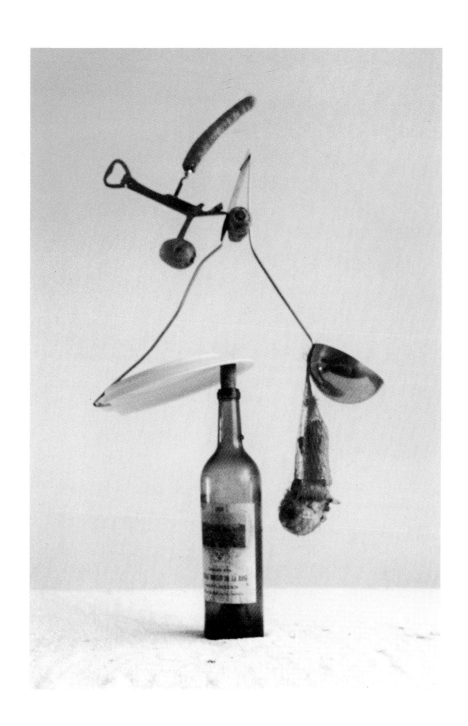

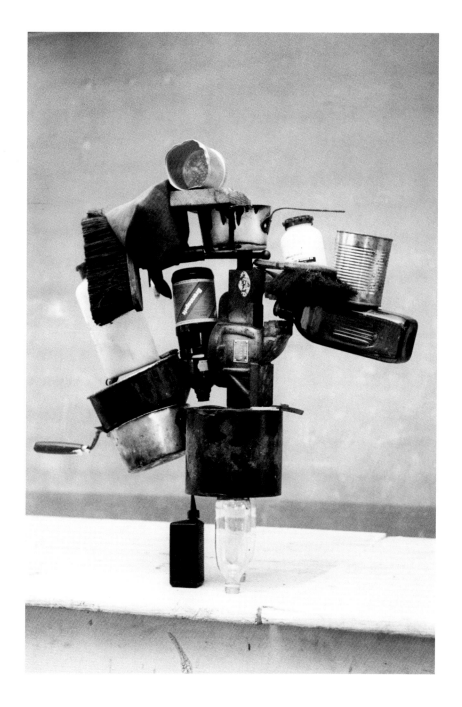

46 Natural Grace, 1985

47 o.T. (Equilibre Serie), 1986

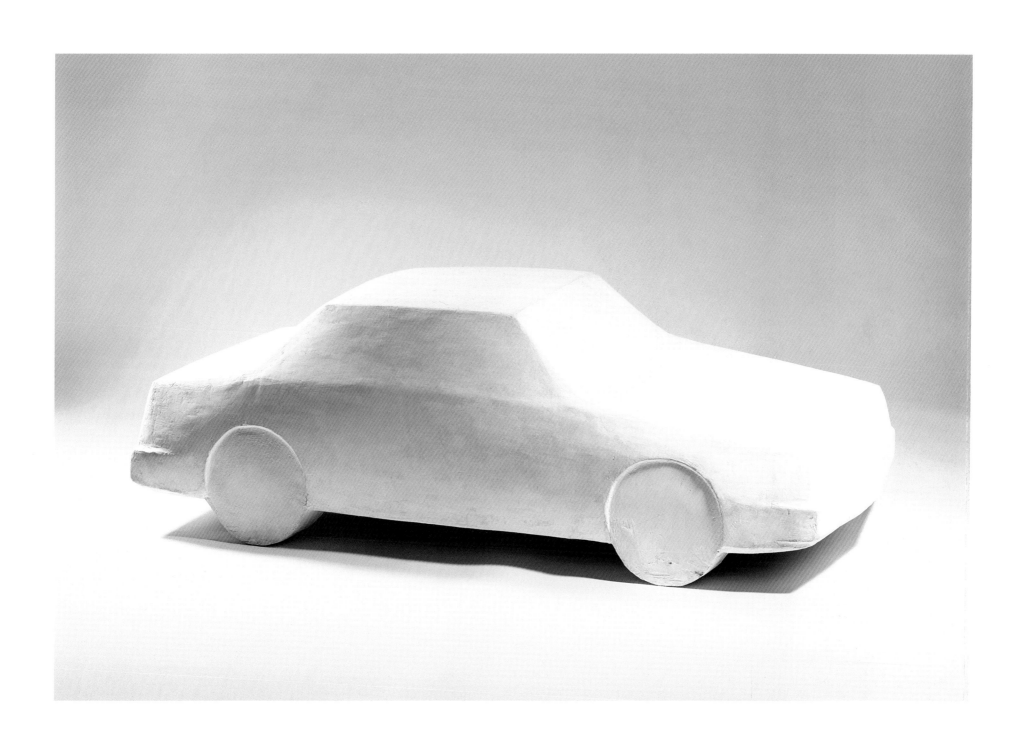

48 Car Sculpture, 1989

49 Airport, 2000

Sylvie Fleury

52 Current issues, 1999

THE FACE

THE LABEL IS BACK
FASHION'S ALL-TIME TOP 40

FASHION SPECIAL

PUFF DADDY
HITCHCOCK'S LOST FILM
TOM AND NICOLE
ANDREW WEATHERALL
HELMUT LANG
NICE GIRL
PORN CHIC

Harper's BAZAAR

10.90 Frs

LAURYN HILL
DOING THE
RIGHT THING

THE DOUBLE
LIFE OF MARC
JACOBS

OUR GUIDE TO THE
NEW GROOVY
DESIGNERS

FABULO
FALL!

207
LOOKS
YOU'LL LOVE
SEXY BOOTS
FAR-OUT FURS
AND LOTS
OF LEATHER

L'OFFICIEL
PARIS

DE LA COUTURE ET DE LA MODE

Bêtes
de Mode

Plaisir :
La fin d'un tabou

Nuits de noces :
Pour le pire
et le meilleur

Neve Campbell
la rebelle

Punta del Este :
Le nouvel Eldorado

Spécial
Prêt-à-Porter
Hiver 2000

PORTRAITS, 6 HÉRITIERS: SOFIA COPPOLA, JULIAN LENNON, MARIE NIMIER,
PIERRE SOUCHON, JULIEN VOULZY, JULIAN CERRUTI

marie claire

Hair special
Get the best style for you

Men, sex
& you
What attracts him most?

HOW TO GET
MORE DATES
HOW SAFE IS THE
FOOD YOU'RE EATING?

72 BEST
BEAUTY BUYS
10 sex secrets
you're entitled to know

GET MORE TIME,
LESS STRESS
RUNWAY TO
REALWAY:
WHAT TO
BUY NOW

FASHIO
37
NEW LOO
AT EVERY

SAVE 20% ON FALL SKIN CARE
PLUS FREE SKIN CARE

fait
néro

20 ANS

JEU-TEST
CE QU'IL DIT
AU LIT
LE TRAHIT !

TON MEC
EN BOMBE
SEXUELLE !
Tout pour le rendre
meilleur à embrasser,
à cajoler, à croquer...

E EAU &
PUCEAU
Oui, il se garde pour
le grand amour

756
RÉPONSES
INTIMES A
NOTRE SONDAGE

PETITE B.
GROSSE B.
Deux personnalités
bien distinctes

LES MYTHES
DU PORNO
L'envers (l'enfer ?)
du décor

LE BONDAGE
EXPLIQUÉ AUX
JEUNES FILLES
Comment
bien attacher
votre amoureux

Trouvez de quoi
la remplir p.53

SKYROCK

CONCOURS MANNEQUINS
De l'audace ! Envoyez-nous vos photos !!!

N° 155 - AOÛT 1999

FLAUNT

BUILT FOR SPEED

MODA: GLI INDISPENSABILI ACCESSORI PER L'INVERNO

AMICA

scienza:
quando il sesso
è doppio

intervista esclusiva:
Salma Hayek
nuova diva latina

bellezza:
reportage
sul corpo

cultura:
Martinica, all'origine
della magia

cinema
Venezia in anteprima:
vecchi amori e nuove passioni

FREE! FANTASTIC PLASTIC ELASTIC JEWELLER

19

Sex
Are you getting as good as you give?

Catwalk styling
at a fraction of the cost

Sweat like a
Bounce
19 tests mega-mad
Californian fitness fads

LOVELY?
LECHY?
LOSER?
What you really think of
his friends and what he
thinks of yours

MAN-CHA
UN

Eight thi
admire abo

"I slept
19 in
celebri

BIG BREAK
EXCLU

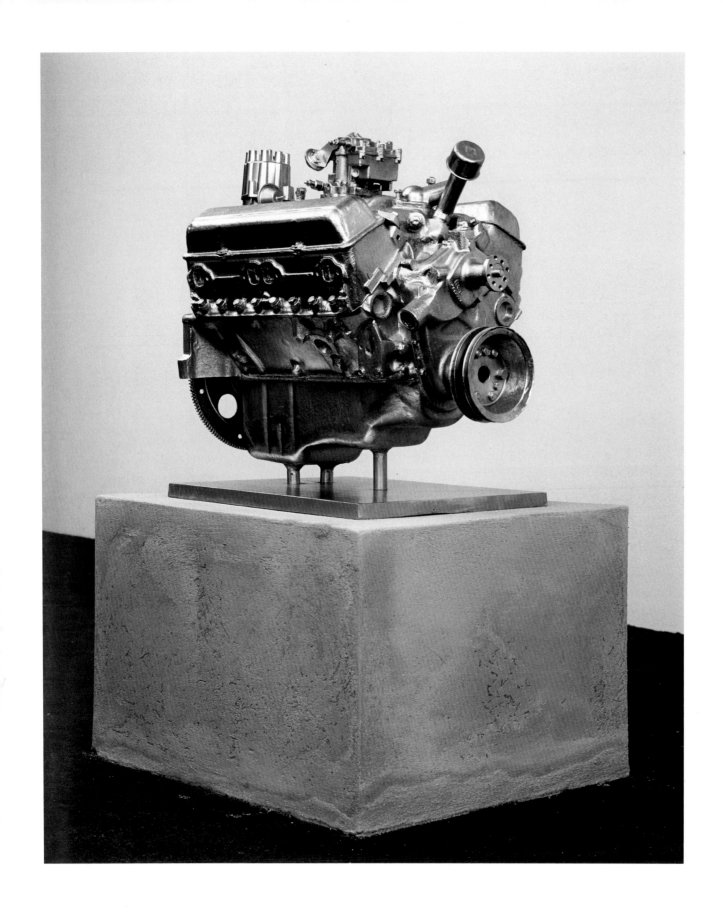

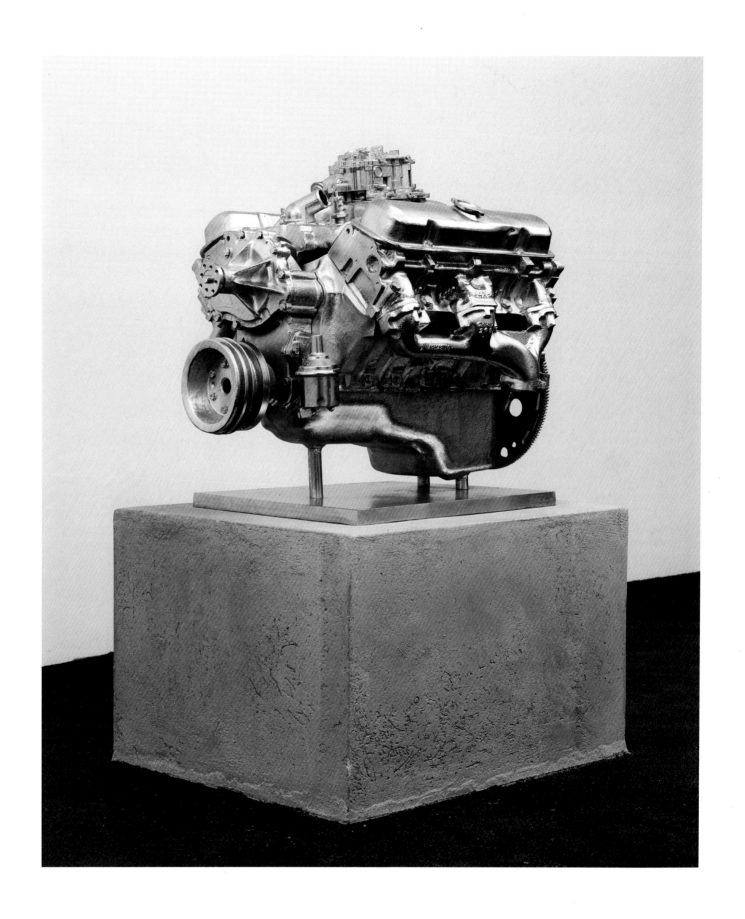

54 283 Chevy, 1999

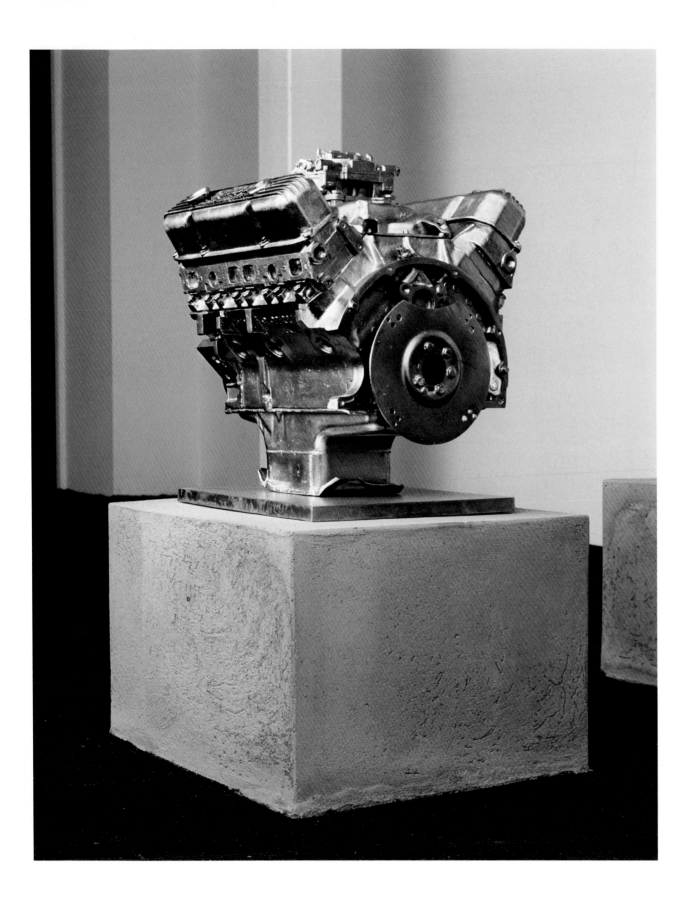

55 400 Pontiac, 1999

56 Eagle, Good Year, 1999

Andreas Gursky

57 Untitled I, 1993

58 Union Rave, 1995

59 Hong Kong, Shanghai Bank, 1994

60 Athens, 1995

62 Ayamonte, 1997

65 Untitled V, 1997

66 Hong Kong Stock Exchange, 1994

Damien Hirst

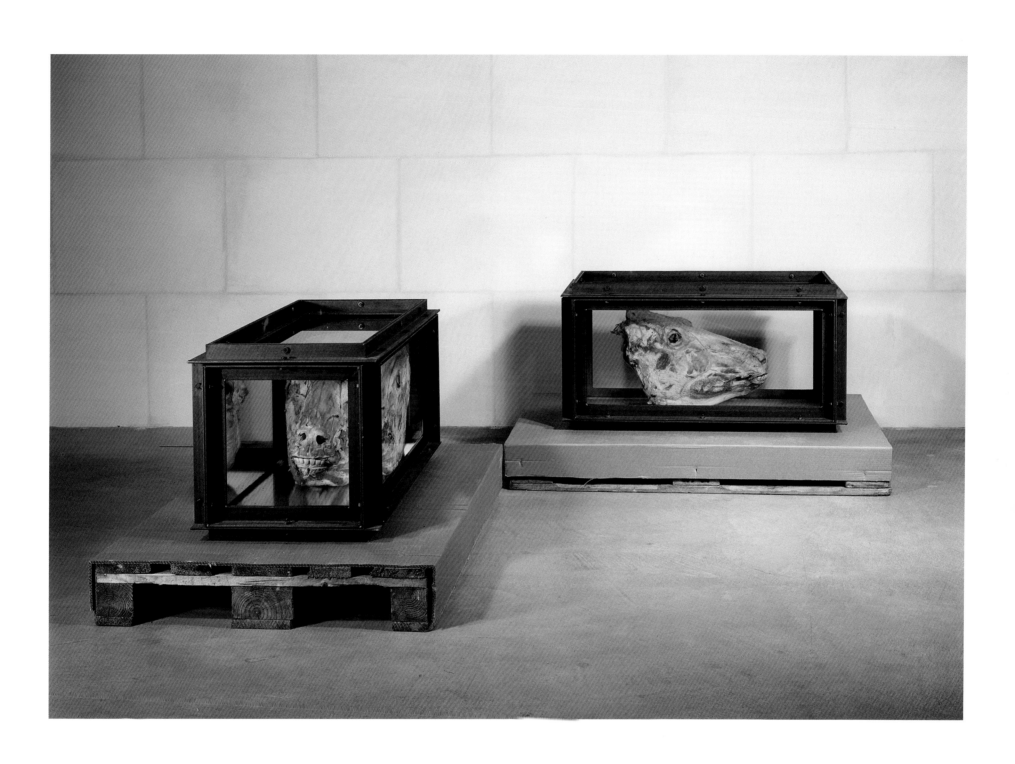

68 Untitled (Pill Painting), 1989/90

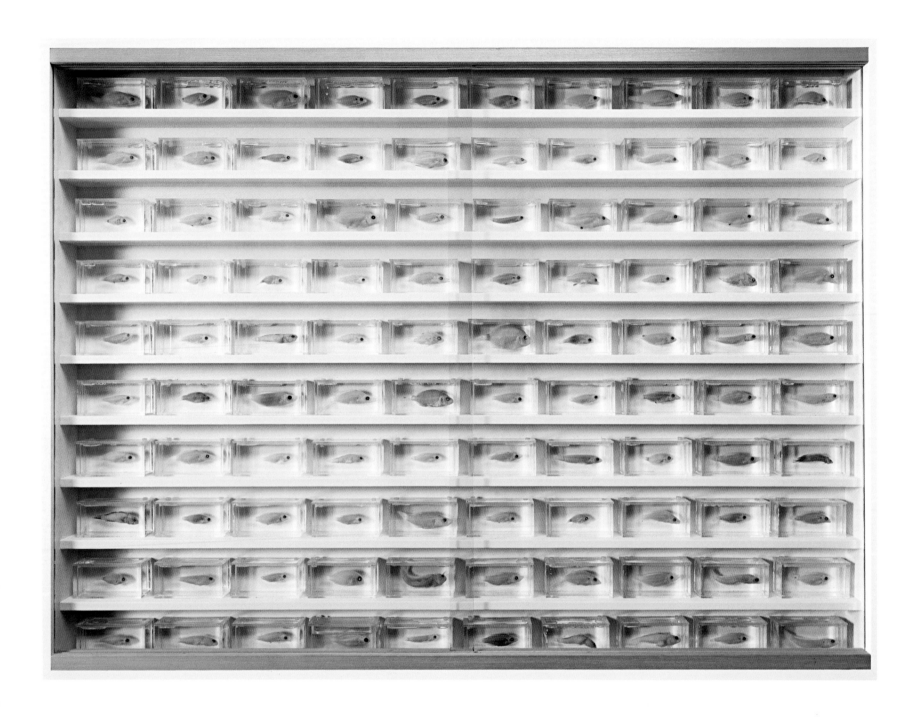

71 We've got style, 1993

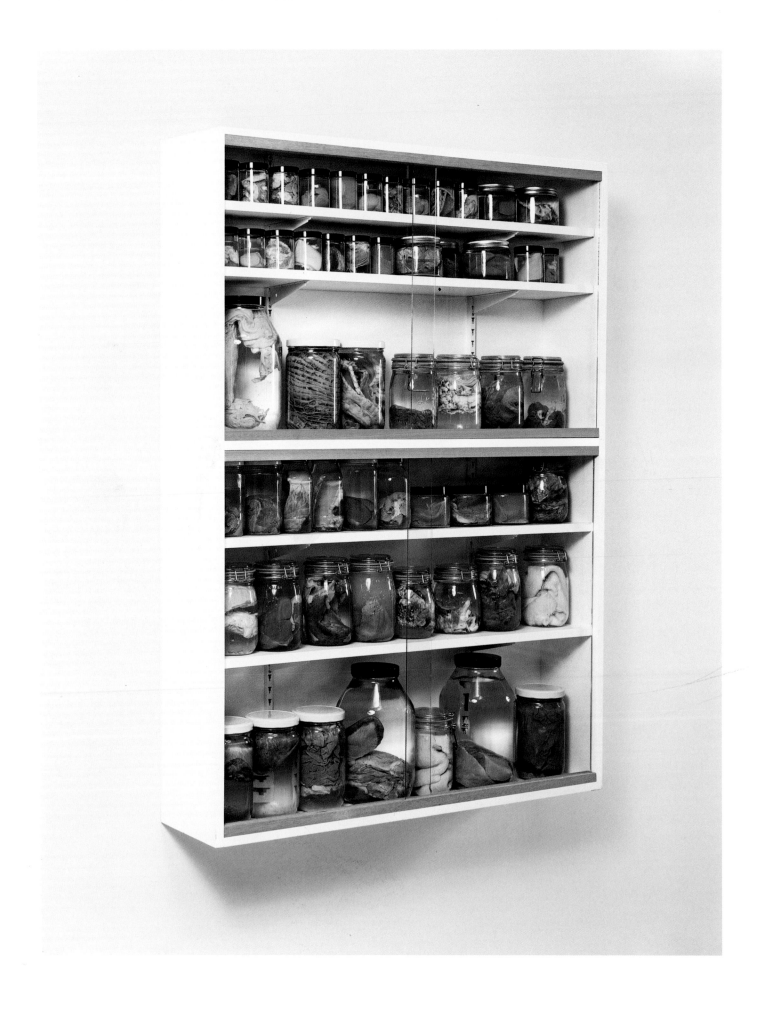

73 We are Afraid of Nothing, 1992

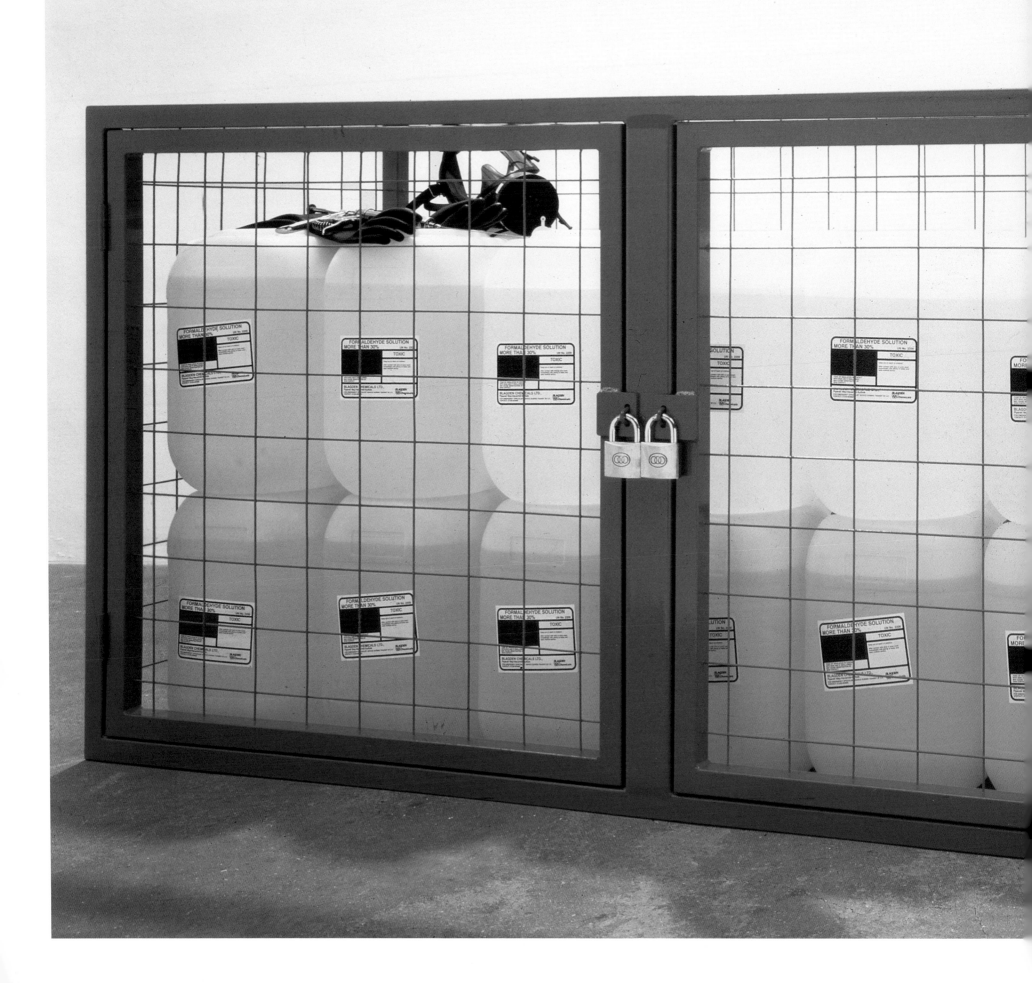

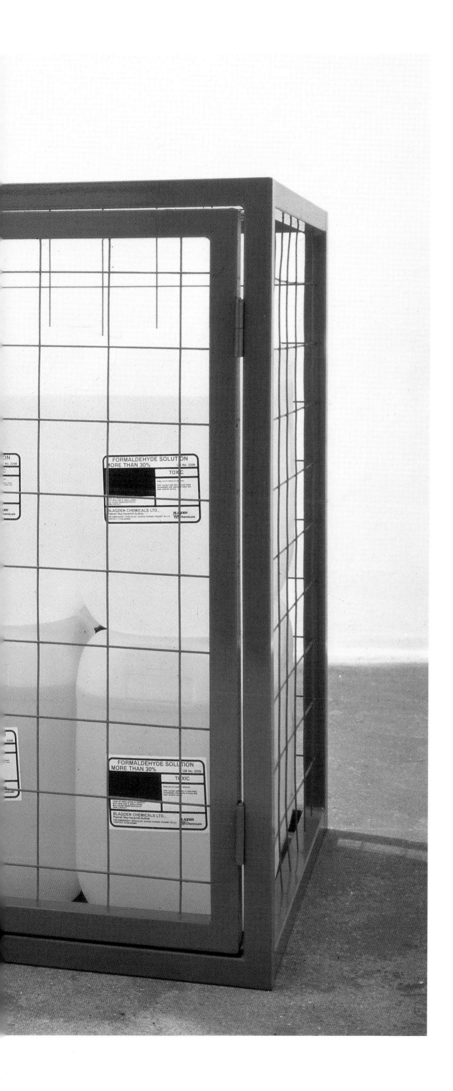

FORMALDEHYDE SOLUTION
MORE THAN 30%

TOXIC

BLAGDEN CHEMICALS LTD.,

FORMALDEHYDE SOLUTION
MORE THAN 30%

TOXIC

BLAGDEN CHEMICALS LTD.,

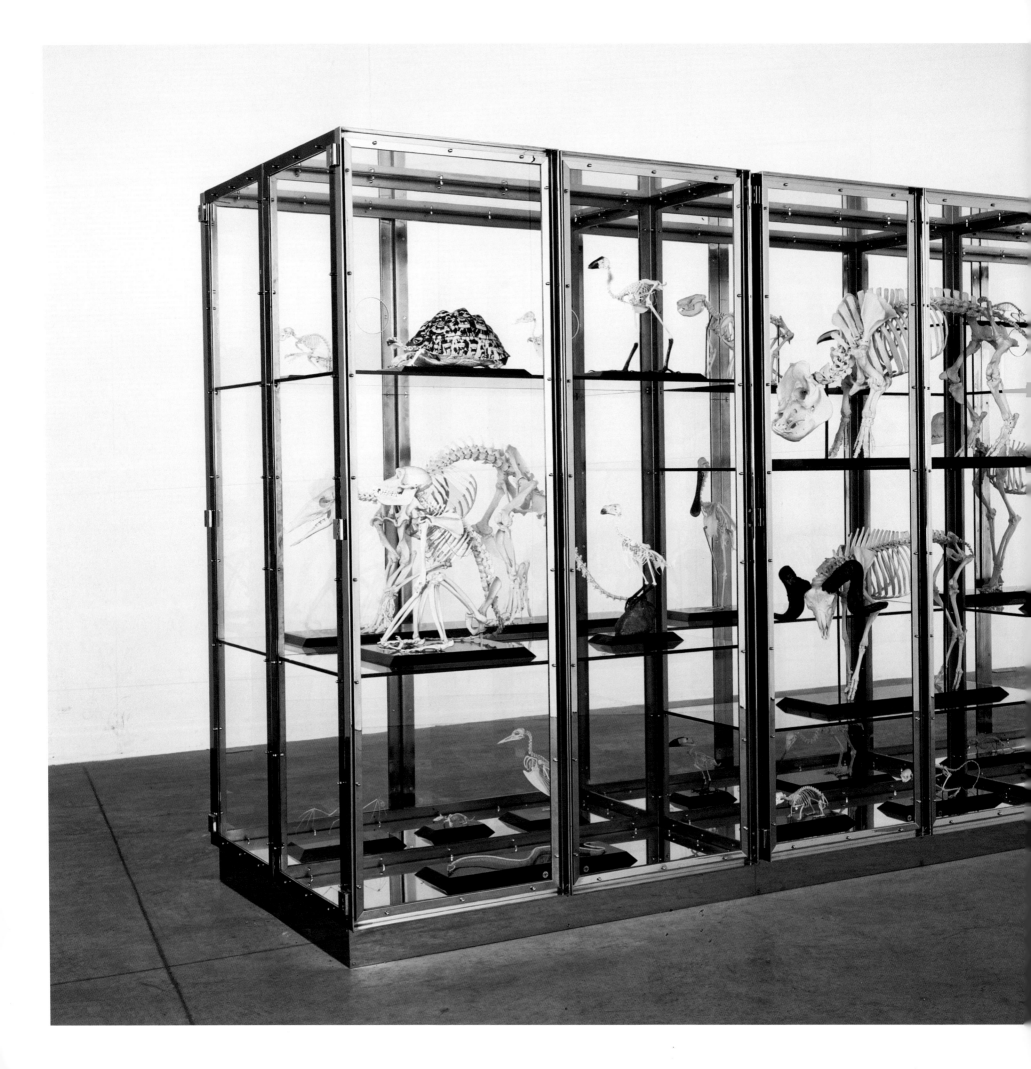

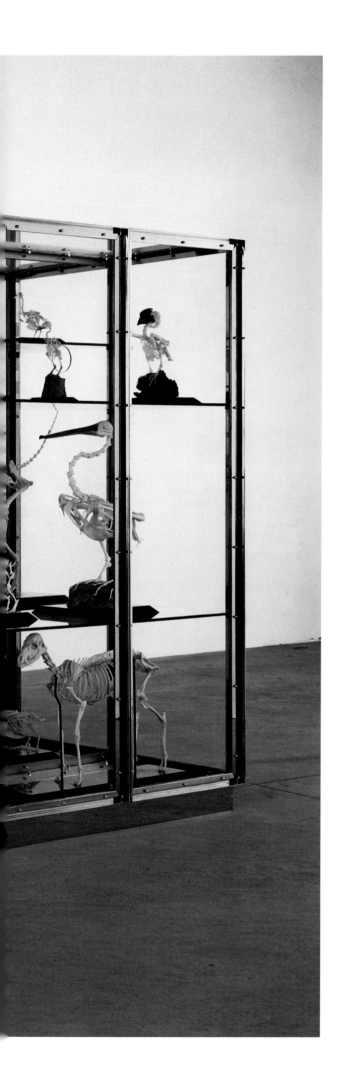

75 Something Solid Beneath the Surface of All Creatures Great
and Small, 2001

Jeff Koons

76 Wild Boy and Puppy, 1988

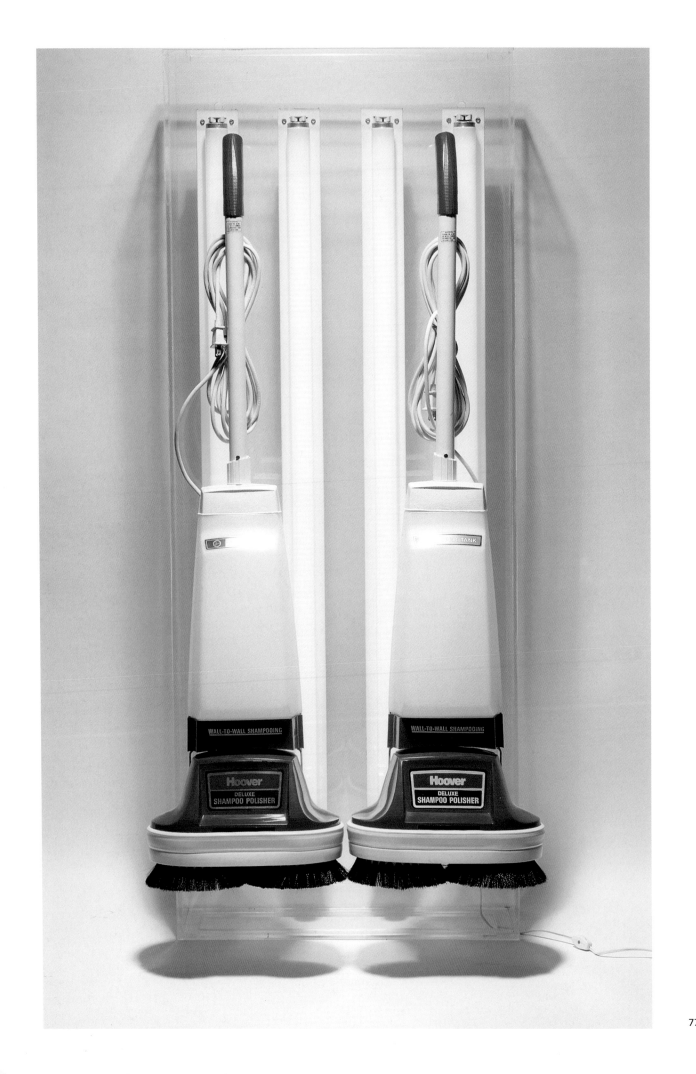

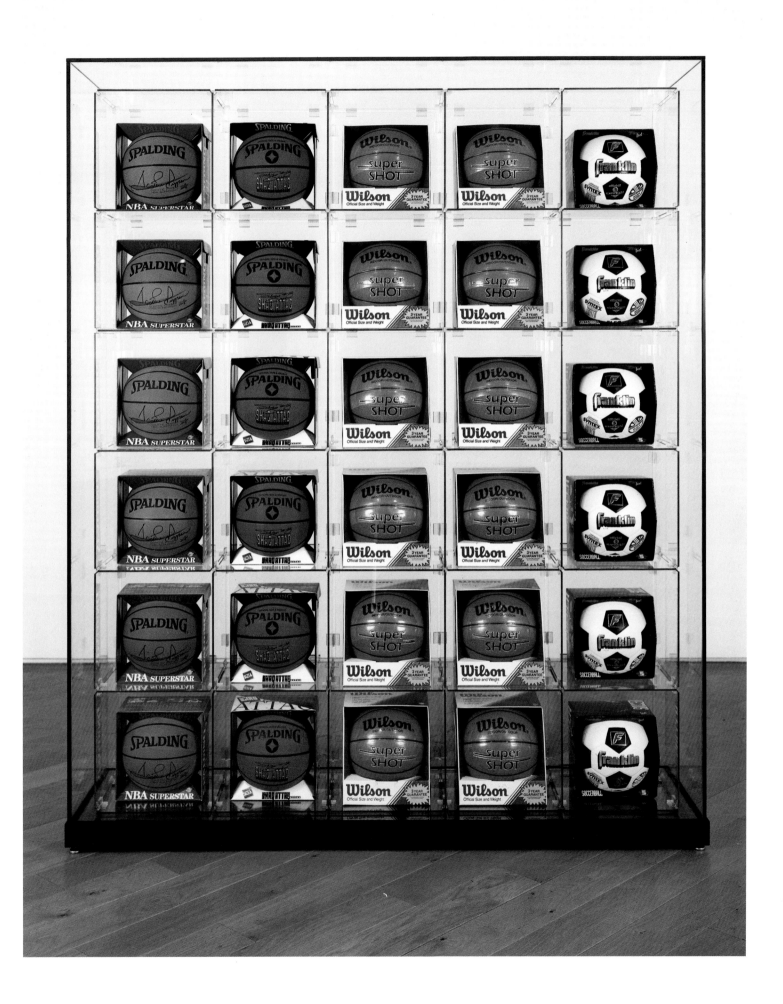

Encased Five Rows, 1983/1993

Paul McCarthy

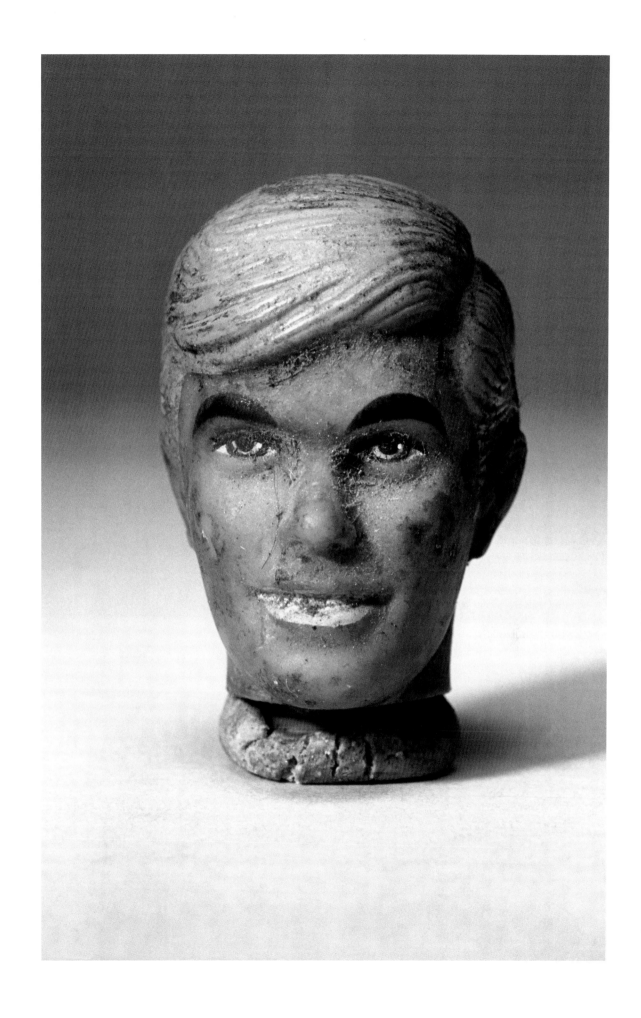

79 Propo Objects (Ken – Pink Head), 1991

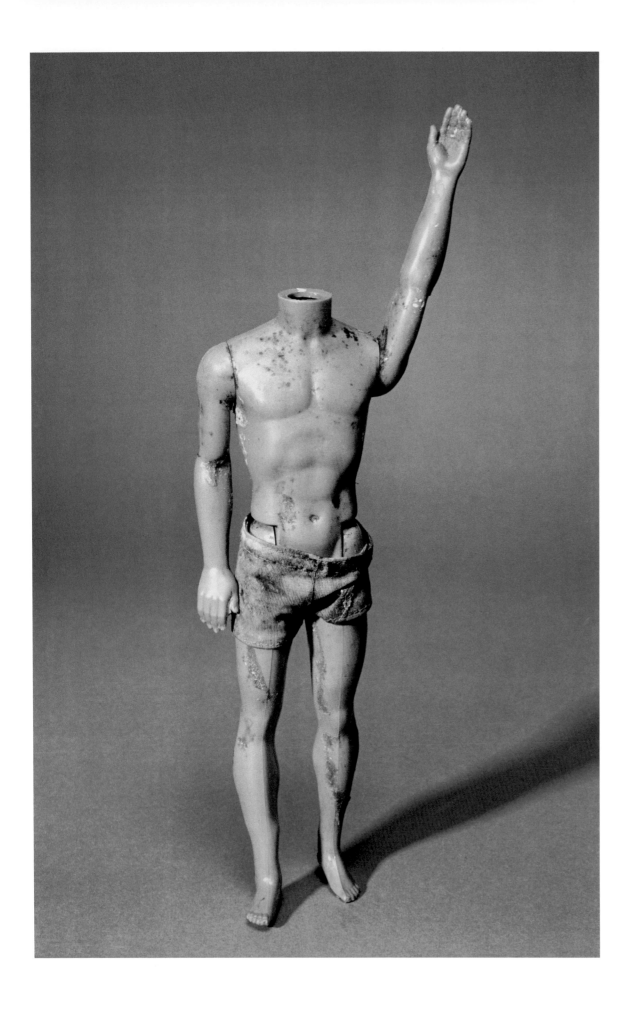

80 Propo Objects (Ken – No Head), 1991

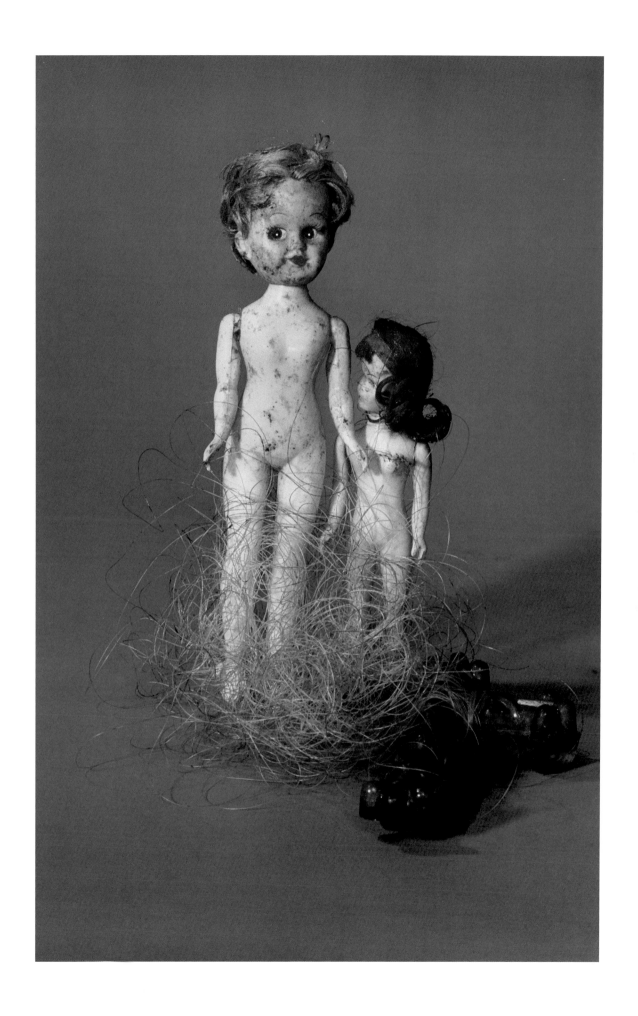

81 Propo Objects (Sisters), 1991

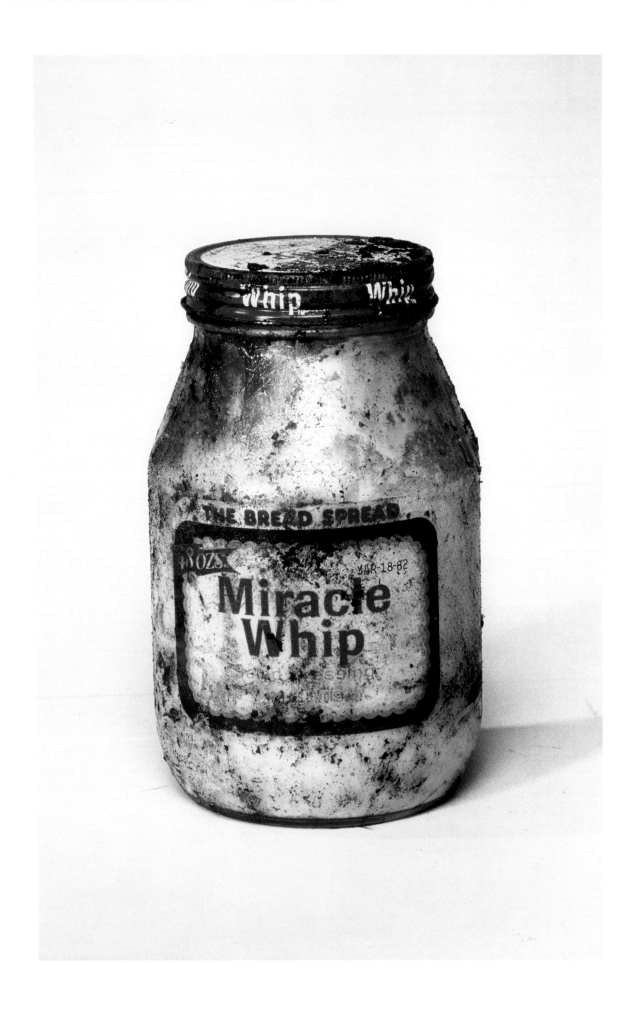

82 Propo Objects (Miracle Whip), 1991

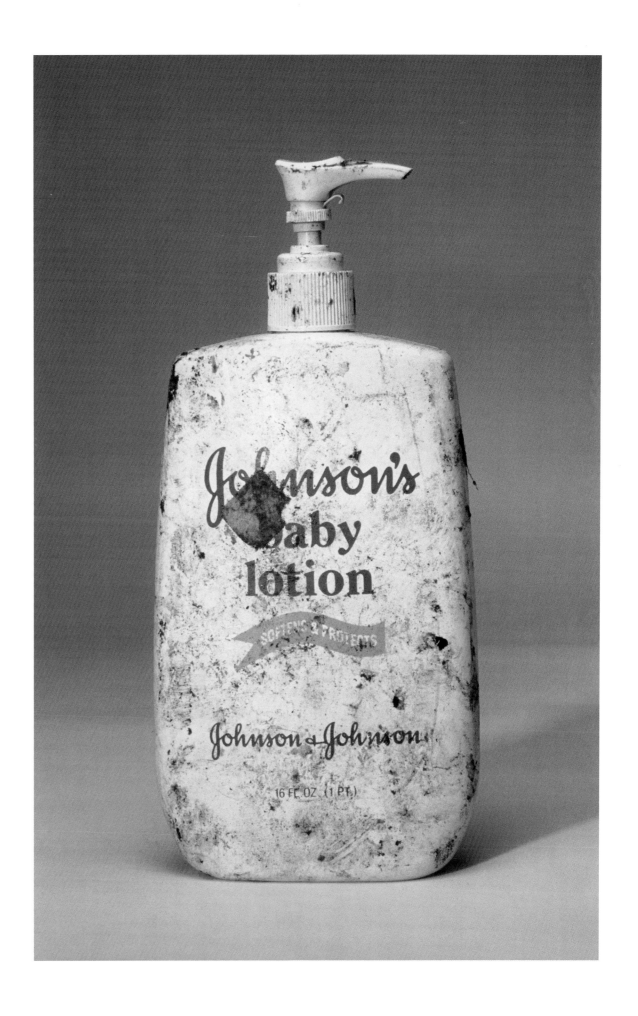

83 Propo Objects (Baby Lotion), 1991

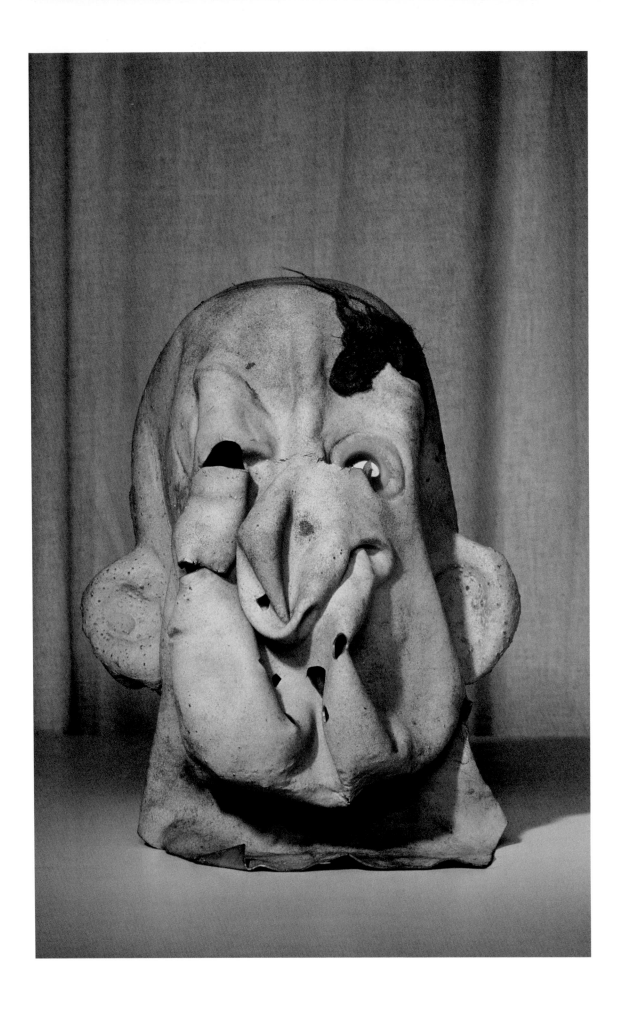

84 Masks (Popeye), 1994

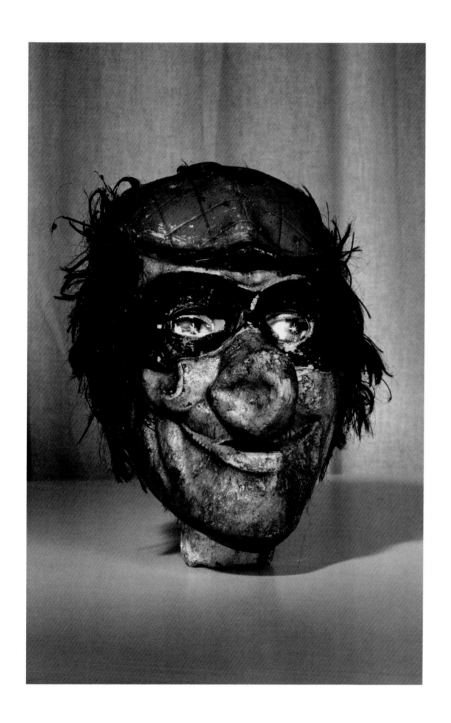

85 Masks (Rocky), 1994

86 Masks (Pig Mask), 1994

87 Masks (Arafat), 1994

88 Masks (Monkey Man), 1994

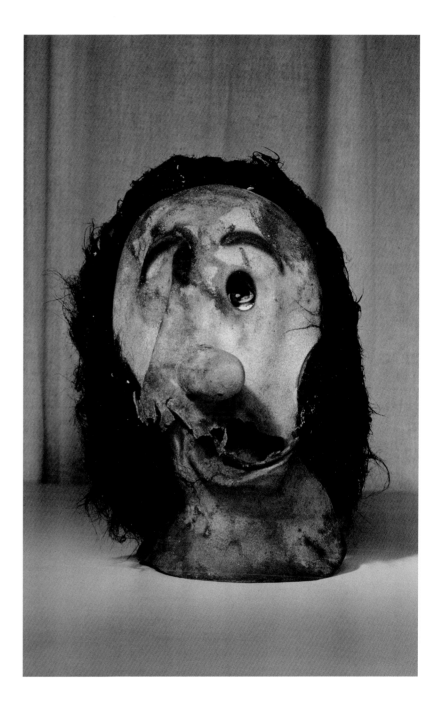

89 Masks (Monkey Man Inside Out), 1994

90 Masks (Olive Oil), 1994

Mariko Mori

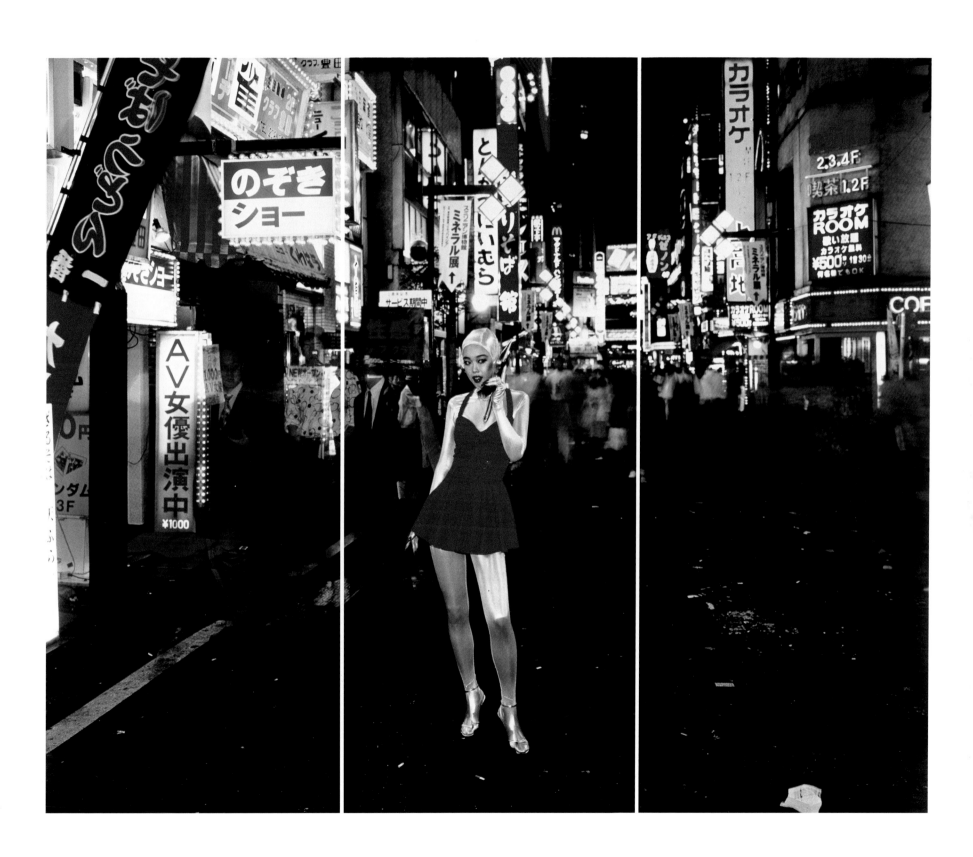

91 Red Light, 1994

Jack Pierson

Richard Prince

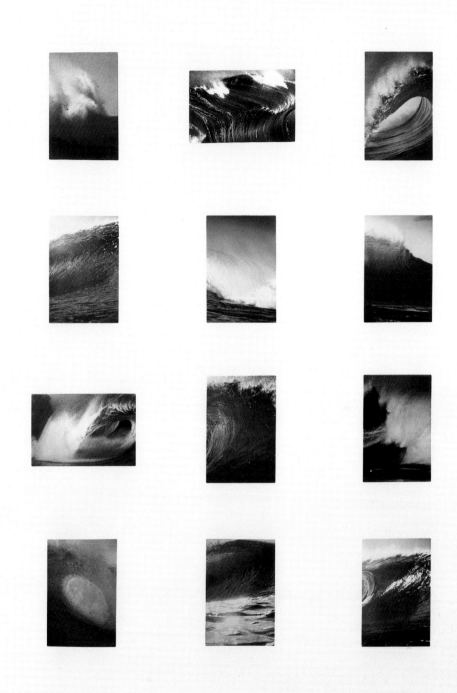

94 Real Big Surf, 1984/85

I never had a penny to my nam

o I changed my name.

Male Patient to Lady Psychiatrist: "I had a dream about you last nite." "Did you?" asked the Lady Doc. "No you wouldn't let me."

97 Untitled ("Are you Linda?"), 1993–1995

99 Limp, 1999

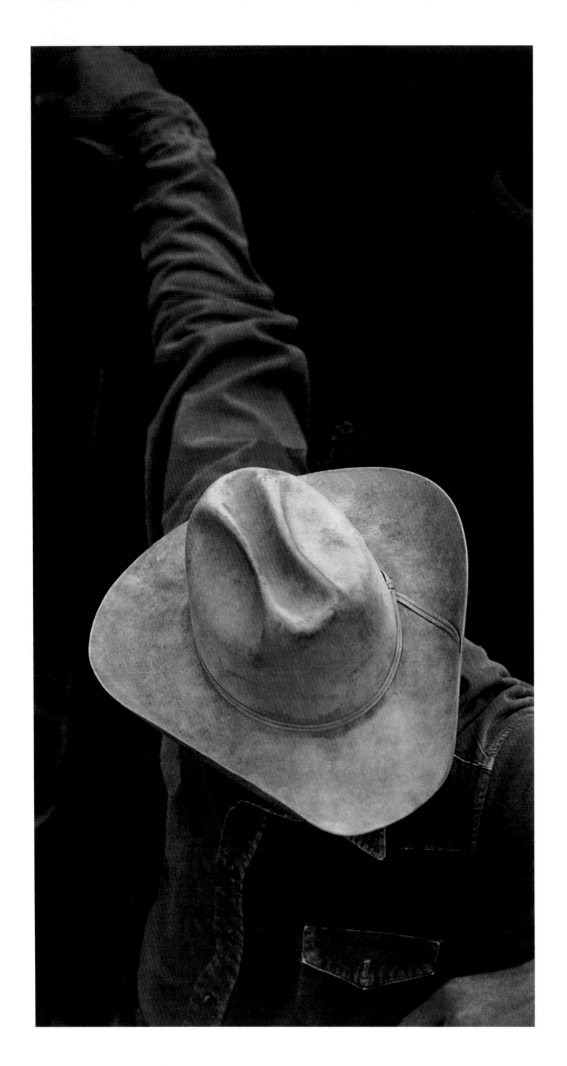

100 Untitled (Cowboy), 1999

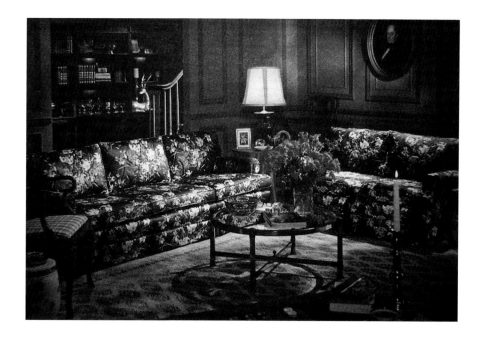
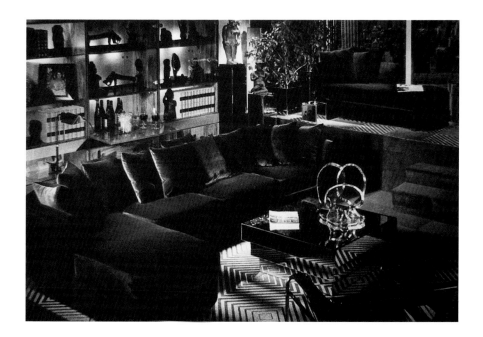
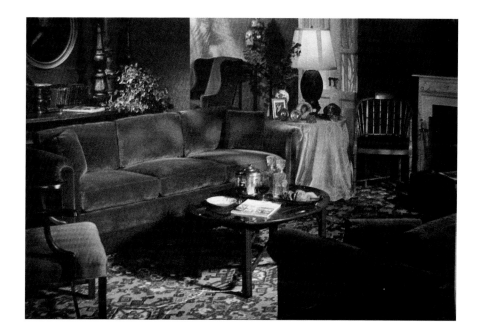

Ugo Rondione

102 No. 69, 1996

Fünfzehnteroktoberneunzehnhundertachtundneunzig, No. 114, 1999

Thomas Ruff

17H 38 M -30 Degrees, 1990

David Salle

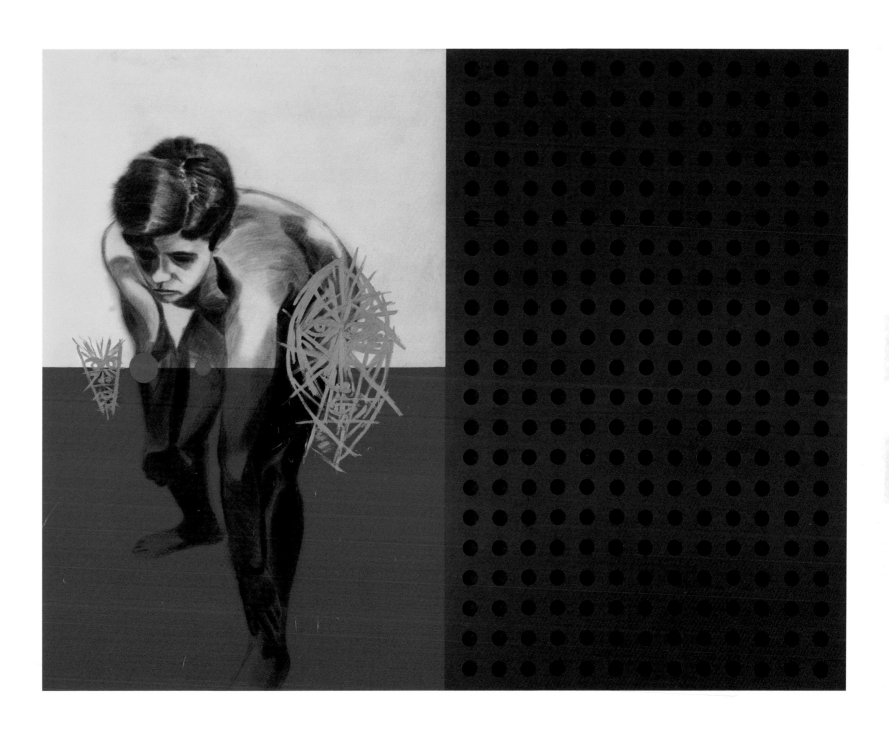

109 To Count Steps With, 1982

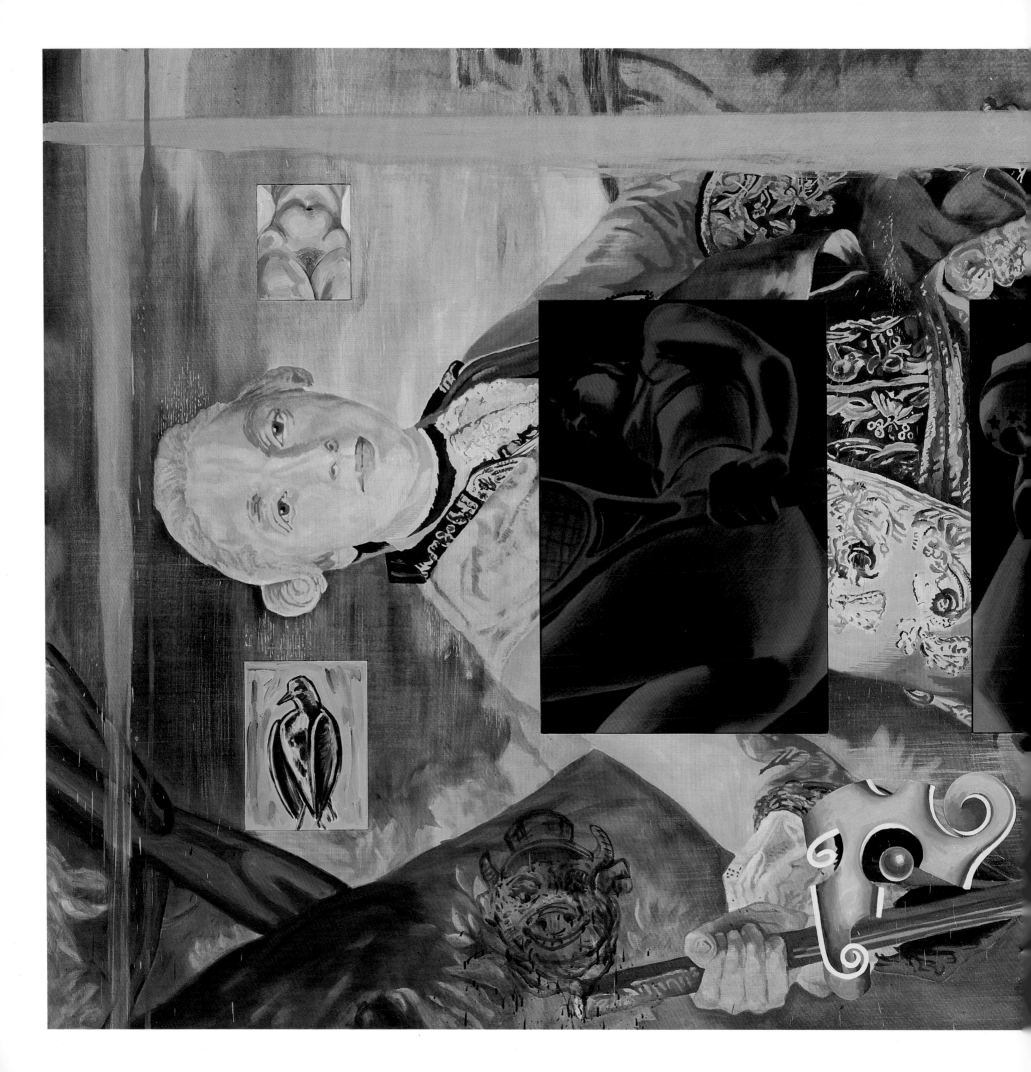

110 Lampwick's Dilemma, 1989

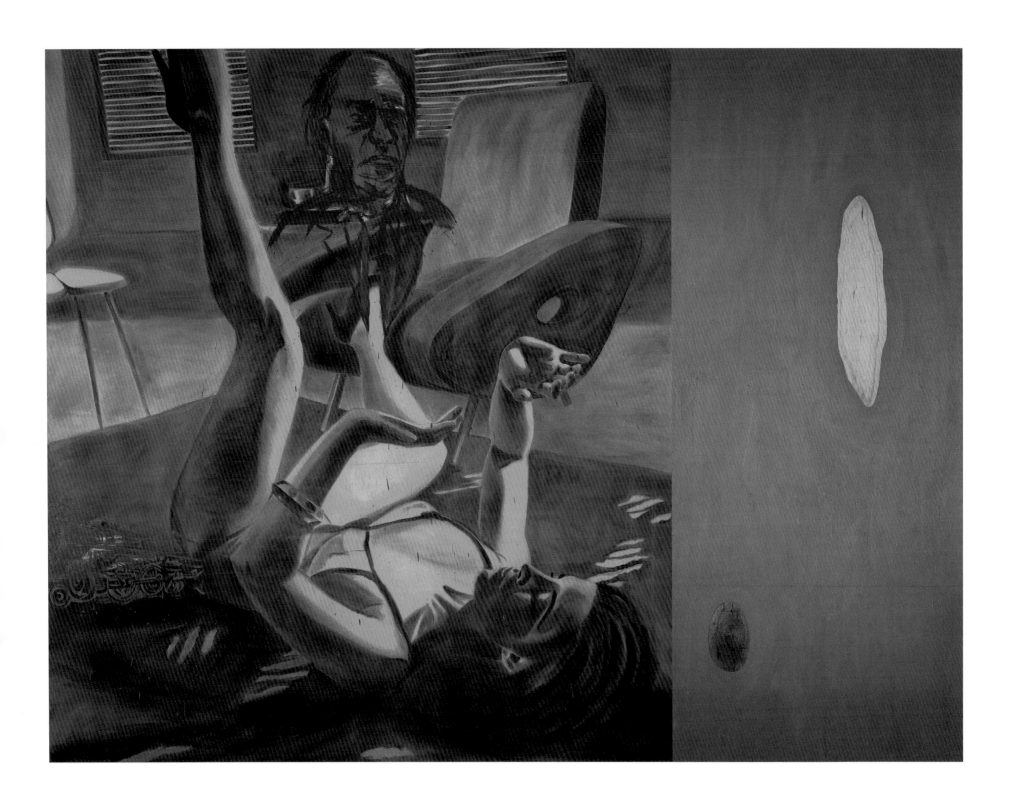

111 Midday, 1984

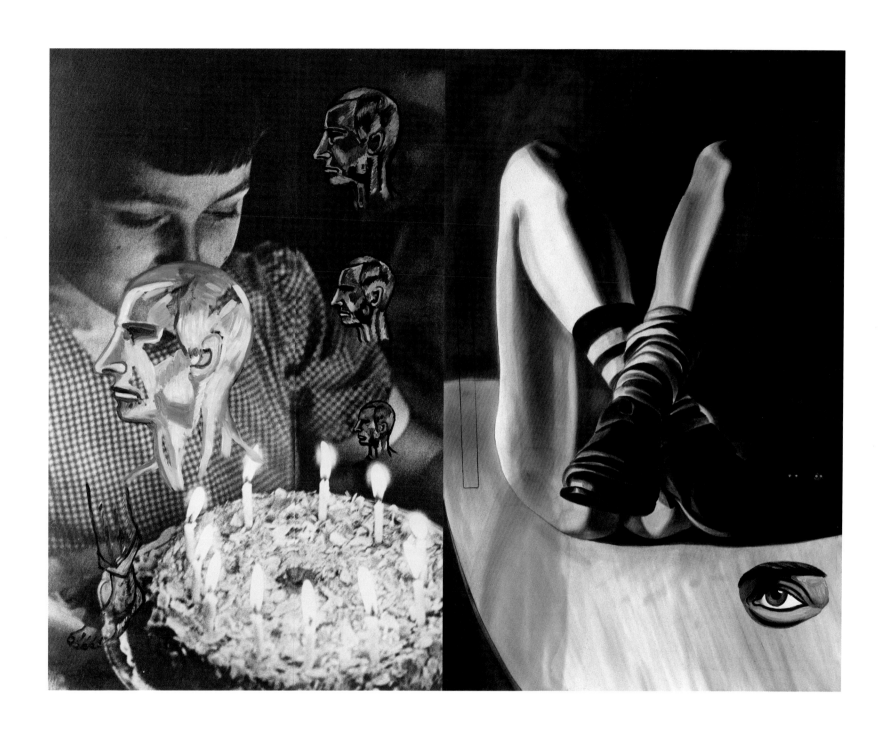

112 Birthday Cake with One Eye, 1986

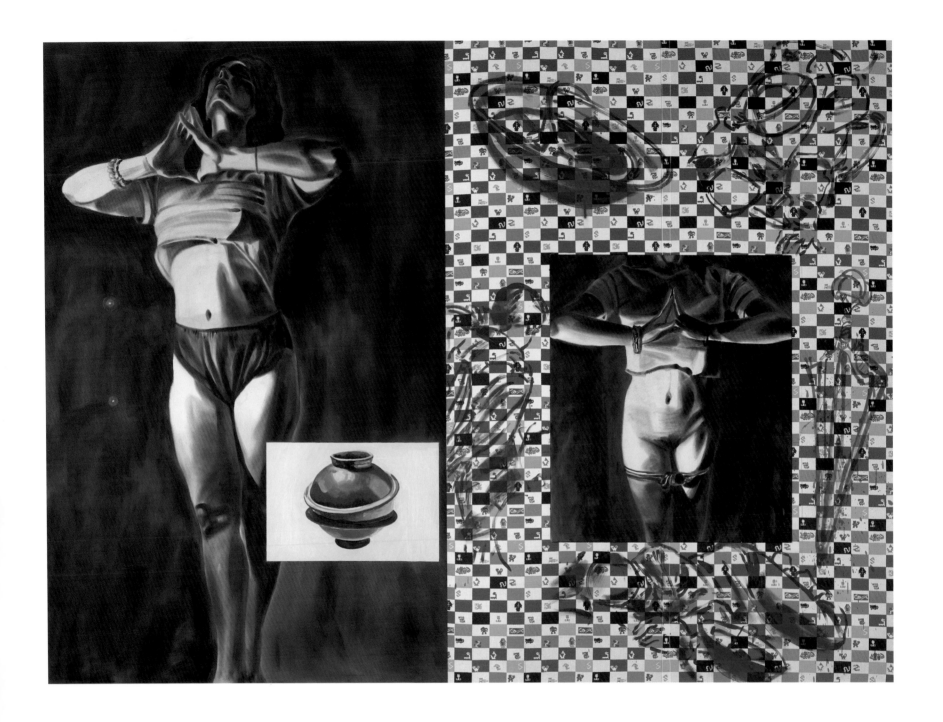

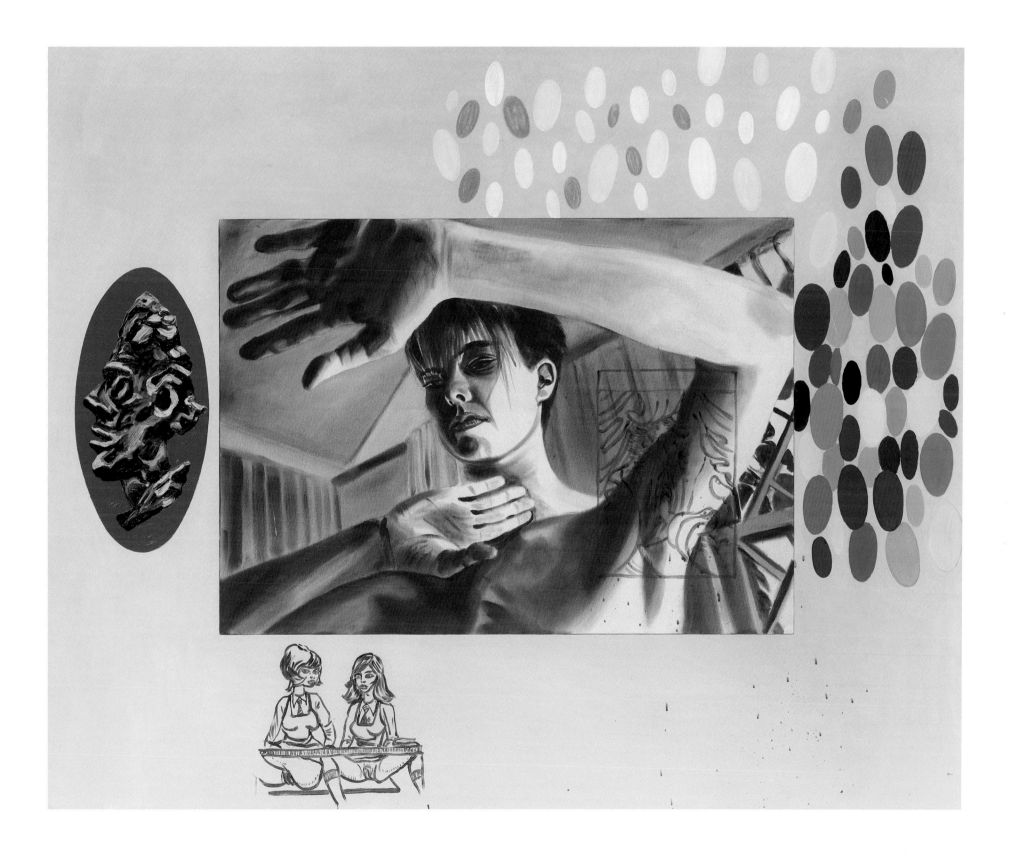

114 Reliance, 1985

115 A Double Life, 1993

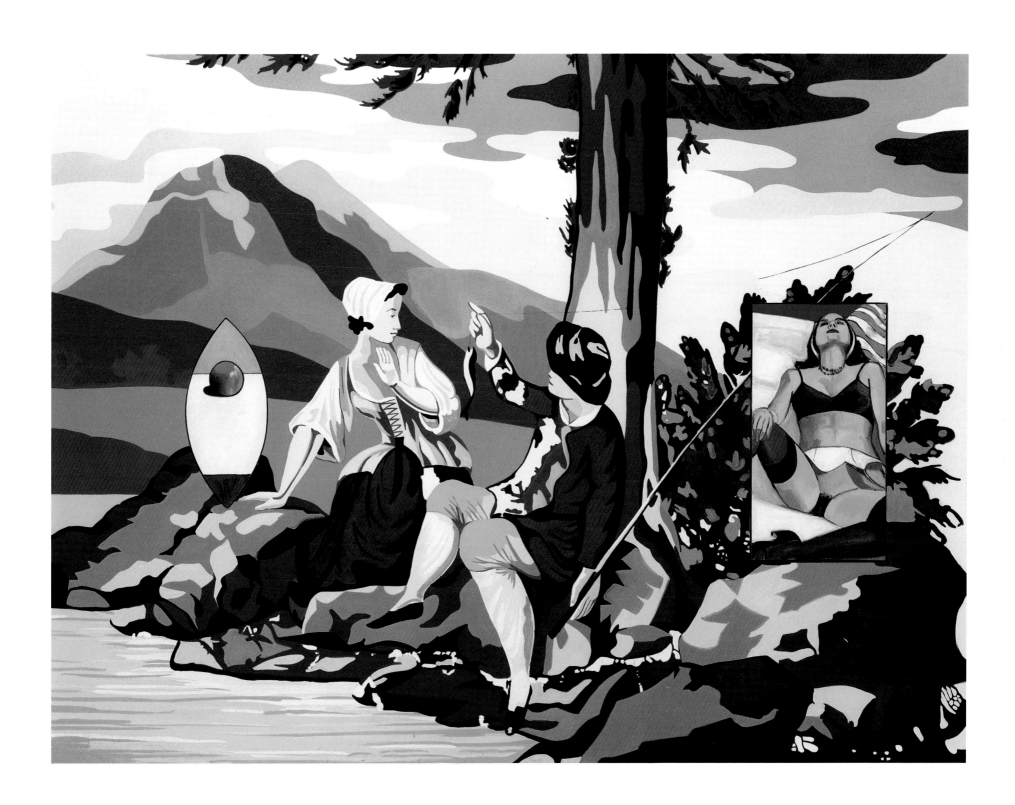

116 Pastoral with nude, 1999

Cindy Sherman

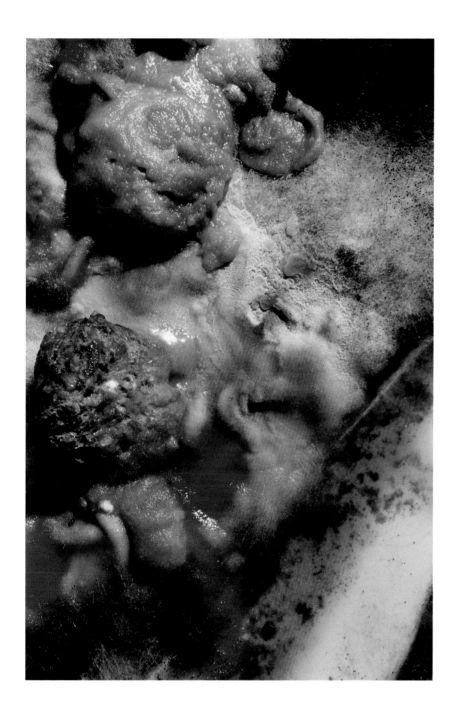

117 Untitled #234, 1987-1991

118 Untitled #235, 1987-1991

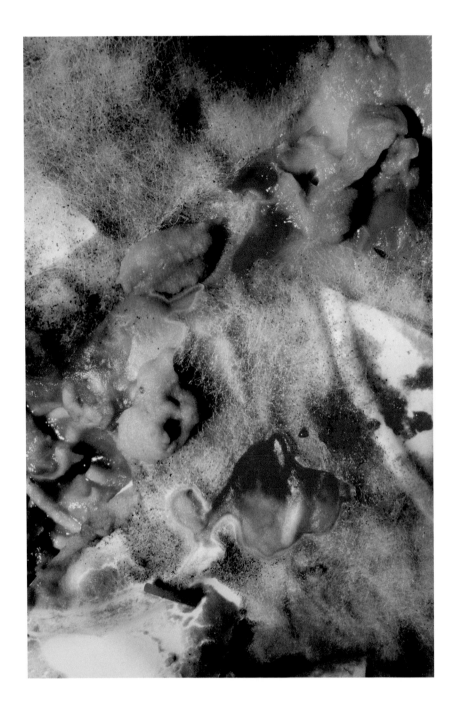

119 Untitled #236, 1987-1991 120 Untitled #237, 1987-1991 160

121 Untitled #238, 1987-1991

122 Untitled #239, 1987-1991

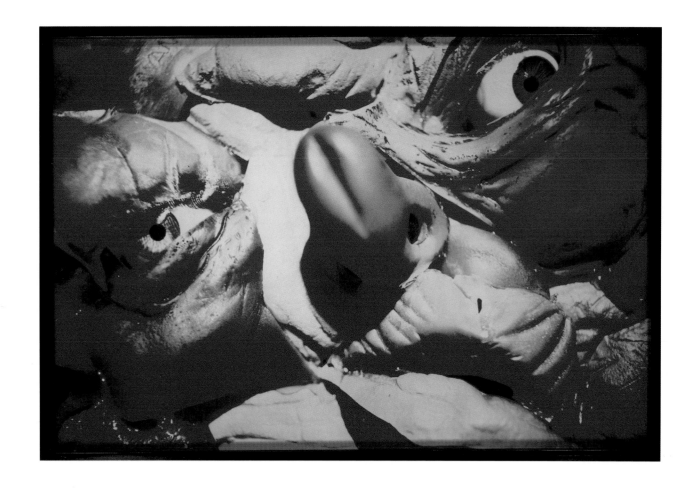

123 Untitled #314a, 1994

124 Untitled #314b, 1994

125 Untitled #314c, 1994

126 Untitled #314d, 1994

127 Untitled #314e, 1994

128 Untitled #314f, 1994

Thomas Struth

129 Huanghe Lu, Shanghai, 1997

130 Paradies 2 (Pilgrim Sands), 1998

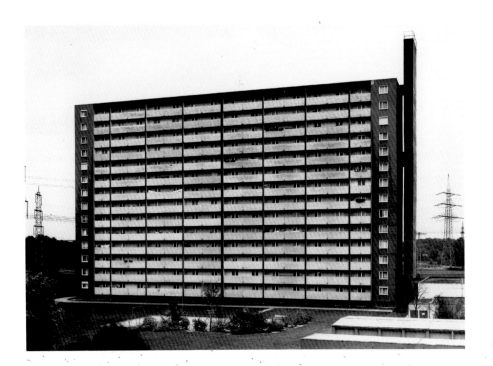

131 Okerstraße, Leverkusen, 1980

132 Am Kreuzacker, Duisburg, 1986

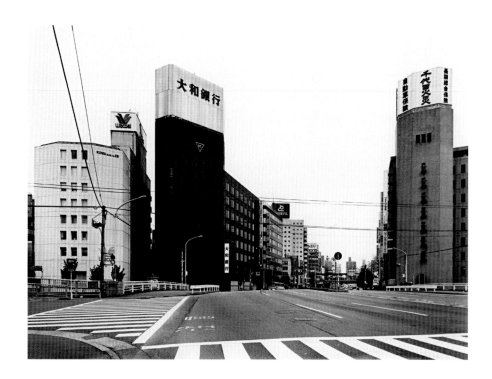

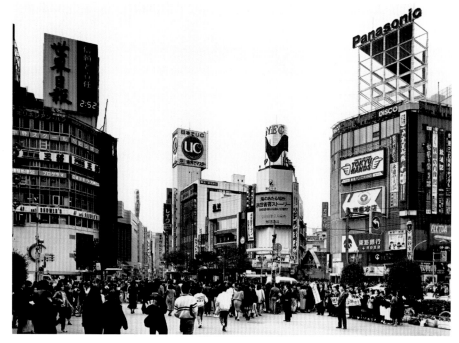

133 Gotanda (BIC-Lighters), Tokyo, 1987 134 Shibuya-ku Station, Tokyo, 1987

135 Via Giovanni a Mare, 1988 136 Via Monte Cardonet, Rome, 1988

137 Via Guglielmo, Rome, 1988

138 Via Guglielmo, Rome, 1988

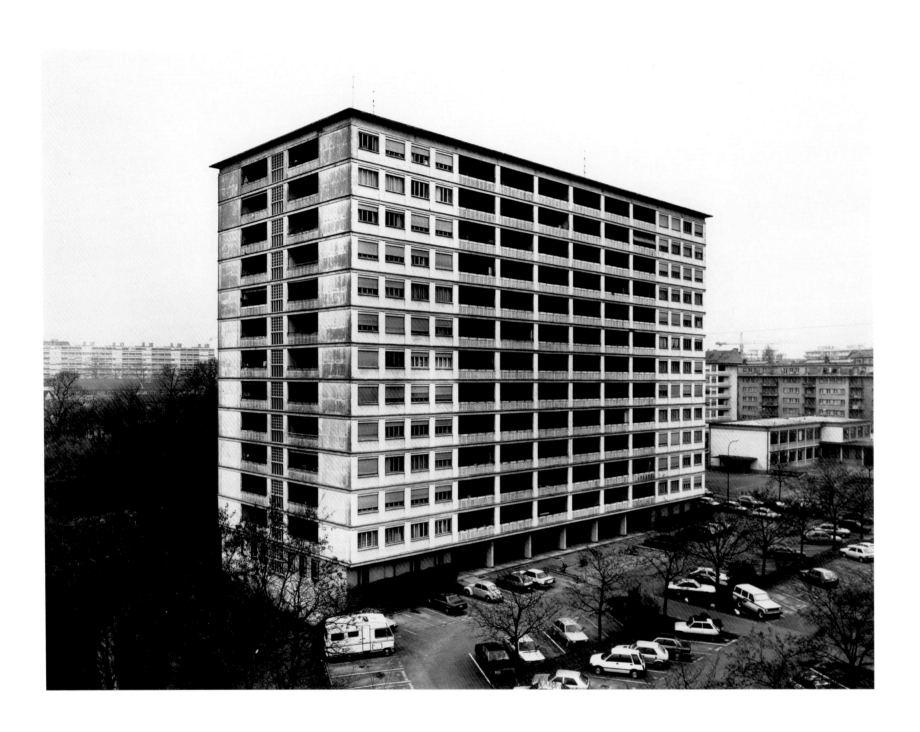

139 Avenue du Devin du Village, Geneva, 1989

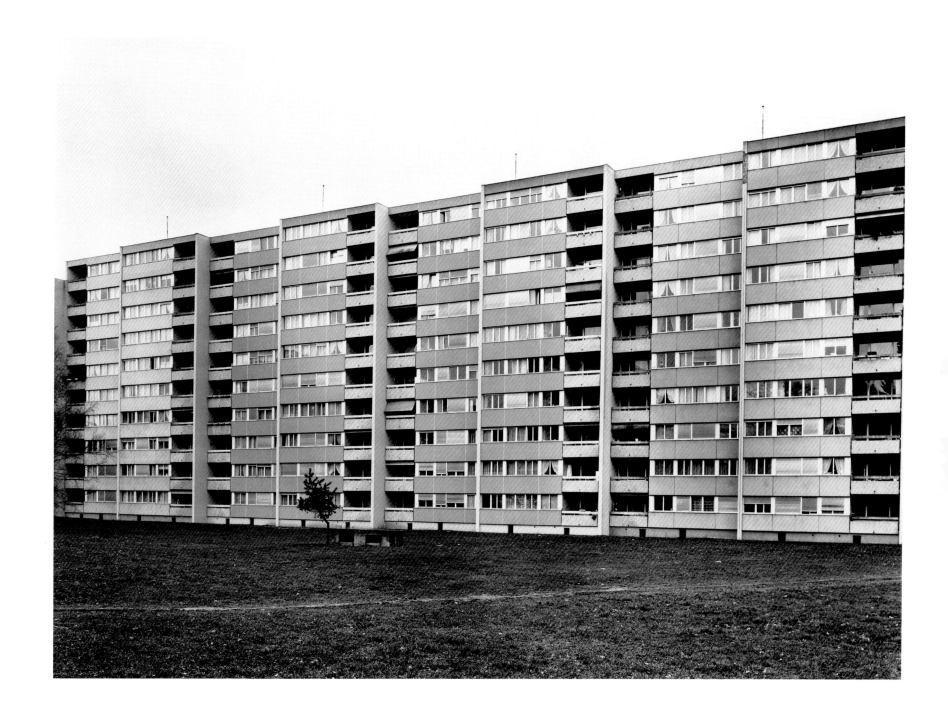

175 **140** Chemin des Coudriers, Geneva, 1989

Rosemarie Trockel

141 Untitled (Brown Wool Seal), 1986

143 Untitled, 1982

144 Untitled (After Toroni), 1988

145 Trophäe der Sehnsucht, 1984

146 Balaclavas , 1986

147 Gewohnheitstier 2, 1990

148 Gewohnheitstier 6, 1996

149 Untitled (Homage to Bridget Riley), 1990

150 Untitled, 1992

Franz West

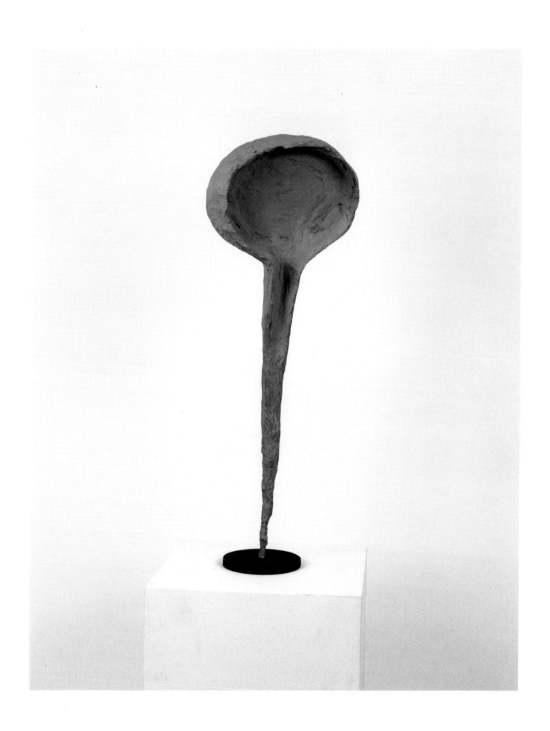

151 Ohne Titel, 1984

153 Passstück, 1977- 1980

154 Das Rohe und das Gekochte, 1982/83

Christopher Wool

RUN DOG RUN DOG RUN

155 Untitled, 1990

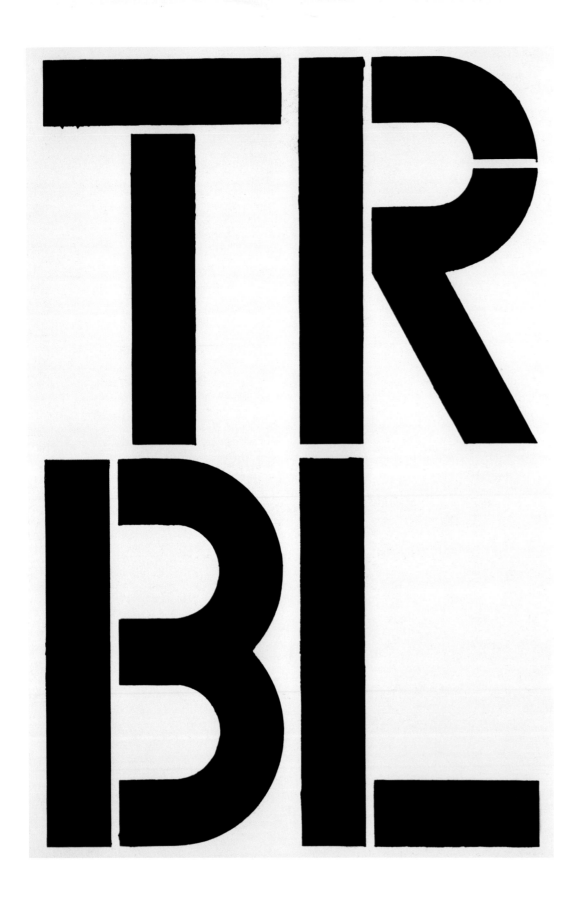

157 Untitled, 1990

158 Untitled, 1993

159 If It's Going to Be That Kind of Party..., 1999

List of Works

JOHN M ARMLEDER

1 Untitled, 1992
 Mirrored glass, Mosaic on wood
 150 x 300 cm
 p. 27

2 Untitled, 1986
 Acrylic on canvas, 250 x 200 cm
 p. 28

3 Untitled, 1986
 Acrylic on canvas, 250 x 200 cm
 p. 29

4 Liberty Dome VIIa, 1998
 8 domes, mirrored Plexiglas
 each ø 122 cm
 p. 30

5 Untitled, 2001
 20 magnifying glasses, each ø 25.5 cm
 p. 31

6 Untitled, 2001
 10 disco mirror balls, each ø 50 cm,
 pp. 32/33

ROSS BLECKNER

7 Fallen Sky, 1981
 Oil on canvas, 274 x 199 cm
 p. 35

8 Infatuation, 1986/87
 Oil on canvas, 244 x 508 cm
 pp. 36/37

9 The Sixth Examined Life, 1991
 Modelling paste and wax, 244 x 183 cm
 p. 38

10 Blue Net, 1999
 Oil on canvas, 244 x 244 cm
 p. 39

11 Behavior, 1999
 Oil on canvas, 213 x 183 cm
 p. 40

12 Hand to Hand, 2001
 Oil on canvas, 213 x 366 cm
 p. 41

GEORGE CONDO

13 Jimi Hendrix, 1999
 Silkscreen and acrylic on canvas
 152 x 152 cm
 p. 43

14 The Jimi Hendrix Experience, 1999
 Silkscreen on canvas
 152 x 152 cm
 p. 44

15 Charlie Parker, 1999
 Silkscreen on canvas, 152 x 152 cm
 p. 45

16 Jazz at Newport, 1999
 Silkscreen on canvas, 152 x 152 cm
 p. 46

17 Jim Hall, 1999
 Silkscreen on canvas, 52 x 152 cm
 p. 47

18 Miles Davis, 1999
 Silkscreen on canvas, 152 x 152 cm
 p. 48

19 John Coltrane, 1999
 Silkscreen on canvas, 152 x 152 cm
 p. 49

20 Ornette Coleman, 1999
 Silkscreen on canvas, 152 x 152 cm
 p. 50

21 The Beatles, 1999
 Silkscreen on canvas, 152 x 152 cm
 p. 51

22 Wes Montgomery, 1999
 Silkscreen on canvas, 152 x 152 cm
 p. 52

23 Wes Montgomery, 1999
 Acrylic on canvas, 91 x 91 cm
 p. 53

24 John Coltrane, 1999
 Acrylic on canvas, 91 x 91 cm
 p. 53

25 The Beatles, 1999
 Acrylic on canvas, 91 x 91 cm
 p. 53

26 Miles Davis, 1999
 Acrylic on canvas, 91 x 91 cm
 p. 53

27 Ornette Coleman, 1999
 Acrylic on canvas, 91 x 91 cm
 p. 53

28 Jazz at Newport, 1999
 Acrylic on canvas, 91 x 91 cm
 p. 53

29 Jim Hall, 1999
 Acrylic on canvas, 91 x 91 cm
 p. 53

30 The Jimi Hendrix Experience, 1999
 Acrylic on canvas, 91 x 91 cm
 p. 53

31 Charlie Parker, 1999
 Acrylic on canvas, 91 x 91 cm
 p. 53

WIM DELVOYE

32 Marble floor no. 11, 1998
 Cibachrome, 59 x 76 cm
 p. 55

33 Marble floor no. 19, 1998
 Cibachrome, 59 x 76 cm
 p. 56

34 Marble floor no. 23, 1998
 Cibachrome, 59 x 76 cm
 p. 57

FISCHLI/WEISS

35 Pflanze, 1987
 Rubber, height 41 cm
 p. 59

36 Frau, 1986
 Rubber, 43 x 21 x 20 cm
 p. 60

37 Haus, 1986
 Rubber, 12 x 72 x 51 cm
 p. 60

38 Auto, 1986
 Rubber, 20 x 59 x 23 cm
 p. 60

39 Vase, 1986
 Rubber, height 37 cm, Ø 21 cm
 p. 61

40 Krähe, 1986
 Rubber, 27 x 41 x 14 cm
 p. 61

41 Marokkanisches Sitzkissen, 1986/87
 Rubber, height 28 cm, Ø 56 cm
 p. 61

Biographies

JOHN M ARMLEDER

1948 born in Geneva; lives and works in Geneva, Switzerland

SELECTED SOLO EXHIBITIONS

1973 Palais de l'Athénée, Geneva, Switzerland

1980 891 und weitere Stücke, Kunstmuseum Basel, Basle, Switzerland

1982 Nylistasafnik, The Living Arts Museum, Reykjavik, Iceland

1983 Le Coin du Miroir, Le Consortium, Dijon, France

1986 Musée d'Art et d'Histoire, Geneva, Switzerland

1987 Musée d'Art Moderne de la Ville de Paris, France
 Kunstverein für die Rheinlande und Westfalen, Düsseldorf, Germany

1989 Le Consortium, Dijon, France

1991 Castello di Rivara, Torino, Italy

1993 Wiener Secession, Vienna, Austria

1998 Peintures Murales 1967–1998, Casino Luxembourg, Luxembourg
 at any speed, Staatliche Kunsthalle Baden-Baden, Germany

1999 Artspace, Auckland, New Zealand

2000 Projects 72, The Museum of Modern Art, New York (NY), USA
 John Armleder & Sylvie Fleury, Kunstmuseum, St. Gallen, Switzerland

2001 Peinture Murale, Le Magasin – Centre National d'Art Contemporain de Grenoble, France
 Enter at your own Risk II, Kunstraum, Innsbruck, Austria

SELECTED GROUP EXHIBITIONS

1973 8e Biennale des jeunes, Musée d'art Moderne de la Ville de Paris, France

1983 Alles und noch viel mehr, Kunstmuseum and Kunsthalle Bern, Berne, Switzerland
 XVII Bienal Internacional de São Paulo, Brazil

1986 42. Biennale di Venezia, Swiss Pavilion, Venice, Italy
 6th Biennale of Sydney, Australia

1987 documenta 8, Kassel, Germany

1990 44. Biennale di Venezia, Venice, Italy

1991 Objects for the Ideal Home – The Legacy of Pop Art, Serpentine Gallery, London, UK
 Metropolis, Martin-Gropius-Bau, Berlin, Germany

1993 Post Human, Deichtorhallen, Hamburg, Germany

1994 Ready Made Identities, The Museum of Modern Art, New York (NY), USA
 3e Biennale de Lyon, France

1996 Péchés Capitaux, Centre Georges Pompidou, Paris, France

1997 Don't do it!, Musée d'Art Moderne et Contemporain, Geneva, Switzerland

1998 Freie Sicht aufs Mittelmeer, Kunsthaus Zürich, Zurich, Switzerland
 fast forward, Kunstverein in Hamburg, Germany

1999 Avant Garde Robe / Addressing the Century / 100 Years of Art and Fashion, Kunstmuseum Wolfsburg, Germany and Hayward Gallery, London, UK

2000 Ich ist etwas Anderes – Kunst am Ende des 20. Jahrhunderts, Kunstsammlung Nordrhein-Westfalen, Düsseldorf, Germany

2001 Ornament und Abstraktion, Fondation Beyeler, Basle, Switzerland
 Art/Music: Rock, Pop, Punk, Techno, Museum of Contemporary Art, Sydney, Australia

2002 Malerei ohne Malerei, Museum der bildenden Künste, Leipzig, Germany
 Iconoclash, ZKM Zentrum für Kunst und Medientechnologie, Karlsruhe, Germany
 Painting on the Move, Museum für Gegenwartskunst and Kunsthalle Basel, Basle, Germany

SELECTED BIBLIOGRAPHY

1990 John M Armleder, Furniture Sculpture 1980–1990, Musée Rath, Geneva, France

1992 John M Armleder – Pour Paintings 1982–1992. Utrecht Centraal Museum, Utrecht, The Netherlands

1994 John M Armleder, Milan, Italy

1998 John M Armleder – Complete Writings & Interviews, Le Consortium, Dijon, France

1999 John M Armleder – at any speed. Ostfildern, Germany

1987 Collected Interviews with John M Armleder, Dijon/Geneva, France/Switzerland

2002 John M Armleder, Wallpaintings & Wallpieces, catalogue raisonné des peintures murales et autres pièces murales, Le Magasin – Centre National d'Art Contemporain de Grenoble, France

ROSS BLECKNER

1949 born in New York; lives and works in New York (NY), USA

SELECTED SOLO EXHIBITIONS

1988 San Francisco Museum of Modern Art, San Francisco (CA), USA

1987 Milwaukee Art Museum, Milwaukee (WI), USA
 Contemporary Arts Museum, Houston (TX), USA
 Carnegie Museum of Art, Pittsburgh (PA), USA

1990 Art Gallery of Ontario, Toronto, Canada
 Kunsthalle Zürich, Zurich, Switzerland

1991 Kölnischer Kunstverein, Cologne, Germany
 Moderna Museet, Stockholm, Sweden

1995 Solomon R. Guggenheim Museum, New York, (NY), USA
 Astrup Fearnley Museet for Moderne Kunst, Oslo, Norway
 IVAM Centre Julio González, Valencia, Spain

1997 Bawag Foundation, Vienna, Austria

SELECTED GROUP EXHIBITIONS

1979 New Painting/New York, Hayward Gallery, London, UK

1981 New York in Black and White, The Museum of Modern Art, New York (NY), USA

1984 The Meditative Surface, The Renaissance Society, Chicago (IL), USA

1985 Currents, Institute of Contemporary Art, Boston (MA), USA

1987 Whitney Biennial, Whitney Museum of American Art, New York (NY), USA

1988 7th Biennial of Sydney, Australia
 BiNATIONALE: Deutsche/Amerikanische Kunst der 80er Jahre, Kunsthalle, Kunstsammlung Nordrhein-Westfalen, Kunstverein für die Rheinlande und Westfalen, Düsseldorf, Germany
 The Image of Abstraction, The Museum of Contemporary Art, Los Angeles (CA), USA
 Art at the End of the Social, Rooseum – Center for Contemporary Art, Malmö, Sweden
 Carnegie International, Carnegie Museum of Art, Pittsburgh (PA), USA

1989 Whitney Biennial, Whitney Museum of American Art, New York (NY), USA

1991 Mito y Magia en America: Los Ochenta, Museo de Arte Contemporáneo de Monterrey, Mexico

Metropolis, Martin-Gropius-Bau, Berlin, Germany

1992 Slow Art: Painting in New York Now, P.S.1, Long Island City (NY), USA

1995 Passions Privées, Musee d'Art Moderne de la Ville de Paris, France

1996 Nuevas Abstracciones, Museo Nacional Centro de Arte Reina Sofía, Madrid, Spain

1997 Birth of the Cool – American Painting from Georgia O'Keeffe to Christopher Wool, Deichtorhallen, Hamburg, Germany and Kunsthaus Zürich, Zurich, Switzerland

1999 The American Century: Art and Culture 1950–2000, Whitney Museum of American Art, New York (NY), USA

2000 In the Power of Painting, Moderna Museet, Stockholm, Sweden
On Canvas: Contemporary Painting, Solomon R. Guggenheim Museum, New York (NY), USA

2001 Mythic Proportions: Painting in the 1980s, Museum of Contemporary Art, Miami (FL), USA

SELECTED BIOGRAPHY

1989 Ross Bleckner, Milwaukee Art Museum, Milwaukee (WI), USA

1990 Ross Bleckner, Kunsthalle Zürich, Zurich, Switzerland

1997 Ross Bleckner, Bawag Foundation, Vienna, Austria

1998 Ross Bleckner – Watercolor, Santa Fe (NM), USA

1999 Art at the Turn of the Millennium, Cologne, Germany

GEORGE CONDO

1957 born in Concord, (NH), lives and works in New York (NY), USA

SELECTED SOLO EXHIBITIONS

1987 George Condo: Gemälde/Paintings 1984–1987, Kunstverein München, Munich, Germany

1994 Contemporary Arts Museum, Houston (TX), USA
Palais des Congrès, Paris, France

SELECTED GROUP EXHIBITIONS

1983 Terminal Show, Artists' Library, Brooklyn (NY); USA

1985 Künstliche Paradiese, Museum Folkwang, Essen, Germany; Kunstverein München, Munich, Germany; Bonnefantenmuseum, Maastricht, The Netherlands Steirischer Herbst, Graz, Austria

1986 Terrae Motus 3, Villa Campolito, Ercolano, Italy

1987 Whitney Biennial, Whitney Museum of American Art, New York (NY), USA

Amerikanische Künstler des 20. Jahrhunderts in Deutschland, Kunstverein München, Munich, Germany

1988 Recent Drawings: George Condo, Mike Kelley, Ellan Phalan, Janis Provisor, Whitney Museum of American Art, New York (NY), USA

1989 Triennal de Dibuix – Joan Miró, Fundació Joan Miró, Barcelona, Spain
Bilderstreit: Widerspruch, Einheit und Fragment in der Kunst seit 1960, Rheinhallen, Cologne Fair Grounds, Cologne, Germany
Painting Beyond the Death of Painting, Koznetzky Most Exhibition Hall, Moscow, Russia
Drawings of the Eighties, The Museum of Modern Art, New York (NY), USA

1991 Myth & Magic in the Americas: The Eighties, Museo de Arte Contemporáneo de Monterrey, Mexico
Das Goldener Zeitalter, Württembergischer, Kunstverein, Stuttgart, Germany

1992 Allegories of Modernism: Contemporary Drawing, The Museum of Modern Art, New York (NY), USA
Le Portrait dans l'Art Contemporain, Musee d'Art Moderne et d'Art Contemporain, Nice, France

1993 Salon de los 16, Palacio de Velázquez, Madrid, Spain

1994 Modern Drawings II, The Museum of Modern Art, New York (NY), USA
U.S. Painting in the 1980's, Irish Museum of Modern Art, Dublin, Ireland

1995 Collection in Context: Picassoid, Whitney Museum of American Art, New York (NY), USA

1997 Premier MARCO 1996, Museo de Arte Contemporáneo de Monterrey, Mexico

1999 Bad Bad – That is a good excuse, Staaliche Kunsthalle Baden-Baden, Germany

SELECTED BIBLIOGRAPHY

1987 George Condo – Gemälde/Paintings 1984–1987, Kunstverein München, Munich, Germany

1995 George Condo – Paintings and Drawings, New York (NY), USA

1998 George Condo – Collage Paintings, New York (NY), USA

1999 George Condo Portraits Lost in Space, Minneapolis (MN), USA

2002 Imaginary Portraits of George Condo, New York (NY), USA

WIM DELVOYE

1965 born in Wervik, Belgium; lives and works in Ghent, Belgium and New York (NY), USA

SELECTED SOLO EXHIBITIONS

1991 Art Gallery of New South Wales, Sydney, Australia
Castello di Rivoli, Torino, Italy

1992 Kunsthalle Nürnberg, Nuremberg, Germany

1994 Center for the Arts, San Francisco (CA), USA
Modulo, Centro diffusor de Arte, Lisbon, Portugal

1995 Musée Départemental de Rochechouart, Limoges, France

1997 Open Air Museum Middelheim, Antwerp, Belgium
Delfina, London, UK

1999 Fonds Régional d'Art Contemporain des Pays de la Loire, Nantes, France

2000 Cement Truck, Centre Georges Pompidou, Paris, France
CLOACA, MuHKA, Antwerp, Belgium

2001 CLOACA – New and Improved, Migros Museum für Gegenwartskunst, Zurich, Switzerland

2002 CLOACA, Museum Kunst Palast, Düsseldorf, Germany
CLOACA – New and Improved, New Museum of Contemporary Art, New York (NY), USA

SELECTED GROUP EXHIBITIONS

1988 Confrontatie & Confrontaties Museum van Hedendaagse Kunst, Ghent, Belgium

1990 Aperto, 43. Biennale di Venezia, Venice, Italy

1991 Kunst, Europa, Belgien, Niederlande, Luxembourg, Kunstverein für die Rheinlande und Westfalen, Düsseldorf, Germany

1992 documenta IX, Kassel, Germany
9th Biennial of Sydney, Australia

1993 Post Human, Deichtorhallen, Hamburg, Germany

1994 Cocido y Crudo, Museo Nacional Centro Reina Sofía, Madrid, Spain

1995 ARS 95, Nykytaiteen Museo, Museum of Contemporary Art, Helsinki, Finland

1996 Under Capricorn (Art in the Age of Globalisation), Stedelijk Museum, Amsterdam and City Gallery, Wellington, New Zealand

1997 Kwangju Biennale, Kwangju, South Korea

1998 Patchwork in progress 3, Musée d'Art Moderne et Contemporain, Geneva, Switzerland
Baroque, Slovak National Gallery, Bratislava, Slovakia

1999 La Consolation, Le Magasin – Centre National d'Art Contemporain de Grenoble, France
48. Biennale di Venezia, Venice, Italy
Zeitwenden, Kunstmuseum Bonn, Germany

Dehors – dedans, capcMusée d'Art Contemporain, Bordeaux, France

2000 Over the Edges, Stedelijk Museum voor Actuele Kunst, Ghent, Belgium
5e Biennale de Lyon, France

2001 Give & Take, Victoria & Albert Museum, London, UK
Eine Barocke Party, Kunsthalle Wien, Vienna, Austria
Irony, Fondació Joan Miró, Barcelona, Spain
Sonsbeek 9 – LocusFocus, Arnhem, The Netherlands
Un art populaire, Fondation Cartier pour l'Art Contemporain, Paris, France
Marking the Territory, Irish Museum of Modern Art, Dublin, Ireland
Sense of Wonder, Herzliya Museum of Art, Herzliya, Israel

2002 Melodrama, Atrium-Centro-Museo Vasco de Arte Contemporáneo, Vitoria-Gasteiz, Spain

SELECTED BIOGRAPHY

1992 Wim Delvoye – Fünf Arbeiten, Kunsthalle Nürnberg, Nuremberg, Germany

1996 Wim Delvoye – Volume 1, Ghent, Belgium

1997 Wim Delvoye, Open Air Museum Middelheim, Antwerp, Belgium

2000 Wim Delvoye – Cloaca, Ghent/Amsterdam, Belgium/The Netherlands

PETER FISCHLI/DAVID WEISS

PETER FISCHLI
1952 born in Zurich; lives and works in Zurich, Switzerland
DAVID WEISS
1946 born in Zurich; lives and works in Zurich, Switzerland

work together since 1979

SELECTED SOLO EXHIBITIONS

1985 Kunsthalle Basel, Basle, Switzerland
Kölnischer Kunstverein, Cologne, Germany

1987 The Renaissance Society, Chicago (IL), USA
The Museum of Contemporary Art, Los Angeles (CA), USA

1988 Institute of Contemporary Arts, London, UK
Centre d'Art Contemporain, Geneva, Switzerland
Portikus, Frankfurt am Main, Germany

1990 IVAM Centre del Carme, Valencia, Spain
Kunstverein München, Munich, Germany

1991 Kunstverein für die Rheinlande und Westfalen, Düsseldorf, Germany
Wiener Secession, Vienna, Austria

1992 Centre Georges Pompidou, Paris, France

1996 Walker Art Center, Minneapolis (MN), USA
Serpentine Gallery, London, UK
Arbeiten im Dunkeln, Kunsthaus Zürich, Zurich, Switzerland

1997 Institut of Contemporary Art, Philadelphia (PA), USA
San Francisco Museum of Modern Art, San Francisco (CA), USA

1998 Kunstmuseum Wolfsburg, Germany

1999 Musée d'Art Moderne de la Ville de Paris, France

2000 Sichtbare Welt, Plötzlich diese Übersicht, Grosse Fragen-Kleine Fragen, Museum für Gegenwartskunst, Basle, Switzerland
El mondo visible, Museu d'Art Contemporani de Barcelona, Spain

2001 Büsi (Kitty) 2001, Times Square Project, Public Art Fund, New York (NY), USA
Mundo visivel, Museu de Arte Contemporânea Fundação de Serralves, Porto, Portugal

SELECTED GROUP EXHIBITIONS

1984 An International Survey of Recent Painting and Sculpture, New York (NY), USA

1986 Sonsbeek 86, Arnhem, The Netherlands

1987 Skulptur. Projekte in Münster 1987, Münster, Germany
documenta 8, Kassel, Germany
Stiller Nachmittag, Kunsthaus Zürich, Zurich, Germany

1988 Aperto, 43. Biennale di Venezia, Venice, Italy
Carnegie International, Carnegie Museum of Art, Pittsburgh (PA), USA

1989 XIX Bienal Internacional de São Paulo, Brazil

1990 Villa Arson, Nice, France
8th Biennale of Sydney, Australia

1991 Metropolis, Martin-Gropius-Bau, Berlin, Germany

1992 Platzverführung, Stuttgart/Schondorf, Germany
Expo 1992, Swiss Pavilion, Sevilla, Spain

1993 Doubletake, Kunsthalle Wien, Vienna, Austria
Post Human, Deichtorhallen, Hamburg, Germany

1995 Zeichen und Wunder, Kunsthaus Zürich, Zurich, Switzerland
46. Biennale di Venezia, Swiss Pavillon, Venice, Italy

1996 Now Here, Louisiana Museum of Modern Art, Humlebæk, Denmark

1997 Skulptur. Projekte in Münster 1997, Münster, Germany
documenta X, Kassel, Germany

1998 11th Biennale of Sydney, Australia
Freie Sicht aufs Mittelmeer, Kunsthaus Zürich, Zurich, Switzerland

2000 voilà – le monde dans la tête, Musée d'art Moderne de la Ville de Paris, France
Tate Gallery, London, UK

2001 Bildarchive, Kunst-Werke, Berlin, Germany

2002 Wallflowers, Kunsthaus Zürich, Zurich, Switzerland

SELECTED BIBLIOGRAPY

1982 Fischli/Weiss – Plötzlich diese Übersicht, Zurich; Switzerland

1985 Fischli/Weiss – Stiller Nachmittag, Zurich, Switzerland

1988 Fischli/Weiss, Portikus, Frankfurt am Main, Germany

1990 Das Geheimnis der Arbeit – Texte zum Werk von Peter Fischli & David Weiss, München/Düsseldorf, Germany
Fischli/Weiss – Airports, Zurich, Switzerland

1991 Fischli/Weiss. Bilder, Ansichten. Die Sichtbare Welt, Zurich, Switzerland

1992 Peter Fischli David Weiss, Centre Georges Pompidou, Paris, France

1996 Fischli/Weiss – In A Restless World, Walker Art Center Minneapolis (MN), USA

1997 Fischli/Weiss – Arbeiten im Dunkeln, Kunstmuseum Wolfsburg, Germany

1999 Peter Fischli David Weiss, Musée d'Art Moderne de la Ville de Paris, France

2000 Fischli/Weiss – Sichtbare Welt, Cologne, Germany

SYLVIE FLEURY

1961 born in Geneva; lives and works in Geneva, Switzerland

SELECTED SOLO EXHIBITIONS

1992 Centre d'art contemporain, Martigny, Switzerland

1993 The Art of Survival, Neue Galerie am Landesmuseum Joanneum, Graz, Austria

1994 Escape, Le Consortium, Dijon, France

1995 Façade Series, Museum of Contemporary Art, Chicago (IL), USA

1996 First Spaceship on Venus, Musée d'Art Moderne et Contemporain, Geneva, Switzerland

1998 Hot Heels, Migros Museum für Gegenwartskunst, Zurich, Switzerland

1999 Villa Merkel, Esslingen, Germany

2000 John Armleder & Sylvie Fleury, Kunstmuseum St. Gallen, Switzerland

2001 Museum für neue Kunst, ZKM Zentrum für Kunst und Medientechnologie, Karlsruhe, Germany

SELECTED GROUP EXHIBITIONS

1991 No Man's Time, Villa Arson, Nice, France

1992 7 Rooms / Shows, P.S.1, Long Island City (NY), USA

1993 Aperto, 45. Biennale di Venezia, Venice, Italy
Post Human, Deichtorhallen, Hamburg, Germany

1994 Cocido y Crudo, Museo Nacional Centro de Arte Reina Sofía, Madrid, Spain

1995 Exotic Erotic, Ursula Blickle Stiftung, Kraichtal, Germany

Fémininmasculin: le sexe de l'art, Centre Georges Pompidou, Paris, France

1996 Love Hotel, Australian Center for Contemporary Art, Melbourne, Australia

Some Kind of Heaven, Kunsthalle Nürnberg, Nuremberg, Germany

1998 fast forward, Kunstverein in Hamburg, Germany

XXIV Bienal Internacional de São Paulo, Brazil

1999 oh cet écho! (duchampiana), USA, Musée d'Art Moderne et Contemporain, Geneva, Switzerland

Heaven, Kunsthalle Düsseldorf, Germany

2000 What if, Moderna Museet, Stockholm, Sweden

Présumé Innocent, capcMusée d'Art Contemporain, Bordeaux, France

Kwangju Biennale, Kwangju, South Korea

2001 Sonje Art Centre, Seoul South Korea

Art > Music. Rock Pop Punk Techno, Museum of Contemporary Art, Sydney

SELECTED BIBLIOGRAPHY

1998 Sylvie Fleury – First Spaceship On Venus And Other Vehicles, XXIV Bienal Internacional de São Paulo

1999 Sylvie Fleury – Close Encounters/Contacts Intimes, The Ottawa Art Gallery, Ottawa, Canada

2000 Sylvie Fleury, Ostfildern-Ruit, Germany

2001 S. F., Museum für neue Kunst, ZKM Zentrum für Kunst und Medientechnologie, Karlsruhe, Germany

Women Artists, Cologne, Germany

2002 ART NOW, Cologne, Germany

ANDREAS GURSKY

1955 born in Leipzig; lives and works in Düsseldorf, Germany

SELECETED SOLO EXHIBITIONS

1989 P.S.1, Long Island City (NY), USA (with Thomas Struth)

Museum Haus Lange, Krefeld, Germany

1991 Künstlerhaus Stuttgart, Germany

1992 Kunsthalle Zürich, Zurich, Switzerland

1994 Andreas Gursky: Fotografien 1984–1993, Deichtor-hallen, Hamburg, Germany

1995 Rooseum – Center for Contemporary Art, Malmö, Sweden

Andreas Gursky: Images, Tate Gallery, Liverpool, UK

Portikus, Frankfurt am Main, Germany

1997 Currents 27, Milwaukee Art Museum (WI);

Contemporary Arts Museum, Houston (TX), USA

1998 Andreas Gursky: Fotografien 1984–1998, Kunstmuseum Wolfsburg, Germany

Andreas Gursky: Fotografien 1984 bis heute, Kunsthalle Düsseldorf, Germany

1999 Serpentine Gallery, London, UK

Scottish National Gallery of Modern Art, Edinburgh, UK

Castello di Rivoli, Torino, Italy

Centro Cultural de Belém, Lisbon, Portugal

2001 The Museum of Modern Art, New York (NY), USA

Museo Nacional Centro de Arte Reina Sofia, Madrid, Spain

SELECTED GROUP EXHIBITIONS

1989 Städtische Galerie im Lenbachhaus, Munich, Germany

1. Internationale Photo-Triennale, Galerien der Stadt Esslingen, Germany

1990 Aperto, 44. Biennale di Venezia, Venice, Italy

The Past and the Present of Photography – When Photographs Enter the Museum, The National Museum of Modern Art, Tokyo and The National Museum of Modern Art Kyoto, Japan

1991 Aus der Distanz, Kunstsammlung Nordrhein-Westfalen, Düsseldorf, Germany

1992 Doubletake, Hayward Gallery and South Bank Centre, London, UK

Qui, quoi, oú?, Musée d'Art Moderne de la Ville de Paris, France

1993 Die Photographie in der deutschen Gegenwartskunst, Museum Ludwig, Cologne, Germany

1994 Junge deutsche Kunst der 90er Jahre aus Nordrhein-Westfalen. Die Generation nach Becher, Beuys, Polke, Richter, Ruthenbeck, Sonje Museum of Contemporary Art, Kyongju, South Korea

1995 Reverendo– Brasília neu gesehen, Palacio Gustavo Capanema, Rio de Janeiro; Museu Metropolitano de Arte, Curabita; Usian do Gasómetro, Porto Alegre; Centro Cultural da UFMG, Belo Horizonte, Brazil

Close to Life, 3. Internationale Photo-Triennale, Galerien der Stadt Esslingen, Germany

1996 Im Kunstlicht, Kunsthaus Zürich, Zurich, Switzerland

10th Biennale of Sydney, Australia

1997 Positionen künstlerischer Fotografie in Deutschland nach 1945, Martin-Gropius-Bau, Berlin, Germany

1999 Räume, Kunsthaus Bregenz, Austria (with Lucinda Devlin and Candida Höfer)

Große Illusionen: Thomas Demand, Andreas Gursky, Edward Ruscha, Kunstmuseum Bonn, Germany and Museum of Contemporary Art, Miami (FL), USA

2000 Let's Entertain, Walker Art Center, Minneapolis MN, USA

How You Look at It, Sprengel Museum, Hanover, Germany

12th Biennale of Sydney, Australia

2001 ex(o)DUS, Haifa Museum of Art, Haifa, Israel

SELECTED BIBLIOGRAPHY

1989 Andreas Gursky, Krefelder Museen, Krefeld, Germany

1992 Andreas Gursky, Kunsthalle Zürich, Zurich, Switzerland

1994 Andreas Gursky – Fotografien 1984–1993, Munich, Germany

1995 Andreas Gursky – Images, Tate Gallery, Liverpool, UK

1997 Currents 27 – Andreas Gursky, Milwaukee Art Museum, Milwaukee (WI), USA

1998 Andreas Gursky – Fotografien 1984–1998, Kunstmuseum Wolfsburg, Germany

Andreas Gursky – Fotografien 1984 bis heute, Kunsthalle Düsseldorf, Germany

2001 Andreas Gursky – The Museum of Modern Art, New York (NY), USA

DAMIEN HIRST

1965 born in Bristol; lives and works in Devon, UK

SOLO EXHIBITIONS

1991 Internal Affairs, Institute of Contemporary Arts, London, UK

1994 Currents 23, Milwaukee Art Museum (WI), USA

A Bad Environment for White Monochrome Paintings, Mattress Factory, Pittsburgh (PA), USA

A Good Environment for Coloured Monochrome Paintings, DAAD Galerie, Berlin, Germany

Pharmacy, Dallas Museum of Art, Dallas (TX), USA

1997 Astrup Fearnley Museet for Moderne Kunst, Oslo, Norway

1998 Southampton City Art Gallery, Southampton, UK

1999 Pharmacy, Tate Gallery, London, UK

SELECTED GROUP EXHIBITIONS

1991 Broken English, Serpentine Gallery, London, UK

1992 3. Istanbul Biennial, Istanbul, Turkey

Turner Prize Exhibition, Tate Gallery, London, UK

1993 Post Human, Deichtorhallen, Hamburg, Germany

The 21st Century, Kunsthalle Basel, Basle, Switzerland

The Nightshade Family, Museum Fridericianum, Kassel, Germany

Aperto, 45. Biennale di Venezia, Venice, Italy

1994 Some Went Mad, Some Ran Away, Serpentine Gallery, London, UK

Virtual Reality, National Gallery of Australia, Canberra, Australia

Cocido y Crudo, Museo Nacional Centro de Arte Reina Sofía, Madrid, Spain

From Beyond the Pale, The Irish Museum of Modern Art, Dublin, Ireland

1995 New Art in Britain, Museum Sztuki, Lodz, Poland

Signs and Wonders, Kunsthaus Zürich, Zurich, Switzerland

Here and Now, Serpentine Gallery, London, UK

Brilliant Art From London, Walker Art Centre, Minneapolis (MN), USA

1996 Life/Live, Musée d'Art Moderne de la Ville de Paris, France

Twentieth Century British Sculpture, Musée du Jeu de Paume, Paris, France

Spellbound, Hayward Gallery, London, UK

1997 Sensation: Young British Artists from the Saatchi Collection, Royal Academy of Arts, London, UK

Picture Britanica. Art from Britain, Museum of Contemporary Art, Sydney, Australia; Art Gallery of South Australia, Adelaide, Australia; Te Papa, Wellington, New Zealand

A Ilha do Tesouro, Fundação Calouste Gulbenkian, Lisbon, Portugal

1998 Wall Projects: Damien Hirst, Museum of Contemporary Art, Chicago (IL)

Modern British Art, Tate Gallery, London, UK

1999 Thin Ice, Stedelijk Museum, Amsterdam, The Netherlands

On the sublime, Rooseum – Center for Contemporary Art Center for Contemporary Art, Malmö, Sweden

2000 Sincerely yours: British art from the 90s, Astrup Fearnley Museet for Moderne Kunst, Oslo, Norway

SELECTED BIBLIOGRAPHY

1991 Damien Hirst, Institute of Contemporary Arts, London, UK

1994 Some Went Mad, Some Ran Away, Serpentine Gallery., London, UK

1997 I Want to Spend the Rest of My Life Everywhere, with Everyone, One to One, Always, Forever, London, UK

2000 Theories, Models, Methods, Approaches, Assumptions, Results and Findings, New York (NY), USA

2001 Damien Hirst – The Saatchi Gallery, London, UK

JEFF KOONS

1955 born in York (PA); lives and works in New York (NY), USA

SELECETD SOLO EXHIBITIONS

1988 Museum of Contemporary Art, Chicago (IL), USA

1992 Jeff Koons Retrospective, Stedelijk Museum, Amsterdam, The Netherlands; San Francisco Museum of Modern Art, San Francisco (CA), USA

1993 Jeff Koons Retrospective, Walker Art Center, Minneapolis, (MN), USA; Staatsgalerie Stuttgart, Germany; Aarhus, Denmark

1995 Puppy, Museum of Contemporary Art, Sydney, Australia

1997 Puppy, Guggenheim Museum, Bilbao, Spain

1999 Jeff Koons, A Millennium Celebration, Deste Foundation, Athens, Greece

2000 Easyfun – Ethereal, Deutsche Guggenheim, Berlin, Germany

2001 Kunsthaus Bregenz, Austria

SELECTED GROUP EXHIBITIONS

1981 Lighting, P.S.1, Long Island City, (NY), USA

1982 A Fatal Attraction: Art and the Media, The Renaissance Society, Chicago (IL), USA

Energie New York, Espace Lyonnais d'Art Contemporain, Lyon, France

1984 A Decade of New Art, Artists' Space, New York (NY), USA

1986 Endgame: Reference and Simulation in Recent Painting and Sculpture, Institute of Contemporary Art, Boston (MA), USA

1987 Avant-Garde in the Eighties, Los Angeles County Museum, Los Angeles (CA), USA

Whitney Biennial, Whitney Museum of American Art, New York (NY), USA

Art and It's Double: A New York Perspective, Fundácio Caixa de Pensions, Barcelona, Spain

1988 Carnegie International, Carnegie Museum of Art, Pittsburgh (PA), USA

L'Objet de l'Exposition, Centre National des Arts Plastiques, Paris, France

Art at the End of the Social, Rooseum – Center for Contemporary Art, Malmö, Sweden

BiNATIONALE: Deutsche/Amerikanische Kunst der 80er Jahre, Kunsthalle, Kunstsammlung Nordrhein-Westfalen, Kunstverein für die Rheinlande und Westfalen, Düsseldorf, Germany

1989 A Forest of Signs: Art in the Crisis of Representation, The Museum of Contemporary Art, Los Angeles (CA), USA

Whitney Biennial, Whitney Museum of American Art, New York (NY), USA

1990 High & Low: Modern Art and Popular Culture, The Museum of Modern Art, New York (NY), USA

Aperto, 43. Biennale di Venezia, Venice, Italy

8th Biennial of Sydney, Australia

Horn of Plenty, Stedelijk Museum, Amsterdam, The Netherlands

1991 Objects for the Ideal Home – The Legacy of Pop Art, Serpentine Gallery, London, UK

Metropolis, Martin-Gropius-Bau, Berlin, Germany

1992 Doubletake: Collective Memory & Current Art, Hayward Gallery, London, UK

1993 Amerikanische Kunst im 20. Jahrhunndert, Martin-Gropius-Bau, Berlin, Germany

1994 Black Male: Representations of Masculinity in Contemporary American Art, Whitney Museum of American Art, New York (NY), USA

1995 Signs and Wonders, Kunsthaus Zürich, Zurich, Switzerland

Unser Jahrhundert, Museum Ludwig, Cologne, Germany

45 Nord & Longitude 0, capcMusée d'Art Contemporain, Bordeaux, France

1996 Playpen & Corpus Delirium, Kunsthalle Zürich, Zurich, Switzerland

1997 47. Biennale di Venezia, Venice, Italy

Objects of Desire: The Modern Still Life, The Museum of Modern Art, New York (NY), USA

1998 fast forward, Kunstverein in Hamburg, Germany

1999 The American Centruy, Whitney Museum of American Art, New York (NY), USA

Heaven, Kunsthalle Düsseldorf, Germany

2000 Hypermental, 1950 – 2000 from Salvador Dalí to Jeff Koons, Kunsthaus Zürich, Zurich, Switzerland

Au-delà du spectacle, Centre Georges Pompidou, Paris, France

Innocence and Experience, The Museum of Modern Art, New York (NY), USA

Apocalypse: Beauty & Horror in Contemporary Art, Royal Academy of Arts, London, UK

2001 un art populaire, Fondation Cartier pour l'Art Contemporain, Paris, France

Give & Take, Victoria & Albert Museum, London, USA

SELECTED BIBLIOGRAPHY

1988 Jeff Koons. The Art Institute of Chicago (IL), USA

1992 Jeff Koons, Cologne, Germany

Jeff Koons, San Francisco Museum of Modern Art, San Francisco (CA), USA

2000 Jeff Koons: Easyfun – Ethereal, Deutsche
Guggenheim, Berlin, Germany

2001 Jeff Koons, Kunsthaus Bregenz, Austria

2002 ART NOW, Cologne, Germany

PAUL McCARTHY

1945 born in Salt Lake City (UT); lives and works in Los Angeles
(CA), USA

SELECTED SOLO EXHIBITIONS

1979 Contemporary Cure All, Los Angeles Institute of
Contemporary Art (CA), USA

1995 Hamburger Kunsthalle, Hamburg, Germany (with
Mike Kelley), USA
Tomato Head, Künstlerhaus Bethanien, Berlin,
Germany

1998 Sod and Sodie Sock (with Mike Kelley), USA, Wiener
Secession, Vienna, Austria

2000 New Museum of Contemporary Art, New York (NY),
and The Museum of Contemporary Art, Los Angeles
(CA), USA

2001 Film- und Videoretrospektive Paul McCarthy,
Kunstverein in Hamburg, Germany
New Museum of Contemporary Art, New York (NY),
USA

2002 Paul McCarthy Retrospective, Moderna Museet,
Stockholm, Sweden
Propposition (with Jason Rhoades), Santa Monica
Museum, Santa Monica (CA), USA

SELECTED GROUP EXHIBITIONS

1992 Helter Skelter, The Museum of Contemporary Art, Los
Angeles (CA), USA

1993 Post Human, Deichtorhallen, Hamburg, Germany
Aperto, 45. Biennale di Venezia, Venice, Italy
Identity and Home, The Museum of Modern Art,
New York (NY), USA

1994 Hors limites, Centre Georges Pompidou, Paris, France
Cocido y Crudo, Museo Nacional Centro de Arte
Reina Sofía, Madrid, Spain

1995 Fémininmasculin: le sexe de l'art, Centre Georges
Pompidou, Paris, France
46. Biennale di Venezia, Venice, Italy

1996 Sex & Crime, Sprengel Museum, Hanover, Germany

1997 Kwangju Biennale, Kwangju, South Korea
Deep storage, Haus der Kunst, Munich, Germany
4e Biennale de Lyon, France
Sunshine & Noir, Louisiana Museum of Art,
Humlebæk, Denmark

1998 Double Trouble, Museum of Contemporary Art,
San Diego (CA), USA
Crossings, Kunsthalle Wien, Vienna, Austria
Out of Actions: Between Performance and the
Object, 1949–1979, The Museum of Contemporary
Art, Los Angeles (CA), USA

1999 Propposition, 48. Biennale di Venezia, Venice, Italy

2000 Let's Entertain, Walker Art Center, Minneapolis (MN),
USA
In Between, EXPO 2000, Hanover, Germany
12th Biennial of Sydney, Australia

2001 Painting at the Edge of the World, Walker Art Center,
Minneapolis (MN), USA

SELECTED BIBLIOGRAPHY

1996 Paul McCarthy, London, UK

1999 Art at the Turn of the Millennium, Cologne, Germany

2000 Paul McCarthy, Ostfildern, Germany
Fresh Cream – Contemporary Art in Culture, London,
UK
Paul McCarthy – 'Dimensions of the Mind', The Denial
and the Desire in the Spectacle, Cologne, Germany

2002 ART NOW, Cologne, Germany

MARIKO MORI

1967 born in Tokyo, Japan; lives and works in New York (NY),
USA

SELECTED SOLO EXHIBITIONS

1988 Le Magasin – Centre National d'Art Contemporain de
Grenoble, France

1989 Play with Me, Dallas Museum of Art, Dallas (TX), USA

1990 The Andy Warhol Museum, Pittsburgh (PA), USA
Contemporary Projects 2: Mariko Mori, Los Angeles
County Museum of Art, Los Angeles (CA), USA
The Serpentine Gallery, London, UK

1991 Dream Temple, Prada Foundation, Milan, Italy
Empty Dream, The Brooklyn Museum of Art, Brooklyn
(NY), USA
Esoteric Cosmos, Kunstmuseum Wolfsburg, Germany,
Museum of Contemporary Art, Chicago (IL), USA

2000 Beginning of the End, Centre National de la Photo-
graphie, Paris, France
Link, Centre Georges Pompidou, Paris, France

2002 Form Follows Fiction, Castello di Rivoli, Torino, Italy,
Pure Land, Museum of Contemporary Art, Tokyo,
Japan

SELECTED GROUP EXHIBITIONS

1995 Self Made, Grazer Kunstverein, Graz

1996 Cities On The Move, Wiener Secession, Vienna,
Austria
By Night, Fondation Cartier pour l'Art Contemporain,
Paris, France

1997 Kwangju Biennale, Kwangju, South Korea
2nd Johannesburg Biennale, Johannesburg, South
Africa
5. Istanbul Biennial, Istanbul, Turkey
4e Biennale de Lyon, France
47. Biennale di Venezia, Venice, Italy
Some Kind of Heaven, Kunsthalle Nürnberg,
Nuremberg, Germany

1998 I Love NY, Museum Ludwig, Cologne, Germany

1999 Regarding Beauty: A View of the Late Twentieth
Century, Hirshhorn Museum and Sculpture Garden,
Washington D.C., USA
Heaven, Kunsthalle Düsseldorf, Germany

2000 Seeing Time, ZKM Zentrum für Kunst und Medien-
technologie, Karlsruhe, Germany
Hypermental, 1950 – 2000 from Salvador Dalí to Jeff
Koons, Kunsthaus Zürich, Zurich, Switzerland
Shanghai Biennale, Shanghai Art Museum, Shanghai,
China
Au-delà du spectacle, Centre Georges Pompidou,
Paris, France
Apocalypse: Beauty and Horror in Contemporary Art,
Royal Academy of Art, London, UK
12th Biennial of Sydney, Australia

2001 Jheronimus Bosch, Museum Boijmans Van
Beuningen, Rotterdam, The Netherlands

SELECTED BIBLIOGRAPHY

1998 Cream – Contemporary Art in Culture, London, UK
2000 Dream Temple, Fondazione Prada, Milan, Italy
Esoteric Cosmos, Kunstmuseum Wolfsburg, Germany
Art at the Turn of the Millennium, Cologne, Germany

2000 Apocalypse: Beauty & Horror in Contemporary Art,
Royal Academy of Art, London, UK

2001 Women Artists, Cologne, Germany

2002 Pure Land, Museum of Contemporary Art, Tokyo,
Japan
ART NOW, Cologne, Germany

JACK PIERSON

1945 born in Plymouth (MA); lives and works in New York (NY), USA and Provincetown (MA), USA, USA

SELECTED SOLO EXHIBITIONS

1992	White Columns, New York (NY), USA
1994	Edward Hopper and Jack Pierson: American Dreaming, Whitney Museum of American Art, New York (NY), USA
	Museum of Contemporary Art, Chicago (IL), USA
1996	Modulo Centro Difuso de Arte, Lisbon, Portugal
	Ursula Blickle Stiftung, Kraichtal, Germany
1997	Kunstverein Frankfurt, Germany
1999	Sprengel Museum, Hanover, Germany
	Kunstverein Heilbronn, Germany
	Espacio Aglutinador, Havana, Cuba
2001	The Magic Hour, Neue Galerie am Landesmuseum Joanneum, Graz, Austria
2002	Jack Pierson: Regrets, Museum of Contemporary Art, Miami (FL), USA

SELECTED GROUP EXHIBITIONS

1992	True Stories, Institute of Contemporary Art, London, UK
	Identities, Forum Stadtpark, Graz, Austria
1993	Whitney Biennial, Whitney Museum of American Art, New York (NY), USA
1995	Boston School, Institute of Contemporary Art, Boston (MA), USA
	Whitney Biennial, Whitney Museum of American Art, New York (NY), USA
	Close to Life, 3. Internationale Photo-Triennale, Galerien der Stadt Esslingen, Germany
1996	Traffic, capcMusée d'Art Contemporain, Bordeaux, France
1998	Double Trouble, Museum of Contemporary Art, San Diego (CA), USA
	Emotions & Relations: Contemporary American Photography, Hamburger Kunsthalle, Hamburg, Germany
1999	The American Century: Art and Culture, 1900–2000, Whitney Museum of American Art, New York (NY), USA
2000	Let's Entertain, Walker Art Center, Minneapolis (MN), USA
	Quotidiana: The continuity of the everyday in 20th Century Art, Castello di Rivoli, Torino, Italy

SELECTED BIBLIOGRAPHY

1992	True Stories, The Institute of Contemporary Arts, London, UK

1996	Jack Pierson, The Lonely Life, Ursula Blickle Stiftung, Kraichtal, Germany
1997	Jack Pierson, Sing a Song of Sixpence, Cologne, Germany
1998	Emotions & Relations, Hamburger Kunsthalle, Hamburg, Germany
1999	Art at the Turn of the Millennium, Cologne, Germany

RICHARD PRINCE

1949 born in the Panama Canal Zone, lives and works in Upstate New York, USA

SELECTED SOLO EXHIBITIONS

1980	Artists' Space, New York
1983	Le Nouveau Musée, Lyon, France
	Institute of Contemporary Arts, London, UK
1984	Riverside Studios, London, England, UK
1988	Le Magasin – Centre National d'Art Contemporain de Grenoble, France
	Tell Me Everything, Spectacolor Lightboard on Times Square, New York, The Public Art Fund, New York (NY), USA
1989	Spiritual America, IVAM Centre Julio González, Valencia, Spain
1992	Whitney Museum of American Art, New York (NY), USA
1991	Richard Prince: Fotos, Schilderijen, Objecten, Museum Boijmans Van Beuningen, Rotterdam, The Netherlands
	San Francisco Museum of Modern Art, San Francisco (CA), USA
	Kunstverein für die Rheinlande und Westfalen and Kunsthalle, Düsseldorf, Germany
1994	Kestner Gesellschaft, Hanover, Germany
1996	Haus der Kunst, Munich
1997	Museum Haus Lange/Museum Haus Esters, Krefeld, Germany
2000	Richard Prince: 4 x 4, MAK Museum für Angewandte Kunst, Vienna, Austria
	Richard Prince: Upstate, MAK Center for Art and Architecture, Schindler House, Los Angeles (CA), USA
2002	Museum für Gegenwartskunst Basel, Basle Switzerland
	Kunsthalle Zürich, Zurich, Switzerland
	Kunstmuseum Wolfsburg, Germany

SELECTED GROUP EXHIBITIONS

1980	Ils se disent peintres, ils se disent photographes, Musee d'Art Moderne de la Ville de Paris, France

1982	Art and the Media, The Renaissance Society, Chicago (IL), USA
1983	XVII Bienal Internacional de São Paulo, Brazil
1985	Whitney Biennial, Whitney Museum of American Art, New York (NY), USA
1986	6th Biennial of Sydney, Australia
1987	Photography and Art: Interactions since 1946, Los Angeles County Museum of Art, Los Angeles (CA), USA
1988	BiNATIONALE: Deutsche/Amerikanische Kunst der 80er Jahre, Kunsthalle, Kunstsammlung Nordrhein-Westfalen, Kunstverein für die Rheinlande und Westfalen, Düsseldorf, Germany
	The Object of the Exhibition, Centre National des Arts Plastiques, Paris, France
	Aperto, 43. Biennale di Venezia, Venice, Italy
1989	Wittgenstein The Play of the Unsayable, Paleis voor Schone Kunsten, Brussels, Belgium
	A Forest of Signs: Art in the Crisis of Representation, The Museum of Contemporary Art, Los Angeles (CA), USA
	The Photography of Invention: American Pictures of the 1980's, National Museum of American Art, Washington D.C., USA
	Bilderstreit: Widerspruch, Einheit und Fragment in der Kunst seit 1960, Rheinhallen, Cologne Fair Grounds, Cologne, Germany
	Photography Now, Victoria & Albert Museum, London, UK
	Horn of Plenty, Stedelijk Museum, Amsterdam, The Netherlands
1990	Life Size: A Sense of the Real in Recent Art, The Israel Museum, Jerusalem, Israel
	Art et Publicité 1890–1990, Centre Georges Pompidou, France
	The Decade Show: Frameworks of Identity in the 80's, New Museum of Contemporary Art, New York (NY), USA
1991	Metropolis, Martin-Gropius-Bau, Berlin, Germany
1992	documenta IX, Kassel, Germany,
	Allegories of Modernism: Contemporary Drawings, The Museum of Modern Art, New York (NY), USA
1993	Die Sprache der Kunst, Kunsthalle Wien, Vienna, Austria
1994	Tuning Up, Kunstmuseum Wolfsburg, Germany
1995	Close to Life, 3. Internationale Photo-Triennale, Galerien der Stadt Esslingen, Germany
1996	Passions Privée, Musée d'Art Moderne de la Ville de Paris, France
1997	Whitney Biennial, Whitney Museum of American Art, New York (NY), USA

Birth of the Cool – American Painting from Georgia O'Keeffe to Christopher Wool, Deichtorhallen, Hamburg, Germany and Kunsthaus Zürich, Zurich, Switzerland

1998 American Playhouse: The Theatre of Self-Presentation, The Power Plant, Toronto, Canada

1999 The American Century, Whitney Museum of American Art, New York (NY), USA

Fame after Photography, The Museum of Modern Art, New York (NY), USA

2000 Au-delà du spectacle, Centre Georges Pompidou, Paris, France

Apocalypse: Beauty & Horror in Contemporary Art, Royal Academy of Arts, London, UK

Let's Entertain, Walker Art Center, Minneapolis (MN), USA

2001 Mythic Proportions: Painting in the 1980's, Museum of Contemporary Art, Miami (FL), USA

2002 Chic Clicks, Institute of Contemporary Art, Boston (MA), USA

Televisions, Kunsthalle Wien, Vienna, Austria

SELECTED BIBLIOGRAPHY

1992 Richard Prince – Pamphlet, Le Nouveau Musée, Villeurbanne, France

1988 Richard Prince, Le Magasin – Centre National d'Art Contemporain de Grenoble, France

1992 Richard Prince, New York (NY), USA

1993 Richard Prince – Girlfriends, Museum Boijmans Van Beuningen, Rotterdam, The Netherlands

1994 Richard Prince – Photographs 1977–1993, Kestner Gesellschaft, Hanover, Germany

1993 Richard Prince – Zeichnungen, Museum Haus Lange/Haus Esters, Krefeld, Germany

2002 Richard Prince – Principal: Gemälde und Fotografien 1977–2001, Ostfildern, Germany

UGO RONDINONE

1964 born in Brunnen, Switzerland; lives and works New York (NY), USA

SELECTED SOLO EXHIBITIONS

1994 Raum für aktuelle Schweizer Kunst, Lucerne, Switzerland

1988 Centre d'art contemporain, Martigny, Switzerland

1989 Migrateurs, Musée d'Art Moderne de la Ville de Paris, France

1990 Dog days are over, Migros Museum für Gegenwartskunst, Zurich, Switzerland

Heyday, Centre d'Art Contemporain, Geneva, Switzerland

1997 Galleria Nazionale d'Arte Moderna e Contemporanea, Rome, Italy (with Jessica Diamond)

1999 Guided by Voices, Galerie für zeitgenössische Kunst, Leipzig, Germany

Guided by Voices, Kunsthaus Glarus, Switzerland

2000 So much water so close to home, P.S.1, Long Island City (NY), USA

2001 Dreams and Dramas, Herzliya Museum of Art, Herzliya, Israel

Kiss tomorrow goodbye, Palazzo delle Esposizioni, Rome, Italy

2002 Kunsthalle Wien, Vienna, Austria

Württembergischer Kunstverein, Stuttgart, Germany

SELECTED GROUP EXHIBITIONS

1989 Kunstmuseum Luzern, Lucerne, Switzerland

Igitur, Kunsthalle Winterthur, Switzerland

1993 Prospect 93, Frankfurter Kunstverein, Frankfurt am Main, Germany

1994 Oh boy, it's a girl, Messepalast Wien, Vienna, Austria; Kunstverein München, Munich, Germany

Endstation Sehnsucht, Kunsthaus Zürich, Zurich, Switzerland

Steirischer Herbst, Graz, Austria

1996 Where do we go from here?, XXIII Bienale Internacional de São Paulo, Brazil

1998 From the corner of the eye, Stedelijk Museum, Amsterdam, The Netherlands

Berlin Biennial, Berlin, Germany

4. Internationale Photo-Triennale, Galerien der Stadt Esslingen, Germany

1999 6. Istanbul Biennial, Istanbul, Turkey

L'autre sommeil, Musée d' Art Moderne de la Ville de Paris, France

Signs Of Life, 1st Melbourne International Biennial, Melbourne, Australia

2000 Let's Entertain, Walker Art Center, Minneapolis (MN), USA

une mise en scène du réel: artiste/acteur, Villa Arson, Nice, France

Présumé Innocent, capcMusée d'Art Contemporain, Bordeaux, France

Over the edges, Stedelijk Museum voor Actuele Kunst, Ghent, Belgium

Ich ist etwas Anderes, Kunstsammlung Nordrhein-Westfalen, Düsseldorf, Germany

2001 Loop – Alles auf Anfang, Kunsthalle der Hypokulturstiftung, Munich, Germany

Mouvements Immobiles, Museo de Arte Moderno, Buenos Aires, Argentina

Gestes, Musée des Beaux-Arts de Montréal, Canada

SELECETED BIBLIOGRAPHY

1996 Ugo Rondinone – Where do we go from here?, XXIII Bienal Internacional de São Paulo, Brazil

Ugo Rondinone – Heyday, Zurich, Switzerland

1999 Ugo Rondinone – Guided by Voices, Kunsthaus Glarus, Switzerland

2001 Ugo Rondinone– Kiss tomorrow goodbye, Palazzo delle Esposizioni, Rome, Italy

Loop – Alles auf Anfang, Kunsthalle der Hypokulturstiftung, Munich, Germany

2002 ART NOW, Cologne, Germany

THOMAS RUFF

1958 born in Zell am Harmersbach; lives and works in Düsseldorf, Germany

SELECTED SOLO EXHIBITIONS

1989 Cornerhouse, Manchester, UK

Stedelijk Museum, Amsterdam, The Netherlands

1990 Le Magasin – Centre National d'Art Contemporain de Grenoble, France

1991 Kunstverein Bonn; Kunstverein Arnsberg; Kunstverein Braunschweig; Galerie der Stadt Sindelfingen, Germany

1996 Rooseum – Center for Contemporary Art, Malmö, Sweden

1997 Œuvres 1979–97, Centre National de la Photographie, Paris, France

2000 Museum Haus Lange/Haus Esters, Krefeld, Germany

2001 Kunsthalle Baden-Baden, Germany

2002 Folkwang Museum, Essen, Germany

Städtische Galerie im Lenbachhaus, Munich, Germany

Museet for Samtidskunst, Oslo, Norway

The Irish Museum of Modern Art, Dublin, Ireland

Atrium-Centro-Museo Vasco de Arte Contemporáneo, Vitoria-Gasteiz, Spain

Museo Tamayo, Mexico City, Mexico

SELECTED GROUP EXHIBITIONS

1986 Reste des Authentischen, Museum Folkwang, Essen, Germany

1988 Aperto, 44. Biennale di Venezia, Venice, Italy

BiNATIONALE: Deutsche/Amerikanische Kunst der 80er Jahre, Kunsthalle, Kunstsammlung Nordrhein-

Westfalen, Kunstverein für die Rheinlande und
Westfalen, Düsseldorf, Germany

1989 1. Internationale Photo-Triennale, Galerien der Stadt
Esslingen, Germany

1990 New Work: A New Generation, San Francisco
Museum of Modern Art, San Francisco (CA), USA

1991 Metropolis, Martin-Gropius-Bau, Berlin, USA
Museum für Gegenwartskunst, Basle, Switzerland

1992 documenta IX, Kassel, Germany
Qui, quoi, où?, Musée d'Art Moderne de la Ville de
Paris, France
More than one photography, The Museum of Modern
Art, New York (NY), USA
Photography in contemporary German art: 1960 to
the present, Walker Art Center, Minneapolis (MN), USA

1993 Distanz und Nähe, Neue Nationalgalerie, Berlin,
Germany
Post Human, Deichtorhallen, Hamburg, Germany

1994 Aura, Wiener Secession, Vienna, Austria

1995 Virtual Reality, National Gallery of Australia, Canberra,
Australia
46. Biennale di Venezia, German Pavilion, Venice,
Italy (with Katharina Fritsch and Martin Honert)

1996 by night, Fondation Cartier pour l'Art Contemporain,
Paris, France

1997 Die Epoche der Moderne – Kunst im 20. Jahrhundert,
Martin-Gropius-Bau, Berlin, Germany

1998 Wounds: between democracy and redemption in
contemporary art, Moderna Museet, Stockholm,
Sweden
fast forward, Kunstverein in Hamburg, Germany

1999 Digitale Photographie, Deichtorhallen Hamburg,
Germany
Face to Face Cyberspace, Fondation Beyeler, Basle,
Switzerland
das XX. jahrhundert – ein jahrhundert kunst in
deutschland, Altes Museum, Neue Nationalgalerie,
Hamburger Bahnhof, Berlin, Germany

2000 How You Look at It, Sprengel Museum, Hanover;
Germany

2001 Mies in Berlin, The Museum of Modern Art, New York
(NY), USA

2002 heute bis jetzt – Zeitgenössische Fotografie aus
Düsseldorf, Museum Kunst Palast, Düsseldorf,
Germany
Iconografias Metropolitanas, XXVI Bienal
Internacional de São Paulo, Brazil

SELECTED BIBLIOGRAPHY

1988 Thomas Ruff – Porträts, Cologne, Germany

1989 Thomas Ruff – Porträts Häuser Sterne, Stedelijk
Museum, Amsterdam, The Netherlands

1995 Thomas Ruff. Andere Porträts + 3D, Ostfildern,
Germany

1996 Thomas Ruff, Rooseum – Center for Contemporary
Art, Malmö, Sweden

1997 Thomas Ruff – Œuvres 1979–97, Centre National de
la Photographie, Paris, France

2000 l. m. v. d. r./l. m. v. d. r., Haus Lange/Haus Esters,
Krefeld, Germany

2001 Thomas Ruff, Munich, Germany

2002 Thomas Ruff – Identificaciones, Museo Tamayo,
Mexico-City, Mexico

DAVID SALLE

1952 born in Norman (OK); lives and works in Sagaponack/Long
Island (NY), USA

SELECTED SOLO EXHIBITIONS

1976 Artists' Space, New York. (NY), USA

1977 Bearding the Lion in His Den, Foundation de Appel,
Amsterdam, The Netherlands

1983 Paintings, Museum Boijmans Van Beunigen,
Rotterdam, The Netherlands

1985 Museum of Contemporary Art, Chicago (IL), USA

1986 Works on Paper 1974–1986. Museum am Ostwall,
Dortmund, Germany; Kunstmuseum, Aarhus,
Denmark; Institute of Contemporary Art, Boston
(MA), USA
Institute of Contemporary Art, University of
Pennsylvania, Philadelphia (PA); Whitney Museum of
American Art, New York (NY); The Museum of
Contemporary Art, Los Angeles (CA), Museum of
Contemporary Art Chicago (IL), USA; Art Gallery of
Ontario, Toronto, Canada

1987 The Fruitmarket Gallery, Edinburgh, Scotland

1988 The Menil Collection, Houston (TX), USA
Pinturas y acuarelas 1980–1988, Fundación Caja de
Pensiones, Madrid, Spain; Staatsgalerie Moderner
Kunst, Munich, Germany; The Tel Aviv Museum of
Art, Tel Aviv, Israel

1993 New Works, Newport Harbor Art Museum, Newport
Beach (CA), USA

1999 Stedelijk Museum, Amsterdam, The Netherlands;
Museum moderner Kunst, Stiftung Ludwig Wien, 20er
Haus, Vienna, Austria; Castello di Rivoli, Turino, Italy;
Guggenheim Museum, Bilbao, Spain

2000 Museo de Arte Contemporáneo de Monterrey,
Mexico

SELECTED GROUP EXHIBITIONS

1981 Westkunst, Rheinhallen, Cologne Fair Grounds,
Cologne, Germany

1982 documenta 7, Kassel, Germany
Zeitgeist, Martin-Gropius-Bau, Berlin, Germany
Aperto, 40. Biennale di Venezia, Venice, Italy

1983 Whitney Biennial, Whitney Museum of American Art,
New York (NY), USA
XVII Bienal Internacional de São Paulo, Brazil

1984 An International Survey of Contemporary Painting
and Sculpture, The Museum of Modern Art, New York
(NY), USA
The Human Condition: SFMMA Biennial III,
San Francisco Museum of Modern Art, San Francisco
(CA), USA

1985 Carnegie International, Carnegie Museum of Art,
Pittsburgh (PA), USA
Whitney Biennial, Whitney Museum of American Art,
New York (NY), USA

1986 6th Biennale of Sydney, Australia

1987 Europe/America, Museum Ludwig, Cologne, Germany
Avant Garde in the Eighties, Los Angeles County Art
Museum, Los Angeles (CA), USA
L'epoque, la morale, la passion, Centre Georges
Pompidou, Paris, France

1989 Bilderstreit: Widerspruch, Einheit und Fragment in
der Kunst seit 1960, Rheinhallen, Cologne Fair
Grounds, Cologne, Germany
High and Low: Modern and Popular Culture, The
Museum of Modern Art, New York. (NY), USA

1991 Whitney Biennial, Whitney Museum of American Art,
New York (NY), USA
Beyond the Frame: American Art 1960–1990,
Setagaya Art Museum, Tokyo; The National Museum
of Art, Osaka; Fukuoka Art Museum, Fukuoka, Japan

1992 45. Biennale di Venezia, Venice, Italy

1995 American Photography 1890–1965, Stedelijk
Museum, Amsterdam, The Netherlands

1998 The 80's, Culturgest, Lisbon, Portugal

1999 The American Century: Art & Culture, 1900–2000,
Whitney Museum of American Art, New York (NY), USA

2001 Jasper Johns to Jeff Koons: Four Decades of Art form
the Broad Collection, Los Angeles County Museum of
Art, Los Angeles (CA), USA

SELECTED BIBLIOGRAPHY

1983 David Salle – Paintings, Museum Boijmans Van
 Beuningen, Rotterdam, The Netherlands
1985 David Salle, Institute of Contemporary Art,
 Philapelphia (PA), USA
1986 David Salle – Works on Paper 1974–1986, Museum
 am Ostwall Dortmund, Germany
1987 David Salle, The Fruitmarket Gallery, Edinburgh, UK
1988 David Salle, Fundación Caja de Pensiones, Madrid,
 Spain
1994 David Salle, New York (NY), USA
1999 David Salle Retrospective, Stedelijk Museum,
 Amsterdam, The Netherlands

CINDY SHERMAN

1954 born in Glen Ridge (NJ); lives and works in New York (NY),
USA

SELECTED SOLO EXHIBITIONS

1980 Contemporary Arts Museum, Houston (TX), USA
1983 Stedelijk Museum, Amsterdam, The Netherlands
1984 Cindy Sherman, Akron Art Musem, Akron (OH);
 Institute of Contemporary Art, Philadelphia (PA);
 Museum of Art, Carnegie Institute, Pittsburgh (PA);
 De Moines Art Center; Baltimore Museum of Art,
 Baltimore (MD), USA
1987 Whitney Museum of American Art, New York (NY);
 Institute of Contemporary Art, Boston (MA); Dallas
 Museum of Art, Dallas (TX), USA
1989 National Art Gallery, Wellington; Waikato Museum of
 Art and History, Waitako, New Zealand
1991 Kunsthalle Basel, Basle, Switzerland; Staatsgalerie
 Moderner Kunst, Munich, Germany; Whitechapel
 Gallery, London, UK
1994 Tel Aviv Museum of Art, Tel Aviv, Israel
1995 Cindy Sherman: Photographien 1975–19951,
 Deichtorhallen, Hamburg, Germany; Malmö
 Kunsthall, Malmö, Sweden; Kunstmuseum Luzern,
 Lucerne, Switzerland
1996 Museum Boijmans Van Beuningen, Rotterdam, The
 Netherlands; Museu Nacional Centro de Arte Reina
 Sofía, Madrid, Sala de Exposiciones Rekalde, Bilbao,
 Spain; Staatliche Kunsthalle Baden-Baden, Germany
 Museum of Modern Art, Shiga; Marugame Genichiro-
 Inokuma Museum of Contemporary Art, Marugame;
 Museum of Contemporary Art, Tokyo, Japan
1997 Museum Ludwig, Cologne, Germany
 Cindy Sherman: The Complete Untitled Film Stills,
 The Museum of Modern Art, New York (NY), USA

1997–2000 Cindy Sherman: Retrospective, The Museum
 of Contemporary Art, Los Angeles (CA); Museum of
 Contemporary Art, Chicago (IL), USA; Galerie
 Rudolfinum, Prague, Czech Republic; capcMusée
 d'Art Contemporain, Bordeaux, France; Barbican Art
 Gallery, London, UK; Museum of Contemporary Art,
 Sydney, Australia; Art Gallery of Ontario, Toronto,
 Canada

SELECTED GROUP EXHIBITIONS

1982 documenta 7 Kassel, Germany
 40. Biennale di Venezia, Venice, Italy
1983 The New Art, Tate Gallery, London, UK
1984 Alibis, Centre Georges Pompidou, Paris, France
1985 Carnegie International, Carnegie Museum of Art,
 Pittsburgh (PA), USA
1987 Art and It's Double: A New York Perspective,
 Fundácio Caixa de Pensions, Barcelona, Spain
1989 A Forest of Signs: Art in the Crisis of Representation,
 The Museum of Contemporary Art, Los Angeles (CA),
 USA
1991 Metropolis, Martin-Gropius-Bau, Berlin, Germany
1993 Whitney Biennial, Whitney Museum of American Art,
 New York (NY), USA
 American Art of this Century, Martin-Gropius-Bau,
 Berlin, Germany and Royal Academy of Arts, London,
 UK
 Post Human, Deichtorhallen, Hamburg, Germany
1995 46. Biennale di Venezia, Venice, Italy
1997 Gender Performance in Photography, Solomon R.
 Guggenheim Museum, New York (NY), US
1998 Mirror Images: Women, Surrealism and Self-
 Representation, MIT List Center, Cambridge (MA);
 Miami Art Museum, Miami (FL); San Francisco
 Museum of Modern Art, San Francisco (CA), USA
1999 The American Century, Whitney Museum of American
 Art, New York (NY), USA
 Regarding Beauty: A View of the Late Twentieth
 Century, Hirshhorn Museum and Sculpture Garden,
 Washington D.C., USA
2000 Hypermental, 1950 – 2000 from Salvador Dalí to Jeff
 Koons, Kunsthaus Zürich, Zurich, Switzerland
 Die verletzte Diva, Kunstverein München, Munich;
 Städtische Galerie im Lenbachhaus, Munich,
 Staatliche Kunsthalle Baden-Baden, Germany; Galerie
 im Taxis Palais, Innsbruck, Austria

SELECTED BIBLIOGRAPHY

1993 Cindy Sherman 1979–1993, Munich, Germany
1995 Cindy Sherman – Photoarbeiten 1975–1995, Munich,
 Germany
 Cindy Sherman – History Portraits – Die
 Wiedergeburt des Gemäldes nach dem Ende der
 Malerei, Munich, Germany
1996 Cindy Sherman, Museum of Modern Art, Shiga, Japan
1997 Cindy Sherman: Retrospective, Museum of
 Contemporary Art, Los Angeles (CA), USA
 Cindy Sherman – Untitled Fiilm Stills, Munich,
 Germany
2001 Women Artists, Cologne, Germany

THOMAS STRUTH

1954 born in Geldern; lives and works in Düsseldorf, Germany

SELECTED SOLO EXHIBITIONS

1978 P.S.1, Long Island City (NY), USA
1987 Kunsthalle Bern, Berne, Switzerland
 Prefectural Museum of Art, Yamaguchi, Japan
 Fruitmarket Gallery, Edinburgh, UK
1990 The Renaissance Society, Chicago (IL), USA
1992 Museum Haus Lange, Krefeld, Germany
 Hirshhorn Museum and Sculpture Garden,
 Washington D.C., USA
1993 Hamburger Kunsthalle, Hamburg, Germany
1994 Institute of Contemporary Art, Boston (MA), USA
 Institute of Contemporary Arts, London, UK
1995 Art Gallery of Ontario, Toronto, Canada
 Kunstmuseum Bonn, Germany
1997 Fine Arts Foundation of Beijing, International Art
 Palace, Beijing, China (with Luo Yongijn)
 Sprengel Museum, Hannover, Germany
1998 Stedelijk Museum, Amsterdam, The Netherlands
1999 Centre National de la Photographie, Paris, France
2000 National Museum of Modern Art, Tokyo, Japan
 National Museum of Modern Art, Kyoto, Japan
2002 The Museum of Contemporary Art, Los Angeles (CA),
 USA
 Dallas Museum of Art, Dallas (TX), USA
 New Pictures from Paradise, Staatliche
 Kunstsammlungen Dresden, Germany
2003 Museum of Contemporary Art, Chicago (IL), USA
 The Metropolitan Museum of Art, New York (NY), USA

SELECTED GROUP EXHIBITIONS

1979 Schlaglichter: Junge Kunst im Rheinland, Rheinisches
 Landesmuseum Bonn
1989 Standort Düsseldorf '86, Kunsthalle Düsseldorf,
 Germany
1987 Skulptur. Projekte. Münster 1987, Münster, Germany

1989 Un autre Objectivité / Another Objectivity, Centre National des Arts Plastiques, Paris, France

1990 Aperto, 43. Biennale di Venezia, Venice, Italy

1991 Aus der Distanz, Kunstsammlung Nordrhein-Westfalen, Düsseldorf, Germany
Carnegie International, Carnegie Museum of Art, Pittsburgh (PA), USA

1992 documenta IX, Kassel, Germany

1993 Photographie in der deutschen Gegenwartskunst, Museum Ludwig, Cologne, Germany

1994 The Epic and the Everyday, Hayward Gallery, London, UK

1997 Absolute Landscape: Between Illusion and Reality, Yokohama Museum of Art, Yokohama, Japan
Positionen künstlerischer Photographie in Deutschland nach 1945, Berlinische Galerie im Martin-Gropius-Bau, Berlin

1998 11th Biennale of Sydney, Australia

1999 The Museum as Muse: Artists reflect, The Museum of Modern Art, New York (NY), USA

2000 How You Look at It, Sprengel Museum, Hanover, Germany
5e Bienale de Lyon, France
Vision and Reality, Louisiana Museum of Modern Art, Humlebæk, Denmark

2001 ex(o)DUS, Haifa Museum of Art, Haifa, Israel

2002 Wallflowers, Kunsthaus Zürich, Zurich, Switzerland
heute bis jetzt – Zeitgenössische Fotografie aus Düsseldorf, Museum Kunst Palast, Düsseldorf, Germany

SELECTED BIBLIOGRAPHY

1990 Thomas Struth – Unbewußte Orte/Unconscious Places, Kunsthalle Bern, Berne, Switzerland

1992 Thomas Struth – Portraits, Museum Haus Lange, Krefeld, Germany

1995 Thomas Struth – Straßen. Fotografie 1976 bis 1995, Kunstmuseum Bonn, Germany

1997 Thomas Struth – Portraits, Munich, Germany

2002 Thomas Struth – New Pictures from Paradise, Munich, Germany

2002 Thomas Struth – 1977 2002, Munich, Germany

ROSEMARIE TROCKEL

1952 born in Schwerte, lives and works in Cologne, Germany

SELECETED SOLO EXHIBITIONS

1985 Rosemarie Trockel: Bilder – Skulpturen – Zeichnungen, Rheinisches Landesmuseum, Bonn, Germany

1988 Projects: Rosemarie Trockel, The Museum of Modern Art, New York, (NY), USA
Kunsthalle Basel, Basle, Switzerland
Institute of Contemporary Arts, London, UK

1991 Museum für Gegenwartskunst, Basel, Basle, Switzerland
Neuer Berliner Kunstverein, Berlin, Germany
Institute of Contemporary Art, Boston (MA), USA
Museum of Contemporary Art, Chicago (IL), USA

1992 Museo Nacional Centro de Arte Reina Sofía, Madrid, Spain
Museum Ludwig, Cologne, Germany
Nykytaiteen Museo, Museum of Contemporary Art, Helsinki, Finland

1993 De Pont Stichting, Tilburg, The Netherlands
Neues Museum Weserburg, Bremen, Germany
City Gallery, Wellington, New Zealand

1994 Museum of Contemporary Art, Sydney, Australia
MAK Museum für Angewandte Kunst, Vienna, Austria
Centre d'Art Contemporain, Geneva, Switzerlandf

1995 Rosemarie Trockel: Löffel und Mirabelle, Museum Haus Esters, Krefeld, Germany
Rosemarie Trockel: Familien-Modelle, The Israel Museum, Jerusalem, Israel

1996 Center for Contemporary Arts, Ujazdowski Castle, Warsaw, Poland

1998 Hamburger Kunsthalle, Hamburg, Germany
Staatsgalerie Stuttgart, Germany
Whitechapel Art Gallery, London, UK

1999 Musée d'Art Moderne de la Ville de Paris, France (with Carsten Höller)

2000 Städtische Galerie im Lenbachhaus, Kunstbau, Munichen, Germany
Rosemarie Trockel: Drawings, Centre Georges Pompidou, Paris, France

2001 Moderna Museet, Stockholm, Sweden
The Drawing Center, New York (NY), USA

SELECTED GROUP SHOWS

1985 Kunst mit Eigensinn, Museum moderner Kunst, Stiftung Ludwig Wien, 20er Haus, Vienna, Austria

1986 Sonsbeek '86, Arnhem, The Netherlands

1987 Art from Europe, Tate Gallery, London, UK

1988 Carnegie International, Carnegie Museum of Art, Pittsburgh (PA), USA

1989 Bilderstreit: Widerspruch, Einheit und Fragment in der Kunst seit 1960, Rheinhallen, Cologne Fair Grounds, Cologne, Germany

1992 Allegories of Modernism: Contemporary Drawing, The Museum of Modern Art, New York (NY), USA

1993 Widerstand, Haus der Kunst, Munich, Germany

1994 XXII Bienal Internacional de São Paulo, Brazil

1995 4. Istanbul Biennale, Istanbul, Turkey
Fémininmasculin: le sexe de l'art, Centre Georges Pompidou, Paris, France

1996 Manifesta, Rotterdam, The Netherlands
10th Biennale of Sydney, Australia

1997 documenta X, Kassel, Germany (with Carsten Höller)
Kwangju Biennale, Kwangju, South Korea
Art/Fashion, Solomon R. Guggenheim Museum, New York (NY), USA

1999 Face to Face, Fondation Beyeler, Basle, Switzerland
Weaving the World, Yokohama Museum of Art, Yokohama, Japan
6. Istanbul Biennale, Istanbul, Turkey
Beauty Now, Hirshhorn Museum and Sculpture Garden, Washington D.C., USA and Haus der Kunst, Munich, Germany
48. Biennale di Venezia, German Pavilion, Venice, Italy

2000 Ich ist etwas Anderes, Kunstsammlung Nordrhein-Westfalen, Düsseldorf, Germany
Presumé innocent, capcMusée d'Art Contemporain, Bordeaux, France
In Between, EXPO 2000, Hanover, Germany (with Carsten Höller)

2001 Unreal time video, The Korean Culture and Art Foundation, Seoul, South Korea

SELECTED BIOGRAPHY

1985 Rosemarie Trockel, Rheinisches Landesmuseum, Bonn, Germany

1991 Rosemarie Trockel, Institute of Contemporary Art, Boston (MA), USA
Rosemarie Trockel, München

1994 Rosemarie Trockel – Anima, Ostfildern, Germany

1997 Rosemarie Trockel – Herde, Cologne, Germany

1998 Rosemarie Trockel – Werkgruppen 1986–1998, Cologne, Germany

1999 Rosemarie Trockel – 48. Biennale di Venezia, Cologne, Germany

2000 Rosemarie Trockel, Skulpturen, Videos, Zeichnungen, Cologne, Germany

FRANZ WEST

1947 Born in Vienna, lives and works in Vienna, Austria

SELECTED SOLO EXHIBITIONS

1986 Kunstzentrum der Engelhorn Stiftung, Munich, Germany

1987	Neue Galerie am Landesmuseum Joanneum, Graz, Austria
1988	Ansicht, Wiener Secession, Vienna, Austria
1989	Kunsthalle Bern, Berne, Switzerland
	Schöne Aussicht, Portikus, Frankfurt am Main, Germany
1990	Museum Haus Lange, Krefeld, Germany
	Possibilities, P.S.1, Long Island City (NY), USA
	Kunsthistorisches Museum Wien, Vienna, Austria
1991	Villa Arson, Nice, France
1993	Musée de l'Art Contemporain Geneva, Switzerland (with Herbert Brandl)
1994	The Museum of Contemporary Art, Los Angeles (CA), USA
	Dia Center for the Arts, New York (NY), USA
1996	Gelegentliches, Städtisches Museum Abteiberg, Mönchengladbach, Germany
	Proforma, Museum moderner Kunst, Stiftung Ludwig Wien, 20er Haus, Vienna, Austria; Kunsthalle Basel, Basle, Switzerland; Rijksmuseum Kröller-Müller, Otterlo, The Netherlands
	Leviten, Bonnefanten Museum, Maastricht, The Netherlands
1997	Projects, The Museum of Modern Art, New York (NY), USA
	Fundação de Serralves, Porto, Portugal
1998	Middelheim Open Air Museum, Antwerp, Belgium
1999	Rooseum – Center for Contemporary Art, Malmö, Sweden
2000	Pre-Semblance & The Everyday, The Renaissance Society, Chicago (IL), USA
2001	In & Out, Museo Nacional Centro de Arte Reina Sofía, Madrid, Spain

SELECTED GROUP EXHIBITIONS

1981	Westkunst, Rheinhallen, Fair grounds, Cologne, Germany
1985	Spuren, Skulpturen und Monumente ihrer präzisen reise, Kunsthaus Zürich, Zurich, Switzerland
1986	Sonsbeek 86, Arnhem, The Netherlands
	Skulptur Sein, Kunsthalle Düsseldorf, Germany
1987	Skulptur. Projekte. Münster 1987, Münster, Germany
	Aperto, 43. Biennale di Venezia, Venice, Italy
1988	Zeitlos, Hamburger Bahnhof, Berlin, Germany
1989	Open Mind, Museum van Hedendaagse Kunst, Ghent, Belgium
	Einleuchten, Deichtorhallen, Hamburg, Germany
1990	44. Biennale di Venezia, Austrian Pavilion, Venice, Italy
	Musée de l'Art Moderne de la Ville de Paris, France
1991	Metropolis, Martin-Gropius-Bau, Berlin

1992	documenta IX, Kassel, Germany
1995	Carnegie International, Carnegie Museum of Art, Pittsburgh (PA), USA
	Take me (I'm yours), Serpentine Gallery, London. UK
1996	10th Biennial of Sydney, Sydney, Australia
	Model Home, P.S.1, Long Island City (NY), USA
1997	4e Biennale de Lyon, France
	Skulptur. Projekte in Münster 1997, Münster, Germany
	47. Biennale di Venezia, Venice, Italy
	documenta X, Kassel, Germany
1998	Life Style, Kunsthaus Bregenz, Austria
	XXIV Bienal Internacional de São Paulo, Brazil
	Signs of Life, Melbourne International Biennial, Melbourne, Australia
1999	Zeitwenden, Kunstmuseum Bonn, Germany
2000	Quiet Life, Ursula Blickle Stiftung, Kraichtal, Germany
	Quotidiana. The Continuity of the Everyday in 20th Century Art, Castello di Rivoli, Torino, Italy

SELECTED BIBLIOGRAPHY

1991	Franz West – Legitime Skulptur 1950–85, Neue Galerie am Landesmuseum Joanneum, Graz, Austria
1992	Franz West – Ansicht, Wiener Secession, Vienna, Austria
1993	Franz West – Schöne Aussicht, Portikus, Frankfurt am Main, Germany
1994	Franz West, Museum Haus Lange, Krefeld, Germany
1995	Franz West, The Renaissance Society, Chicago (IL), USA
1996	West – Gelegentliches zu einer anderen Rezption, Städtisches Museum Abteiberg, Mönchengladbach, Germany
	Franz West – Proforma, Wien, Austria
1999	Franz West, Rooseum – Center for Contemporary Art, Malmö, Sweden
2000	Limited, Franz West, London, UK
2001	Franz West – In & Out, Museum für Neue Kunst, Zentrum für Kunst und Medientechnologie, Karlsruhe, Germany
	Franz West, Fundação de Serralves, Porto, Portugal

CHRISTOPHER WOOL

1955 born Chicago (IL), lives and works in New York (NY), USA

SELECTED SOLO EXHIBITIONS

1989	New Work: Christopher Wool, San Francisco Museum of Modern Art, San Francisco (CA), USA
1991	Museum Boijmans Van Beuningen, Rotterdam, The Netherlands

	Kölnischer Kunstverein, Cologne, Germany
	Kunsthalle Bern, Berne, Switzerland
1998	The Museum of Contemporary Art, Los Angeles (CA), USA
	Carnegie Museum of Art, Pittsburgh (PA), USA
	Kunsthalle Basel, Basle, Switzerland
1999	Centre d'Art Contemporain, Geneva, Switzerland
2001	Wiener Secession, Vienna, Austria
2002	Le Consortium, Dijon, France

SELECTED GROUP EXHIBITIONS

1993	Die Sprache der Kunst, Kunsthalle Wien, Vienna, Austria and Frankfurter Kunstverein, Frankfurt am Main, Germany
1994	Herbert Brandl, Albert Oehlen, Christopher Wool, National Gallery, Prague, Czech Republic
1995	25 Americans: Painting in the 90s, Milwaukee Art Museum, Milwaukee (WI), USA
1997	Birth of the Cool – American Painting from Georgia O'Keeffe to Christopher Wool, Deichtorhallen, Hamburg, Germany and Kunsthaus Zürich, Zurich, Switzerland
	American Realities, Views from Abroad, European Perspectives on American Art, Whitney Museum of American Art, New York (NY), USA
	Family Values, Hamburger Kunsthalle, Hamburg, Germany
1998	Elements of the Natural, The Museum of Modern Art, New York (NY), USA
1999	The Passion and the Waves, 6. Istanbul Biennial, Istanbul, Turkey
2000	Mixing Memory and Desire, Kunstmuseum Luzern, Lucerne, Switzerland
2002	Five by Five: Contemporary Artists on Contemporary Art, Whitney Museum of American Art at Philip Morris, New York (NY), USA

BIBLIOGRAPHY

1989	Herold, Oehlen, Wool, The Renaissance Society, Chicago (IL). USA
	Christopher Wool, New York (NY), USA
1993	Absent without leave, DAAD Galerie, Berlin
1994	Herbert Brandl, Albert Oehlen, Christopher Wool, National Gallery, Prague, Czech republic
1997	Birth of the Cool, American Painting from Georgia O'Keeffe to Christopher Wool, Zurich
1998	Christopher Wool, Zurich, Switzerland
1999	Art at the Turn of the Millennium, Cologne, Germany

Published on the occasion of the exhibition
"ahead of the 21st century – The Pisces Collection",
Fürstenberg Sammlungen, Donaueschingen,
June 2002 – October 2004

Edited by de Pury & Luxembourg
Exhibition curators: Simon de Pury, Geneva
Andrea Caratsch, Zurich
Assistance: Arlène Bonnant, Geneva

Catalogue
Copy Editing: Uta Grosenick, Cologne
Design and typesetting: Christina Hackenschuh, Stuttgart
Separations: C+S Repro, Filderstadt
Translations: Translate-a-book, Oxford, England (d-e/g-e)
Production: Dr. Cantz'sche Druckerei, Ostfildern-Ruit

© 2002 The Picses Trust c/o de Pury & Luxembourg, Geneva,
Hatje Cantz Verlag and Authors

© 2002 for the reproduced works by George Condo, Andreas
Gursky, David Salle, Rosemarie Trockel by VG Bild-Kunst,
Bonn, the artists and their legal successors

Published by
Hatje Cantz Publishers
Senefelderstrasse 12
73760 Ostfildern-Ruit
Germany
Tel. 0049/711/4 40 50
Fax 0049/711/4 40 52 20
Internet: www.hatjecantz.de

Distribution in the US
D.A.P. Distributed Art Publishers, Inc.
155 Avenue of the Americas, Second Floor
New York, N.Y. 10013-1507
USA
Tel. 212/627 1999
Fax 212/627 9484

ISBN 3-7757-1251-8
Printed in Germany

Photo Credits: Almost all photographs were taken by Patrick
Goetelen, Geneva. "Alone Yet Together" was photographed
by David Willen, Zurich.

Cover: Damien Hirst, "Alone Yet Together", 1993, detail